"A LOVE LETTER TO SHOW BUSINESS! *Try Not to Hold It Against Me* is a must-read written by one of the best & funniest in the industry. Truly a fascinating memoir that will captivate & delight any reader!"
susan stroman, five-time tony award-winning director & choreographer

"If I had only had the chance to read Julian Schlossberg's *Try Not To Hold It Against Me* when I started to launch my own career as an actor I would have been introduced to the world of "show business" it took me decades to discover. Such a wealth of insight into how things get done, i.e. films, plays, and worthy endeavors. The memoir is a joy to read and a trip down memory lane during perhaps its' most creative era."
tony roberts, actor (*annie hall, serpico*,) two-time tony nominee

"Mike Nichols was doing a play in London and afterwards invited me to join him and Jeremy Irons for a bite, where he introduced me to Julian Schlossberg. When Julian left to catch a plane Mike said, 'There goes the nicest producer in show business.' Like a fool, I believed him. I still do."
f murray abraham, academy award winning actor

"*Try Not To Hold It Against Me* is a blockbuster! Julian writes of stars like Al Pacino, Orson Welles, The Beatles, Shirley MacLaine, George C. Scott, Burt Reynolds (and so many others). It was like I was standing on his shoulders seeing VIP doors suddenly open. You'll love this book. I promise."
steve guttenberg, actor (*3 men and a baby, cocoon, police academy* films)

"A brilliant tale of show business, *Try Not to Hold It Against Me* will have readers laughing out loud and giving a standing ovation."
twiggy, actress/model

"Now, what's most amazing about this book: *Try Not to Hold It Against Me* is a true story. Julian Schlossberg's show-business page-turner is a bold adventure, told as a crackling good tale. Inspires as well as excites. Highly recommend."

walter anderson, formerly editor-in-chief, *parade* magazine

"If you have ever found yourself interested, even minutely, in the inner workings of Hollywood directors, *Try Not to Hold It Against Me* is a fantastic starting point. It will hold your interest as you are regaled with stories of Elia Kazan, Arthur Penn, Mike Nichols and many more."

renee taylor, emmy-award winner actress/writer

"Julian Schlossberg's memoir is as original and entertaining as is his amazing body of work. It is packed with unique glimpses of the dazzling array of stars he has worked with. This renowned producer has a jeweler's eye for the foibles and brilliance of artists and a jaundiced eye for the petty and tawdry. He knows show business, and I have to say: He's one helluva writer."

danny goldberg, former president of atlantic records, author of *serving the servant: remembering kurt cobain*

"Julian Schlossberg has already proven that he's an A+ Broadway producer, but here he proves that he's a damn good storyteller. From his childhood in the Bronx to his future in film, Schlossberg shines with this gripping account of what it takes to make it big."

marlo thomas, four-time emmy-award winning actress/writer/producer

try not to hold
it against me

try not to hold
it against me

try not to hold it against me

A PRODUCER'S LIFE

julian schlossberg

BEAUFORT
BOOKS

try not to hold it against me

This book is a memoir. The information included is based on the author's present
recollections of experiences over time. Some dialogue may have been recreated using the
author's best recollection.

Hardcover: 9780825310256
Paperback: 9780825310379
Ebook: 9780825309007

For inquiries about volume orders, please contact:
Beaufort Books, 27 West 20th Street, Suite 1103, New York, NY 10011
sales@beaufortbooks.com

Published in the United States by Beaufort Books
www.beaufortbooks.com

Distributed by Midpoint Trade Books
a division of Independent Publisher Group
https://www.ipgbook.com/

Photos courtesy of the author

Printed in the United States of America

To my wife Merryn,

Who changed my life and brings me joy on a daily basis.

chapters

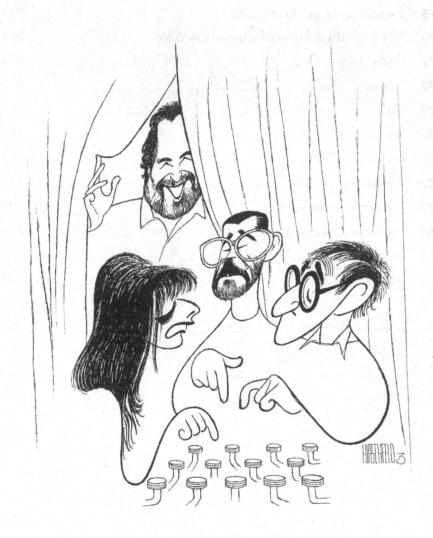

Julian Schlossberg with the playwrights of Death Defying Acts,
Elaine May, David Mamet, and Woody Allen, 1995
© The Al Hirschfeld Foundation. www.AlHirschfeldFoundation.org

foreword

I first met Julian Schlossberg when he was Vice President of Production at Paramount Pictures and screwed my movie.

"I really like *Mikey and Nicky*," he said, "and so does everyone at the studio"—obviously unaware that Paramount had sued me for a year after seeing the dailies—"and," he went on, "there will be a sneak preview of it tomorrow night in Washington, D.C. The ad will be in the morning paper."

"Please don't put my name in it," I said. "It's a dark movie, not like anything I've ever done. If you put my name in the ad, people will think it's a comedy, and kill me when it isn't."

"You've got it," he said. "No name in the ad."

The next day the ad came out, and it said, "Elaine May's new movie previews tonight—The Dupont Theater at 7 p.m."

I sat in the back row and watched as the audience laughed through hate, fistfights, and gunshots, and finally, when the end came and they realized there was no comic twist, they began to boo. *Loud* boos. Threatening gestures.

A man in a suit whispered, "I'm a Vice President with Paramount," and he led me out. He took me to a small office in the theater, crowded with other men in suits who were vice presidents at Paramount. Julian Schlossberg, who was very young at the time, sat perched on a desk. He was very pale. He did not look at me.

"Do you know what a liar is?" I said.

"I told him to do it," another man in a suit cried. "I'm the vice president in charge of . . . him."

Faint boos echoed from the lobby as the audience filed out. I left the room.

The next morning, Julian Schlossberg appeared at my door.

"I'm going to all the Walter Reade Theaters to make sure they're cross-plugging *Mikey and Nicky*," he said.

We went to six theaters, and he spoke to the manager at each one and asked if there was a trailer on the screen for my movie. There wasn't.

By the end of the day I was exhausted, because we had gone by bus. He explained that he could not afford to take that many taxis, and he felt it would be dishonest to charge Paramount, because Paramount did not know he was doing this.

When the film opened, the reviews were mostly about the lawsuit—and on Paramount's side. There was a noticeable absence of crowds. The film closed. And soon afterward, Julian Schlossberg called me and said he was meeting with the Paramount lawyer about the movie, and he thought I should be there.

We met in a restaurant, and he pointed out to the lawyer that according to my contract, there were supposed to be ads and trailers to meet the standards of a Grade A movie release.

The lawyer for Paramount said, "That would have cost a fortune, and we knew no one was going to see it."

"Then we should just give her the movie," Julian said. "Otherwise, she'll sue." He glanced at me. "She's very litigious." He mentioned the year-long lawsuit I had just engaged in with Paramount.

The lawyer shrank back. "Take it," he said.

And the movie was mine. I had no idea what to do with it.

A few months later, Julian quit Paramount and became a distributor. "Would you like me to distribute your movie?" he asked.

I knew he was very knowledgeable about movies, having been the vice president of Walter Reade Theaters for many years.

"Okay," I said. "Give it a try. It's on a shelf in the garage."

He immediately began distributing the film in Europe—where they seemed to like it. He sent it to important film critics in America, who also seemed to like it. Within two years he told me that it had become a cult movie. And he is distributing it to this day.

He then produced all of my plays, went over my accounts, and explained that my accountant was cheating me. He then found me another accountant. He looked over my contracts and made it clear that three zeroes was a thousand, not a hundred. Soon, he did not even *send* me the contracts—he just told me which ones to sign. Every once in a while, when he seemed to be occupied with something other than me, I would remind him how the audience had booed at the screening of *Mikey and Nicky*, and he would snap back to attention.

Recently he has written a book, and I've read it. He certainly knows what a lie is now.

And there isn't one lie in his book.

elaine may
new york city

the wrong coast

I'm not from Hollywood. Or anywhere near it. I grew up in a lower-middle-class apartment on Aqueduct Avenue in the Bronx. I had no room of my own; I slept in a tiny area right off the kitchen with no doors, which was supposed to be a dining room. It led to a hallway that contained our small dining table, and that's where we ate.

As an only child, I was given a lot of attention. And being loved by my parents was one heck of a head start.

As a kid I played on the streets until all hours: hide-and-seek, Johnny on the Pony, ring-a-levio, potsy. At the schoolyard we played softball, handball, stickball. For entertainment, we had the radio, of course—and later, the advent of television.

But most importantly, there were eight movie theaters within walking distance, providing lots of entertainment. The movies, with so many choices, got a weekly visit at the very least. Closest to my home, just three blocks away, was the Kingsbridge Theater, where weekday prices were fourteen cents for kids and thirty cents for adults.

In the summer, we had no air conditioning—but the theaters did.

Cooling off and being entertained: it was an unbeatable combination. And my friends and I spent hours there: two feature films, a newsreel, five or six cartoons, a short, and the coming attractions. I often took my lunch in a brown bag and spent the whole day at the movies.

By most measures, it was was a reasonably normal childhood. I contracted the measles, chicken pox, the mumps, German measles. I still have my tonsils and—so far, so good—have never been admitted to a hospital. I was pretty much a creature of my environs, aware mostly of my immediate neighborhood. Just another New York City street kid.

mom

Charlotte Bash, my mother, graduated high school at fifteen years old and college at nineteen. She could have kept on skipping grades, but my grandmother put an end to it; my mom eventually got her master's degree. Clearly, she was the brains of the outfit.

Mom was very strong, very smart, and very opinionated. She had great loyalty to her family and friends and an enormous amount of integrity. She taught me a lot. She loved me a lot. But unlike my dad, she didn't agree with or accept a lot about me. We didn't see eye-to-eye on many things. She often said she couldn't believe that I'd come from her. On that point, at least, we did agree.

My mother taught me, "It's not what happens to you in life, it's how you handle it." That was a wonderful bit of advice that I cherish even today. "This too shall pass" was another one. (I've relied on that one a lot over the years.) But her best was, "Don't judge people on what you would do yourself."

Now before you get the wrong idea, Mom was no Mrs. Gump. She would be the last person to say that life is like a box of chocolates. She

pretty much saw the box as more than half empty, to begin with.

She clearly wore the pants in our family. My father wasn't weak, but he wasn't strong either. He just didn't care about much—leaving a vacuum to be filled by Mom, who cared about almost everything.

While she was honest, he would cut corners. She loved to read. He loved television. She had loads of friends. He had few. She worried. He...just didn't.

My mom was a teacher. She taught accounting and bookkeeping. She had a great deal of authority, and when she spoke, it came from the mountaintop.

Once, when she was in our apartment alone, she was robbed at knife-point. She told the robber he had to leave her two dollars, which he did. He then said, "Let me out the door," and my mom replied, "You'll leave the way you came in." As directed, the robber left through the window.

My mom would prepare food for me when I was a child, and my dad would sometimes feed it to me. My mother loved to tell me how he'd respond when he tried to put the spoon into my mouth and I'd move my head away. "Look kid, it's no skin off my ass if you eat or not," he would finally say.

My mother was part of a basketball team called the City College Co-eds, or C3 ("C-Cubed"). My father told me he loved to watch her team play. When I asked why, he would adopt a falsetto to imitate Mom and her teammates yelling, "Give me the ball! Throw me the ball!" We both got such a kick out of that story.

Begrudgingly, Mom would laugh a little too. She was clearly the only adult in the house.

In 1950, when I was eight years old, I ran a 105-degree fever and the doctor was called to our home. (They still made house calls in those days.) The doctor examined me and said I had to go to the hospital.

"Can't he go tomorrow?" my mother asked. "Maybe the temperature will drop."

"Only a miracle could make that happen," the doctor answered. "He has polio."

"It's ten o'clock p.m.," my mother demurred. "It's late—let him sleep in his own bed tonight, and I'll take him in the morning. They won't do anything now anyhow."

The doctor gave in.

The next morning, my mom called him. The fever had dropped, she said, and I was back to normal.

"Oh, Mrs. Schlossberg," he replied, not believing her. "I'll be right over."

When he arrived, he couldn't believe it: my temperature was indeed normal.

I still wasn't out of the woods; I was out of school for months. Temporarily, my legs became somewhat paralyzed. (I would ultimately recover fully, with no side effects except one: while everyone has one foot a little larger than the other, my feet are an entire half-size different. Small price to pay for having caught a serious disease before the Salk vaccine had been discovered.)

While I was home recovering, my mom saw to it that I kept up my lessons. My favorite grade-school teacher, Mrs. Knowles, cooperated fully. Whenever it was the birthday of a kid in class, Mrs. Knowles used to draw a cake with colored chalk on the blackboard and all the other kids would sing "Happy Birthday." I missed my birthday that year, and I was crestfallen. But weeks later when I returned to class, there was my beautiful colored-chalk cake, and the kids were singing away. Mom had secretly tipped off Mrs. Knowles. It's funny what we remember.

Mom insisted I go to an out-of-town college. She felt that she and I were too close, and that I needed to be away. By that time she had become one of the first full-time guidance counselors in the Board of Education of the City of New York. I remember arguing with her about her wish to sign one of the first—if not *the* first—full-page ads in *The New York Times* against the Vietnam War. I remember, in college, spouting the domino theory that if Vietnam went communist, then eventually all of Asia would. In the end, she prevailed and signed her name.

try not to hold it against me

My mother and I fought a lot. Our outlook on life was totally different. I admired her character, her honesty, her strength, but she was tough as a mother, and (as she told me) I was no bed of roses.

Still, the love was always there.

the kingsbridge armory

I lived across the street from the Kingsbridge Armory, the largest armory in the world. Long before the Javits Center and the New York City Coliseum were built, the Armory hosted boat shows, car shows, and even rodeos. That's right—rodeos in the Bronx, with bucking broncos, lassoing, heifer-tying, and all the rest!

On top of that, Western movie stars appeared in person: Buster Crabbe and Johnny Mack Brown, to name two. I can't tell you how excited I was to meet and see those people live. I was surprised that Buster had so much rouge on his cheeks and looked so old, but he was so nice and friendly in his black-and-white cowboy shirt that I forgot the small stuff while I basked in his presence.

It was the Kingsbridge Armory, in fact, that started my show-business career. Here's how it happened. All the merchants near the armory would be given two free tickets for opening day. I knew most of them, and close to opening day I would go in and ask if they had any tickets they weren't using. My barber always saved his two tickets for me; after a while, so did the owners of the candy store, the deli, the shoemaker, and

the cleaners. So at ten years old, in the height of winter, I'd take those tickets and sell them outside the armory for a dollar off regular price.

I made a lot of money this way. I have a clear memory of once having sixty or seventy singles spread out all over my bed, and diving into them like Scrooge McDuck in the comic books. When my mom came home unexpectedly one day and caught me doing this, she demanded to know where I'd gotten the money. When I told her, she was very angry and warned me in no uncertain terms never to do it again.

I never did dive into all those singles again. But I confess, I did continue to work the Armory.

dad

My father, Louis Schlossberg, had blue eyes and blond hair and resembled the actor Leslie Howard. He was a great ball player, a true natural athlete. His brothers and friends often talked about how fabulous he was as a shortstop in baseball. He was a switch hitter, a great fielder, and a fast runner.

He played semi-pro for a team called the New York Daltons. In 1929, when he was nineteen, he tried out for the Yankees. This was years before the great Frankie Crosetti became their star shortstop. My father was accepted by Kansas City, the triple-A farm team owned by the Yankees. That was one stop away from the majors—there were also the A, B, C, and D leagues, but my dad was going to play triple-A ball.

Then my grandparents weighed in. Kansas City was too far away. There were almost no Jews in baseball. He was too young to go.

Dad listened to his parents. I don't think there was a day of his life that he didn't regret that decision. But most people at that time and that age obeyed their parents.

My father spent most of his adult life in New York's garment center,

which he hated. He started a business with his brother-in-law; when that failed, he worked for his brothers. But he never enjoyed himself at work. I so clearly remember him trudging home in his suit, top shirt button opened, tie loosened, *The New York Post* under his arm. Eventually, he would quit, and it was a happy day for him when he did. He drove a cab for the rest of his life.

I was the apple of Dad's eye. To him, I could do no wrong. I never doubted his love and his devotion. He had the best sense of humor. I was always laughing with him. He would sometimes sit me down and say, "Julie, always remember: if at first you don't succeed—forget it." And he and I would howl with laughter.

Dad had a beautiful singing voice and often would sing the old songs. He loved show business and show people. Like me, he loved movies. Watching baseball on TV had become too slow for him; as he would often say, "I like the action."

He often took me to the Bronx Zoo when I was a little boy. I loved the animals, and my father did his best to enliven our visits. Two incidents stand out.

Once, in the snake house, the giant, poisonous snakes were curled up behind glass windows, sleeping. Complaining about how boring this was, my father started tapping on the glass. No response. Then he rapped harder. No response.

Finally, he smacked the glass *real* hard. A snake reared up and went for my dad, smashing his face into the window after having released a load of venom.

The keeper came over and escorted us out. "How would you feel if there had been no glass?" he asked.

My father didn't answer, but when we'd left he said, "Well, at least there was some action."

Another time, in the elephant house we had bought some "elephant food," with which we were allowed to feed the mighty ones. My dad put out the food, the elephant extended his trunk and my dad moved the food away. He did that same move three times. Then the elephant

turned his back on us. As we stood there, he turned back around, and with his trunk sprayed water all over us. Soaking wet, we were once again escorted out.

My dad couldn't stop laughing. When we were alone, he said, "Aren't many people asked to leave the zoo."

Dad was an average student who graduated high school, but went no further. (Since I was conceived before World War II, he was able to avoid the armed services.) His first job had been with the Travelers Insurance Company, selling policies door to door.

Dad's sister, Frances, was my mom's best friend, and introduced the two of them. He was always deferring to my mother, even with his sister. One day Aunt Frances called and asked him if he wanted to have dinner that Saturday night.

"Let me ask the chief," Dad said.

Aunt Fran sighed. "Louie, did you ever do anything without asking Charlotte?"

Dad didn't miss a beat. "Hold on," he said, then called to my mom, "Charl, do I ever do anything without asking you?"

Every night after dinner, Dad would stretch out on the couch, Mom would read in a chair, and I'd sit on the floor between them, also reading. If the doorbell rang, my dad would often say, "It's not for me." I'd pipe up, "Not for me, either." Mom would surrender: "Oh, damn it. I'll get it." And she would. The same went for the phone, whenever it rang. Knowing how strong my mother was, I'm surprised she let this routine go on. I suspect she secretly got a kick out of it.

For much of my life, Dad had emphysema. He had smoked three packs a day since he was fifteen, and he only stopped some fifty years later. Many times and in various hospitals, with his lungs deteriorating, we were told by the doctors that this was it: he'd be gone in a day or two.

On one overnight vigil, he lay unconscious while my mom and I stayed with him all night. In the morning, the sun rose and light beamed into the room. We saw his eyes flutter. Slowly he opened them. We couldn't believe it—he was alive.

His lips moved. We leaned in and heard, "Egads, is this the end of Little Caesar?"

It was the only time in my life I laughed and cried at the same time.

At the actual end of Dad's life—which had seemed to be often—I decided to interview him. I thought, *Let me have an audio tape to remember him by.* I had my radio show by then, and I was all gung-ho to sit Dad down and get his story: his thoughts, his dreams, his disappointments, his feelings. I asked him, right at the outset, how he felt being born the last of six brothers, right before the only sister was born. He asked me, what did I mean?

"Did you feel neglected or ignored?" I asked.

"I don't know," he said.

I tried again: "Did you resent all the attention your parents paid to Aunt Fran?"

"I just don't remember."

I asked him a few more questions, and he looked at me and said, "Julie, I love you a lot. I just don't know what you want from me. I really haven't thought very much about any of this."

I stopped the tape, and assured him it didn't matter. I wanted to make sure he didn't feel like he had failed me. He looked so sad.

"Dad," I said, "believe me, I don't need a tape to remember you. You'll be with me forever."

He looked so relieved.

And the truth is, as long as I'm alive, Little Caesar lives.

making hay

One summer morning when I was about ten years old, my friend Walter and I were walking along Kingsbridge Road. As we crossed Jerome Avenue, we saw that the newspaper stand under the elevated train was deserted. Outside on the sidewalk were large parcels of newspapers wrapped in wires; I remember specifically *The Daily News* and *The Daily Mirror*.

I told Walter to go and get a lock at a nearby hardware store. "I'll also get a wire cutter," he added. I said I'd stand guard until he returned.

When he did, we opened the stand, cut the wires, and immediately started selling newspapers. We took turns working behind the counter and retrieving the papers. They were wrapped like bales of hay and so thick that it took several trips to get to them all.

Then in the afternoon, *The New York Post* was dropped off. It was a bonanza. We had to go into a candy store to get some change, and even had to turn down some customers in the morning since we didn't have enough money to do business. We couldn't even change a five-dollar bill.

By early evening, we had sold all the newspapers and divided up the

money. We locked up our "new" stand and returned the next day to find our papers waiting nearby. Once again, we sold out both morning and evening. I remember thinking this was going to be a great summer.

By the third day, once again, we couldn't believe our good fortune. However, it was finished by the fourth day. I guess the word had gotten out: all our suppliers disappeared en masse.

We kept the stand locked and checked every day for our stash to reappear, but it was all over. It had been a great three days under the El.

grandma

I've always had a fine memory, but it doesn't go as far back as my very early years. (My first wife, Susan, could remember looking through the slats of her crib before she was a year old.)

What I do remember vividly, however, is not thinking I was Julian Schlossberg.

I used to think, *Look, Julian Schlossberg is going to school. Julian Schlossberg is playing ball.* This lasted a very long time. I was around twelve years old, putting a dime in the IRT subway slot (there were no tokens then) when I realized I was *me*. My wife Merryn, who knows about these things, says that up until then I was an observer. My body and soul had not connected. Whether or not that was true, what I am sure of was, I wasn't particularly happy about it.

What I was happy about was Ms. Markham and Mrs. Harris. They were two elderly ladies who lived in the same apartment that my grandmother, Celia Bash, rented in Washington Heights, and who loved me entertaining them. They were my first audience.

When I was about five or six years old, I had memorized the lyrics

of the popular songs of the day. I don't remember much about my act except the finale. You see, the act would change weekly, when I would memorize a new song or two—but the finale was always the same. That was me trying to imitate Al Jolson down on one knee, singing *Mammy*. That brought wild applause from the two old ladies.

My grandmother, however, had heard me enough times. She would leave before my show, go to her room, and return once it had concluded.

My grandmother was a tough woman with a huge bosom. (One day I put my little hands under each breast, then lifted them while asking, "Why can't they stay up?" I never got a really good answer to that.) I nicknamed her the General. She was my mother's mother—my only grandparent. The other three—my father's parents, from Minsk in Russia, and my mother's father, from Berlin—had died before I was born.

My father, God knows why, actually liked the General. For her part, she tolerated him. I remember her pushing food at the table to me and my mom saying, "Eat, darling, eat." My father, with a great twinkle in his eye, would say, "What about me?"—to which my grandmother's reply was always, "You're fat enough." I don't know how he remained so kind to her. (I asked him once; he shrugged and said, "Ah, she means well.")

In Washington Heights, there were three movie theaters on 181st Street: The Lane, The Gem, and The Empress—all right in a row. On our visits Grandma would take me to the movies, and then to the automat down the block. What a treat that was. I couldn't wait to put the nickels in the slot and watch the trays of food turn around, then open the hatch and pull out some delicious morsel. I'm sure the food was mediocre, but not to me. I still remember the creamy mashed pota- toes and the baked beans being the greatest I ever ate.

On one beautiful day, after I entertained my willing audience of two, my grandma took me to see the cartoon feature *Bambi*. Things were going pretty well when, out of nowhere, a shot rang out and Bambi's mother was killed. Well, I couldn't stop crying. My grandma tried to soothe me, but I was inconsolable. We had to leave the theater. To this

day I still wonder what Walt Disney was thinking.

I've met other only children who longed for a brother or a sister, or who talked about how lonely they were growing up. But I loved being an only child. To this day, there hasn't been one second of my life that I wasn't happy to have been an only child. (My best friend for close to forty-five years, another only child, feels the same way. More about her later.) Being an only child, I got a lot of attention from my parents, and especially my grandmother.

"Grandma, read to me." I must have said that sentence every time she visited, which at one point was almost every day. She read to me for hours—and I'm sure was ecstatic when I learned to read. Around 1949, when I went to grade school and both of my parents worked, she would often be there when I came home, and would cut up mounds of raw vegetables and give them to me with a piece of buttered rye bread while I watched our early Dumont television set.

(Sometimes when I lecture at colleges, the kids are amazed that early televisions didn't have remotes. You could only be a true couch potato if you left it on one channel; otherwise, every time you wanted to change channels, or raise the volume, or fix the brightness, you had to get up and do it manually. And the thing never turned off all the way instantly; it would slowly fade to black with a white circle. On the few times a year that I have trouble falling asleep, I conjure up the image of that old television set while I try to fade out into sleep. It generally works.)

When I was almost twenty years old and away at college, I decided to get away from the winter with a friend and head down to Florida for the weekend. At that point I knew my grandmother was living there, and I debated with myself whether to see her. I was much more interested in looking for girls in Fort Lauderdale—but in the end I decided to spend one of the days with Grandma anyway. We went out for lunch and a movie, and I went back with her to her sister's home and saw two of my aunts.

Grandma never got over that I did that, and bragged about it a lot.

At the time, I couldn't understand it. Now I realize why it was such a big deal to her.

Not long after our Florida date, she was hospitalized with cancer. I went down to the hospital to see her, but my cousin met me there and took me aside.

"Look, I know you want to see your grandma," she said, "but she looks terrible. I saw my mother at the end of her life, and now that's the only clear picture I have of her. That's what you'll remember if you go in now—so I beg you not to go in."

In the end, I relented. The last clear memories I have of my grandma are of our date in Florida, and they are just plain wonderful.

student and teacher

Going to public school was never something I enjoyed. I did pretty well until I left for college, but I never liked the homework, the regimental aspect of it, and constantly being told what to do. I didn't rebel, but I felt very confined. I have a picture where I'm the only kid in the class with the top button of my shirt unbuttoned. I also had my tie loose around my neck; I remember I often felt like I was being choked. And in all three pre-college schools—elementary, junior high, and high school—I can recall the horrible feeling of being in an institution. The stairs were grey, the walls were grey, the teachers were grey. And I felt blue.

In elementary school in 1949, we learned that Russia had the atomic bomb. We were taught to go under our desks whenever a teacher would scream, "Take cover." This was always done as a surprise. Sometimes even the principal would open the classroom door unannounced and yell the warning.

This actually scared me to such an extent that I was sure I would never grow old. Some of my generation whom I've spoken to did not seem to be as affected as I was; I know there were others who were. What

were the psychological effects on that whole generation of kids—even on those who claim it didn't bother them? Even now, I wonder what the hell they were doing. Was my little desk going to protect me from an atomic bomb? Someone once said it was to protect us from the glass shattering. So the glass couldn't get under the desk? I guess if I were vaporized, at least I wouldn't be cut or bleeding.

It was, as Willie Nelson sang, *Always on My Mind*. I remember hoping to live to at least sixty years old. And strange as it seems, once I'd reached sixty, I was no longer afraid of not being able to live a life; it never bothered me again. It had only taken fifty years or so to get past the "take cover" experience. Don't tell me propaganda can't work.

Years later, I was asked to teach at the School of Visual Arts in New York City. It was to be a class on production, distribution, and exhibition in the motion-picture business. The first evening I arrived early, very excited to teach my first class. As I walked up the stairs, I saw the grey walls and stairs and started to become morose. It was a true Pavlovian response—or, as Yogi Berra once said, "Déjà vu all over again."

But this time things were different. I said to myself, *Wait,* you're *the teacher now. You can do and say whatever you want.* When I realized that, I bucked right up again, and happily entered my new classroom.

And never once in the whole seminar did I have to yell, "Take cover!"

applying myself

I took my father's words about "If at first you don't succeed" to heart during much of my young life. But there were two specific areas I remember where I violated his "forget it."

One was the game of punch ball. This was played exactly like baseball, except there was no pitcher or catcher. The batter flung a "Spalding," or pink rubber ball, in the air and punched it in order to get on base. There were four guys in the infield and three in the outfield, all trying to catch the ball before it hit the ground.

Now, I wasn't much of a baseball player. I was once hit by a hardball, and the memory of the pain kept me from ever playing it again. Man, did that hurt! In softball, too, I was just okay. But I liked punch ball, since there I was more in control—no pitcher to worry about. Besides that, I think I was just better at the sports that didn't mean much in the '50s: handball, ping-pong, and bowling were others I liked. But punch ball was my favorite, and I know it was the first time I applied myself to anything.

As with softball, I was just an average punch-ball player to begin

with. But I decided to try to become a *good* player, so every day I got up at seven a.m. so I could be in the schoolyard practicing by seven-thirty. I did this every day, including weekends, for months at a time. And I got good. I got good enough, in fact, to punch a ball up to the top of the public school I attended, which was six floors high. I became the first baseman for my sixth-grade team, and we won the school championship. And I very clearly remember punching a ball against many walls for a long time until I became a punch-ball slugger.

* * *

Seven years later, I was a sophomore in college, taking a course called Experimental Psychology. I did badly on the first test—I didn't fail, but I barely passed.

I remember there was another student named Ron who sat next to me in class. He had a pipe and always wore a grave expression on his face. He nodded wisely in every class as the professor droned on. Half the time, I had no idea what was being taught. It bored me and seemed to be complicated. Not for Ron. He nodded away, clearly getting all that was said.

After the test, however, the school posted our marks on a bulletin board—and I noticed that I had done a little better than Ron. He was a fraud! He knew less than I did, which was really saying something. And with my bad first test behind me, for some unknown reason I decided to once again apply myself to do better on the next test. I studied and crammed for days, and was rewarded with the third-highest grade out of fifty-six students (two classes' worth of students with the same boring professor).

Well, that might have been it for applying myself during the first eighteen years of my life...if it hadn't been for work.

As it turned out, I loved to work.

early jobs

Outside of my petty-criminal pursuits, I began working at eleven years old.

My first job was in a drugstore one block from my home. I was hired as the store's new delivery boy—I think the kid who'd had the job before me must have been on vacation—working four to seven p.m., five days a week. Two weeks into the job, however, I was sweeping the store, dusting the shelves, and taking out the garbage—everything but making deliveries. I asked when I could again start making deliveries and was assured by the owner that it would be soon.

After two more weeks, I realized that my days of making deliveries were probably over. Somehow they were all mysteriously being taken care of before four o'clock or after seven o'clock. Every once in a while an "emergency" occurred, and I was sent out. But it wasn't enough for me, and I quit.

Throughout my life, I've never left a job without having another one, and this was no exception. I started working immediately for Nick Dorsey of Dorsey Cleaners. Nick was a small Italian man from

the streets, who had a large nose. He had operated a little tailoring shop before, but had met an Israeli man, Armand, who had bankrolled Dorsey Cleaners for him. It was now triple the size of the old shop, and I started working there, again as a delivery boy.

The good news: I was the only delivery boy. The bad news: clothes were a lot heavier to carry than prescription drugs.

The wire hangers often cut into my hands. I delivered a lot of clothes, and sometimes the recipients weren't even home and I'd have to bring them back. The pay wasn't bad for the time—I made two dollars for three hours, which worked out to sixty-six cents an hour, but with tips I was pretty happy.

Next door to Dorsey's, down a long flight of stairs, was a bowling alley—and I got another job there at the same time! (I told the owner of the bowling alley about my job at the cleaners, but I never told Dorsey about the bowling alley.)

How did I manage to do both jobs? Simply put, I ran out with the clothes at top speed, and I ran back after I delivered them. Sometimes I brought the clothes down to the alley first; sometimes I'd come back to the alley with the clothes of people who hadn't been home. Murray, the owner of the bowling alley, got a kick out of my problem and worked around the Dorsey schedule.

At the bowling alley I worked as a pin boy, which was the hardest job I ever had. You worked two alleys or lanes. A bowler would get two chances to knock down all ten pins. Each time I'd send the ball back, and after the second throw, I'd set up the pins that had been knocked down. On the bottom of each pin was a hole, and the back of the alley had a foot lever. You'd push the lever, up came ten prongs, and you'd set up the pins on them. I was paid nineteen cents per line—meaning game—plus tips, which were a rarity.

There was no good news on this job. You had to be vigilant, or you would be hit by flying pins. You would be bending and lifting and sweating the whole time, and it was nonstop, since the two alleys were constantly busy. Going back and forth between Dorsey's and the

bowling alley was tough, but I remember the two jobs fondly...except for how back-breaking the pin-boy job was.

Years later, in the late '50s, I worked as an usher at the Criterion Theatre on Broadway. I sat in the first row of the balcony in the first seat nearest the entrance, and when a customer came in, I would shine a light in front of them and they would follow the light. I didn't get up at all.

Fortunately, I was never caught sitting down on the job, because there was never a crowd. My hours were from noon to five p.m., and the crowds often came as I was leaving.

At other times I worked as a busboy, a waiter, a counselor, a typist. I mowed lawns and shoveled snow. I even drove a taxicab in New York City. Up to that point, I had no idea what my father had put up with. It was awful. The traffic was heavy. Many of the drivers were bad. The buses were your enemy. And the pressure to make time was enormous. It took just one day for me to stop being friendly and animated, and end up quickly grunting my answers when I was addressed. Many people didn't talk to me at all; others talked down to me. Still others "stiffed" me, meaning they left without tipping. Sometimes when we were stopped at a red light, my fare would just jump out of the cab and run down the street without paying at all.

Back then, Fifth Avenue and Madison Avenue were two-way streets. Bus drivers had to make change for passengers, and if they didn't pull into their stop on a two-way street, you couldn't pass them. So sometimes on Fifth Avenue or Madison Avenue, you could sit for two or even three red lights as the drivers ahead made change for ten- and twenty-dollar bills. But the money wasn't bad. We were paid forty-two percent of the metered fares, with fares starting at twenty-five cents when a passenger got in and increasing by five cents every fifth of a mile. Tips were pretty good too, and we all hoped for an airport job to Idlewild (now JFK), LaGuardia, Newark, or Teterboro.

I had cash every day, but I was exhausted after each day's work. I was going to college at night at the time, and I often dozed off in class. And sometimes my taxi job affected my life in other ways.

try not to hold it against me

The most embarrassing incident took place while I was on a date one evening. I had worked a long day, and my date and I were driving down Broadway in my '57 Dodge when a man stepped out into the street to hail a cab. Without thinking, I saw the hand and veered my car toward him. As the car neared him, he screamed and my date screamed too—really loud.

Needless to say, that put a damper on the evening.

a matter of taste

Our apartment was less than a city block away from rows and rows of retail stores on Kingsbridge Road. Delis, drug stores, bakeries, butcher shops, and candy stores were all lined up next to one another there, as far as the eye could see. The only wholesale shop for many miles was Joe Severino's. Its door looked like a speakeasy front from Prohibition days: it was made of silver aluminum, and at its very top was a small diamond-shaped glass window. A stranger might have thought he should knock twice and say, "Joe sent me."

Often when I was a boy, my mother would send me to this exotic place. I would push open the thick door, then walk down a narrow passageway to another door. Once you opened that, you encountered row after row of huge ovens baking away. It was an aroma that would make anyone's mouth water. Joe made Italian breads—not for the public, but for restaurants and delis. Green cases on wooden tables held delicious, warm, crispy loaves, all neatly stacked in long, thin white bags.

I had first discovered the place by accident. It was sandwiched between the two places I worked, Dorsey Cleaners and the bowling alley.

One day, I followed the strong aroma into this oven haven and met Joe. He took a liking to me and agreed to sell me a loaf of bread if I didn't tell anyone—he wasn't looking to go into retail. So for fifteen cents, I got a hot Italian loaf with its end sticking out of a white paper bag.

That was the best Italian bread I ever tasted. Try as I might, I could never walk that short distance home without eating the warm end, and sometimes more.

<div align="center">* * *</div>

There's a lyric to a Johnny Mathis song that goes, "Staring at the open embers, strange the things that one remembers." Well, you don't have to look at the remains of a fire—just spend some time writing your memoirs. I assure you, it unlocks parts of your brain that have lain dormant for years.

I remember clearly that at ten years old, I started buying *Variety*, the show-biz newspaper. I was already so enamored of show business that when I found out there was a newspaper totally devoted to it, I had to read it. My mother became very upset. She insisted that I was going to be a "professional." A professional *what* was never mentioned. The point was not to go into show business. So I stopped bringing home *Variety*, but continued to read it outside the apartment.

In the '50s, *The New York Times* had a TV section, and every Sunday they printed the highlights of the upcoming week. I was so excited when that paper came. I would dutifully take a legal-size pad and make columns for channels 2, 4, 5, 7, 9, 11, and 13, then I would add up which channel had the most shows recommended.

In doing this, I only wanted to know which channel was going to be the best each week. I had no idea which channels were the network stations or local stations, or which shows were network shows or local shows or syndicated shows. I remember how surprised I was to see how often the show *TBA* was played, and on many channels—and how embarrassed I was when I realized one day that the letters stood for "To Be Announced."

It certainly appears, in retrospect, a strange way to spend Sunday mornings. But with where my life and career would take me later, it made a lot of sense.

broadway at a young age

When I was growing up, the ideal place to go was downtown. Downtown meant Broadway and Times Square and Movie Palaces; food at Grant's Hot Dogs and McGuiness (the roast beef king), Lindy's and cheesecake, and Jack Dempsy's; plus the Virginian, the New Yorkian, the Floridian. Long before Petula Clark sang "Things will be great when you're downtown," I knew they were—and I went every chance I could.

At that time, each new movie opened at one theater downtown, and sometimes played for years. So being a wild movie fan (I was regularly asked by my young peers what some new film was like), I would often travel by subway to see the latest film.

These excursions began when I was only nine or ten years old. We had no fear and our parents' permission, and though I was an only child, I was always able to convince a friend to accompany me. I was twelve years old when I finally went alone to see a movie for the first time. It was *On the Waterfront*. As crazy as it may seem, that experience became a watershed time for me: I felt strong and independent. Years later, the director of that film would become my first champion and, in many ways, change my life.

The theaters on Broadway were palaces. Their unbelievable staircases of white marble and magnificent chandeliers hanging above were all so memorable that sixty-plus years later they remain embedded in what's left of my mind. Giant, thick curtains covered the huge screens—oh, the excitement I felt when those curtains were raised slowly, teasingly! And often, there were stage shows before and after each film. Looking back, I never had a chance: I was so enamored with the movies, the full orchestras onstage with their singers, comics, and vaudeville shows, I knew I had to be a part of that world.

I saw Judy Garland at the Palace Theatre in 1952, when fifteen hundred people cried as she sat singing *Over the Rainbow* from the apron of the stage. And that was less than an hour after the same fifteen hundred had roared at the famous vaudeville team of Smith & Dale and their hilarious act, Dr. Kronkite. What an afternoon that was! Judy did two shows a day, and my father had gotten tickets in the mezzanine for a matinee. During the show, Judy introduced the famous people in the audience. There were many, but I only remember one: an English actor, big in the '50s, whom I'd known well, because he played Robin Hood on television. His name was Richard Greene, and that day he was sitting only a few rows away from us. Judy, Smith & Dale, and Richard Greene—for me, they might have been the Incredible Threesome. I was in ecstasy.

Several years later, when I was in my teens, I hung around Broadway on the weekends. Less than a block away from the Palace was a rather innocuous building between 47th and 48th Streets called the Publicity Building. When you walked in, you were immediately hit with the sight of an enormous staircase. To its right, down a narrow passage, were elevators, but if you climbed that gigantic staircase, which seemed to lead to heaven, you were led backstage to the Latin Quarter, a famous New York City nightclub owned by Lou Walters (who was, incidentally, the father of TV icon Barbara Walters). If you were lucky, you could catch a glimpse of the showgirls walking around in fishnet stockings…or less.

try not to hold it against me

Every chance I got I went up that staircase, ostensibly lost, until they got to know me backstage—at which point I was banned. But the fantasies surrounding that stairway to heaven have never faded.

life as an audience member

One of the many advantages of growing up in New York City was the ability to see live broadcasts of television shows. Often these shows had audiences, and I knew where to get the tickets, so I would try to attend on holidays and during the summer. As a result I saw many live television shows and—believe it or not—live radio shows.

Some of the radio shows starred luminaries of the day: Arthur Godfrey, his sister Kathy, Robert Q. Lewis, and Mike & Buff (who were Mike Wallace, later of *60 Minutes,* with his then-wife Buff Cobb). But it was the relatively new phenomenon of television, with its lights and cameras, that really got me excited.

When I was very young, there was a show called *Sheriff Bob Dixon.* I was one of the four or five little kids who appeared in the audience one day. It was my TV debut; I was seven or eight years old. All I remember from that experience was that we had to shoot a rubber-tipped arrow to try and hit the bull's eye on a target. I not only kept missing the bull's eye—I kept missing the target altogether. Live on TV, Sheriff Bob's deputy put some "magic" glue on the arrow, and the next shot hit and

stuck on the target. I was devastated, but no one else seemed to mind, and I immediately forgot about it…until now.

Later, I sat in on many dress rehearsals of *The Perry Como Show*. They would do the "dress" in front of a live audience, and I always tried to go, because sometimes they would stop the show when a mistake was made or a change took place. After the "dress" was done, I would rush home to watch the live broadcast and try to spot the changes they'd made from a few hours before. For some reason, I found it all very exciting.

Once in the mid-1950s, when I was a young teenager in the audience watching Monty Hall host *The Sky's the Limit*, the contestant had to leave the theater and find someone on the streets of New York who had been born in New York City. Not an easy task on a weekday in midtown! However, knowing where the stage-door entrance was located, I ran out of the audience into the street and told the contestant I was born in New York City—and onto TV I went. My cousin and aunt turned out to be the only people who knew me who saw me on TV that day—but I did receive from Monty an expensive cigarette lighter and two ashtrays. And all before eleven-thirty a.m. on a Wednesday!

In the mid 1950s, when I was heavily into being an audience member, Jack Paar had an afternoon variety show on CBS. One winter afternoon after Paar had signed off, I waited with a friend outside the stage door for autographs. The male singer on the show that day came out first. He joked with us and was very friendly. He also had a clear and deliberate signature, which read *Merv Griffin*. After him, every other show member came out…except Paar. We waited more than an hour in the freezing cold before he finally appeared. When we asked him for his autograph, he said, "What the hell do you want my autograph for?" But he did sign.

Years later, in my early twenties, I found out that Frank Sinatra would be taping in New York City that afternoon. This was unbelievable to me for two reasons. One, he would be taping at the NBC network for an ABC show. Two, the show was called *The Hollywood Palace*… and it was going to be shooting in New York. At that time, I guess I still took things literally.

Anyway, I knew had to get into that taping. Because of all my years as an audience member, I knew the NBC studios well, and knew that if the studio was, say, 8H, the floor below that was where the performers entered—i.e., the seventh floor. So I grabbed my only prop—a *Variety* newspaper—and stuck it under my arm, ran to NBC studios in Rockefeller Center, walked right past the guard with my trusty newspaper, and got off one floor below where the taping was going to be. I knew exactly where to go, and with a clipped, no-nonsense stride, I marched right into the studio and stood near the first camera I could find. No one stopped me; no one asked me who I was. There was no audience, just some technicians and a great band, and I stood thirty or forty feet away from Frank as he sang three or four songs.

I was ecstatic. And it was all made possible by my childhood enthusiasm for being an audience member…and, of course, my *Variety* newspaper.

the joy of sex?

Attending an all-boys schools for most of my teens, I was anxious to meet girls, have lots of sex, and travel extensively. I was unable to accomplish any of those things for years.

Rarely, even when I became an adult, did girls come on to me. Add to that the fact that I didn't want to be rejected, and it often took three or four dates with a girl for any kissing to begin. (Later, I had a friend at college who had a completely different approach. He went over to any girl he fancied and asked her if she wanted to go to bed—except he was more graphic, using the "f" word. I asked him how he had the nerve to say that, and he answered, "Well, I get slapped a lot. But I get laid a lot, too.")

Once, I went on a date to the RKO Fordham movie theater in the Bronx and took my date up to the balcony. After we'd been seated awhile, I did the old stretching routine: arms in the air, then bring one arm down and wrap it around the girl's shoulder. She let it stay there, and a little later I touched her breast. It was only for two to three seconds—but I had touched it! The next day, I took a group of my friends behind the handball court to relate this astonishing and monumental news.

"Yesterday, I touched a girl's tit," I said.

"Bullshit," said one friend. "You're full of crap," said another.

"No, no—I really did," I screamed, then told my story. They were riveted.

It's hard to believe that we were fifteen years old. These days at fifteen years old—oh well, why go on?

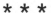

After I was discharged from the army, a buddy of mine, Roger Kramer, and I drove twenty-six hours nonstop to Florida. It was the end of December, and we left in snow and arrived in sunshine. Roger, who was not tall, dark, or handsome, but who had the most beautiful green eyes you've ever seen, said, "Check out that blonde over there."

On the other side of the pool was a true knockout of a girl in a two-piece bathing suit. She was standing next to a little blonde girl about three years old.

"She's a mom, forget it," I said.

Totally ignoring me, Roger fixed his green eyes on the woman and pointed towards her. He then beckoned her to him, with the same finger he had pointed with. I laughed inwardly—but she trotted over immediately, with kid in hand. She and Roger talked, and later they had dinner. She was a divorcee, as it turned out, and she spent that evening with Roger in the twin bed next to mine—making love as I supposedly slept.

* * *

Once, in Las Vegas at Caesar's Palace, I was sitting in the lobby near the registration desk, on a leather banquette with no back. Right next to me on the banquette was a stunning young blonde, just sitting there. She didn't appear to be a hooker, and I thought, *What do I have to lose? I'll just try and strike up a conversation.*

Thinking quickly, I decided to ask if she knew what time it was. I opened with an "er," and she, without turning her head, said crisply, "Forget it." She had been hit on so many times, she knew it was just one

more man. My "er" was enough for her.

I burst out laughing. That one didn't feel so much like a rejection.

* * *

Growing up, it was bad enough that women didn't seem to be interested in me. But to make matters worse, men were constantly trying (as it seemed) to make up the slack. "Not that there's anything wrong with that," as they said on the *Seinfeld* show. But I had no interest in men. Still, I must have had some sort of unknown chemistry, because I was often fending off unwanted advances. It was probably one of the reasons I never even tried to kiss a girl unless she thrust her lips forward and closed her eyes at the same time: I knew what unwanted advances felt like. And though I learned to laugh off a rejection by a woman, I didn't find it as funny when men tried to take liberties with me over the years.

My first experience of this was at sleepaway camp, with the dramatics counselor. I was thirteen years old, and one night I awoke to find him in my bed fondling me. Horrified, I said, "Al, what are you doing?" and pushed him out of the bed and onto the floor. He had been drinking; I smelled it on his breath. He got up from the floor, walked away from me, and never talked about it for the rest of the summer.

A second memorable event was when I was sixteen, working as an usher at a Broadway movie theater. The head usher, a middle-aged man with black curly hair, was very friendly. And I liked him. We kidded and joked around a lot.

One day, he followed me into the locker room at the end of my shift, and talked with me as I changed out of the uniform the theater provided and into my regular duds. As I was in my undershorts and pulling up my pants, he groped me.

I grabbed him and threw him against the lockers. "What the hell do you think you're doing?" I screamed.

He didn't answer. Instead, he slunk out of the room.

After that, all joking and kidding ceased. We were polite and formal for the rest of my time working at the theater.

A third event of this kind occurred when I was in my last year of college at NYU. I was still a history major but was minoring in what was called TMR—television, movies, and radio. One of my classes was with a professor in his late sixties who claimed to have worked with Orson Welles on some of his radio broadcasts in the 1930s. He was a real grandfather figure: a kind, intelligent elderly man. I was crazy about him, and he took a real interest in me too.

One day, he invited me to have dinner at his home. I was excited and when the day arrived, I couldn't wait to go. We had a delicious meal, then retired to his living room. He asked if I had ever read Walt Whitman's *Leaves of Grass*. I said I hadn't, and he proceeded to read it to me from an old, old book.

Afterwards we talked awhile, and then abruptly, he said, "These are not my teeth, you know. They're false—all of them."

I said nothing, but waited to hear his point. He continued, and in so many words—but much more graphically—he let me know how great it would feel if I would let him go down on me toothless.

I jumped out of my chair and ran to the door. He lived in a beautiful ground-floor apartment in Greenwich Village, and as I ran outside I threw up all the wonderful dinner in the street.

I was devastated. For a while, the professor was very cold to me. Then one day he returned to his old, grandfatherly self, and we were able to enjoy our friendship again. But I was never invited to his apartment again.

I feel it's important to point out that these three incidents occurred years apart, so each time I was surprised and hurt. I never felt I had done anything to incite that kind of behavior. But it wasn't always men who mistook me this way.

Years later when I was in my thirties, a woman, high on liquor, grabbed me and try to kiss me at a TV convention. I was single, but I had no interest in her at all, and felt I had done nothing to encourage her. She had a different take: after the convention, she told lots of people I was a homosexual.

I just couldn't win!

college years

Harpur College was located in a blue-collar New York community called Endicott. It was a small town, where Endicott-Johnson shoes had once been manufactured. The entire student body at the college was eight hundred. For perspective, my graduating class at DeWitt Clinton High School was twelve hundred students.

At the time, Harpur was temporarily housed in several Quonset huts. We sat through classes during the cold winter months wearing hats, scarves, and coats. We took tests *with gloves on*. Then, thankfully, at the start of our second year, we became the first students on a new campus in Vestal, another small town nearby that made Endicott look like a metropolis. Many of the buildings hadn't yet been finished, and there was almost no grass—but there was mud. Plenty of mud. I remember walking to class on wooden planks—walking the plank, as I thought.

Anyone attending the school had to have been a damn good student or have impressive grades on the SATs. Going to Harpur was like getting a generous scholarship. In 1959, a year's tuition was $400; room and board for the year was $550. So the cold and the mud was a small

price to pay for, well, a small price.

But though I wish I could say I took advantage of the good college education that was offered me, I didn't. I cut classes a lot.

But it was there that I broke into what would eventually become my career.

the college entrepreneur

The best financial deal I had in my college years, by far, was with a man I knew as Uncle Miltie.

Miltie owned a dry cleaner's in Binghamton, New York, about five or six miles from our school in Vestal. I was able to get the school to give me an empty storage room in the basement of one of the dorms, and it was there that I would take in the students' dry cleaning, two nights a week. The next morning, Uncle Miltie or his driver would pick up the shirts, suits, pants, and so forth, bring them to his store to clean and press them, then bring them back for me to collect the money due from the students. I made twenty percent of the gross without ever leaving campus—and since Miltie and I were providing a service for the school, we paid no rent. It was, to this day, the best deal I've ever made.

But the best single evening I ever had in college, fitting enough, had to do with the movies.

* * *

I had been a pretty healthy young man all through my public-school

years. I was rarely absent, and I was never late. The only time I was sick for any length of time was when I had polio.

In 1955, in the eighth grade, I had done the unthinkable: *I cut school*. I felt fine, almost giddy—but I did it anyway, and I convinced three of my friends to cut, too. Why? It was opening day of the movie *Blackboard Jungle* at the beautiful Loews Paradise theater in the Bronx. The first show at noon was nearly empty. But as the credits began, with Bill Haley and the Comets wailing *Rock Around the Clock,* I was—well, forgive the pun—in paradise.

Okay, fade out.

Five years later, I'm in college. I'm having a good time, and just getting by with "gentlemen's C" grades when I have an idea. I go to the office of Student Activities and ask to rent the college theater. It has five hundred and thirty-five seats, and though I'm told it's pretty booked, I'm given a Monday night. I take it. No one asks why I want it. The projectionists are all college classmates, and the one I'm most friendly with agrees to work that night for ten dollars. I rent a movie from a New York City film company, agreeing to one showing for a total cost of twenty-five dollars.

At this time, there are no cassettes or DVDs, no cable TV, no HBO or Showtime—in fact, the students at the college don't even have television sets. So that Monday night, every seat in the theater is taken. There is a near riot, and many can't get in. On the spot, I schedule a second show at ten p.m. It sells out, too.

I ended up grossing over two thousand dollars for the night. After paying the projectionist and the film company double, and paying out a few friends who'd sold the tickets, I netted $1,860. I couldn't believe it. It seemed too good to be true.

And in a way, it was. The next day I was called into the Student Activities office. The director let me know that I could be put on probation for what he called "that stunt," pointing out: A) I couldn't show a movie; B) I couldn't charge for any on-campus activity; and C) how dare I schedule, without his office okay, a *second* unplanned showing?

Realizing I was in hot water, I suggested that I pay a rental. He agreed that I should do just that—and never, ever try to schedule any activity on my own again.

I agreed. But there was no turning back; the dye was cast. That *Blackboard Jungle* showing was my first hit as a producer—and I was hooked.

early acting

I had toyed with being an actor in my teens. At camp I'd played Alfred P. Doolittle, Eliza's father, in *My Fair Lady*. I had to master a Cockney accent, but I found that dropping the H's in words was fun. *Here* became *'ere*. *Her* became *'er*. And I had two rousing songs to deliver: "With a Little Bit of Luck" and "Get Me to the Church on Time."

The director and I ended up having lots of disagreements, since I had seen the play on Broadway and he hadn't. After one go-around, I waited until the end of the rehearsal and asked to speak to him. "Will we be friends again once this show is over?" I asked him. That really made him laugh, and he told everyone about my question. More than sixty-six years later, I still don't see the humor. Perhaps it was my earnestness.

I also starred in a play entitled *The Sheriff*, as the titular sheriff. (The play opened with my deputy at his desk with his feet up. I still remember my first lines: "I'm tired, Pete. Tired and hot. Dust is thick today.") As the play progressed, a lynch mob descended on the jail; right before that, some woman came into the jailhouse to yell at me for some reason I've

mercifully forgotten. In our production, I had to slap her across the face. I would never do it hard during rehearsals, though I assured the director I would when we played in front of an audience. On our first public performance, I slapped her good and hard. The director, apparently not believing I would hit her hard enough, clapped his hands offstage after my slap, and the audience heard two slaps instead of one. So we got our first big unintentional laugh.

Then when the lynch mob descended on the jailhouse, one of the townsfolk was supposed to warn me of the mob on their way. The actor barged into the office and started to yell, "Sheriff," but a moth flew in his mouth and all he could say was "Sher—." All I could see was the moth fluttering around his open mouth, then the actor gagging as quietly as possible as he tried to talk and expel the creature at the same time. The audience laughed again; I turned upstage trying to stop my own laughter, which got the audience howling.

The evening, as you can imagine, was not a triumph.

Finally, I performed as one of the three sailors in a college production of *On the Town*. The backdrops we used were from the original Broadway production—and they were the only real professional part of the entire show. We did have a twenty-piece orchestra backing us, but the sets and costumes were minimalistic, and the direction pedestrian. I remember my role was Chip, played by Frank Sinatra in the movie—though all Sinatra and I had in common was that we were both males and our last name began with S. Still, I thought I did the role pretty well. Certainly better than the Sheriff.

The three sailors had basically the same co-starring parts, and when the reviews came out, my two co-stars had excellent notices. I thought I was as good as they were, and perhaps better—but my best review said I was "an engaging performer." Now I know that's not a terrible comment, but that was all. I remember thinking, *I'm as good as I can be—I'm acting, singing, and dancing my heart out—and if the best I can get is "an engaging performer," I'm out.*

I had read about all the rejections and heartbreak the acting

profession was famous for, and I decided, at the ripe old age of nineteen, that I would have to make a U-turn on my road to acting. Hi diddle dee dee—an actor's life was not for me.

dr. chalmers

At the end of my time at Harpur, I had a nasty professor. His name was Dr. Chalmers, and he was the head of the college's Economics department. A middle-aged man of medium height with a barrel chest, he liked to advise us, "When you go to college, you must try to be one of three things: a lover, a scholar, or an athlete." He would then pause for effect before adding, "I was all three."

I didn't like him or his class, in which I often found myself daydreaming. I was bored by the "guns and butter" analogies, the charts, the text, and, mainly, Dr. Chalmers himself. Once, when he asked me a question and I told him, "You got me, Dr. Chalmers," he replied, "But I don't *want* you, Mr. Schlossberg."

I gave up. I stopped going to class. I knew I was doomed to fail; I didn't even show up for the final exam. That morning, I was sleeping when my roommate said, "There's a call for you." Since no one had phones in their rooms, I trudged down the hall in my underwear, picked up the phone, and said, "Hello?"

"Schlossberg!" I heard a voice yell in my ear.

"Yes?" I said meekly.

"This is Dr. Chalmers. Get your ass over to my class now." And he hung up.

I got dressed quickly and ran to the classroom. When I'd thrown myself into the room, the good doctor thrust a test booklet into my hand, saying at the same time, "Here. Fail."

I complied, getting 37 out of 100 on the final. In all the schools I've ever gone to, it was the only time I failed a course.

I ended my school years by first attending City College at night and driving a taxi in the daytime. I still needed two more years to graduate, so I transferred to NYU, which accepted more credits from Harpur and offered me a degree in thirteen months if I went to school in the daytime and summer school as well. I used the money I earned from my taxi job to finish at NYU, wanting to get into the workforce as soon as I could.

But my Uncle Sam intervened—and soon I was on my way to the U.S. Army.

u.s. army

In July 1962, I found myself in basic training with the U.S. Army's Third Training Regiment, stationed in Fort Dix, New Jersey. We were totally isolated from all the other regiments at the fort, because during WWII black soldiers had been housed—segregated—in the same barracks there. (Even in the North it had been "separate but equal"—and not all that equal.)

I had a friend at the base who was also going through basic. He was one week ahead of me, and told me in advance what was going to happen and when. In those days it was the same routine, week in and week out. In fact, we were told that everyone in the Army, anywhere in the world, had the same meal each day, whether you were stationed in a European country, an Asian country, or New Jersey.

So I knew, for example, when we were going to be gassed. They would throw teargas at us, and we had to remember not to drop our M-1 rifles but to hold them between our legs. After performing that rather awkward maneuver, we were to remove our gas masks from the pouches we carried and put them on over our faces. Reasonably easy—especially

if you knew in advance the day and place it was going to happen. And thanks to my friend, I did.

On the appointed day, men dropped their rifles and ran helter-skelter in true panic. Forewarned, I quietly went to put on my own gas mask, but found a guy trying frantically to get his face into my mask. I pushed him away and pointed to his pouch, whereupon he dropped his rifle and finally managed to put on his mask. It was a crazy scene, but all part of our training to become, as we were often told, "trained killers."

Part of the eight-week training program was going through the woods and swamps of New Jersey at night. Groups of four men were spread out over a large expanse of land and ordered to reach an objective in a hut with only a compass. There were approximately twelve huts over many miles, with a sergeant stationed in each hut to record where your team landed. The idea was to see how close you could get to your target, and of course to use the compass.

My wise friend told me to just go to hut number five. That was the answer, he said, and we would get a good rating. But my group wouldn't believe or listen to me. They insisted that the objective was at hut number twelve. I tried to no avail to convince them otherwise. So we went into hut number twelve, and the sergeant looked up, quite startled. He took our rating sheets and said, in a strong Southern drawl, "Boys, in the Army we grade you *E* for excellent, *G* for good, *F* for fair, and *P* for poor. I'm putting on your cards *PP*—that stands for piss-poor. You are so far from your target that you'd be easily killed."

Our training took place in the summertime, and it was really hot: temperatures in the nineties and hundreds. We each wore a steel helmet with a liner, boots, and a long-sleeved uniform, and carried an M-1 rifle and a full backpack. We ran, hiked, and walked through sand and woods. The sweat poured out all over our bodies and stung our eyes. And the bugs and mosquitoes!

At only the third or fourth week of this eight-week ordeal, I knew I had to do something.

The first sergeant was named Poitier. (He claimed to be related to Sidney, but we never found out if that was true.) He was big, loud, and strong. One day I walked into his office hesitantly. He was reading a manual. I just stood in the doorway, and finally he looked up and said, "What do you want, boy?"

"Sergeant Poitier, I type one hundred words a minute," I said.

"Sit down over there and show me."

I did. Right away he said, "Tell Sergeant Lopez that you are going to report to the orderly room from now on."

And that's how I got out of the rest of basic training!

I was thrilled. But when I returned to the barracks, I found my bed totally destroyed. The blankets and sheets had been stripped and were strewn all over the barracks. The mattress was in the hallway.

I called together my fellow "trained killers" and, in true William-Holden-from-*Stalag-17* style, said, "Look, I know you hate basic like I do, but why be mad at me? If you could get out of it, I wouldn't be mad at you." I went on for a while this way, and gradually felt I had turned them around. We were a strange group: some from the North, some from the South; some with education and some without; some gung-ho about the Army, others who hated it. (Some of the men had never owned a pair of shoes; Army boots were the first pair of anything they'd had to cover their feet.) But I did feel I had reached them.

The next day when I returned to the barracks, I found the bed stripped again—except my mattress was now in the latrine. I hadn't gotten through to the men at all.

Sergeant Poitier flew into a rage when I told him what was happening.

"Who are they?" he shouted. "Get me their names! I'll make them sorry they were born."

Well, I wasn't going to give these guys up, no matter what. But I did have an idea.

"Sarge," I asked, "can I be in charge of the passes on the weekend?"

"Yeah," he said, catching my drift. "But if you have any more trouble, let me know."

There was no more trouble.

* * *

One morning in 1962, halfway through my Army tour, my unit was suddenly placed on a twenty-four-hour alert. We were ordered to pack our duffel bags and told to be ready to move out swiftly. Weekend passes were cancelled; if any of us left the barracks to go the PX or the base's movie theater or anywhere else, we had to sign out, precisely detailing our destination.

What was going on?

Well, it turned out we were standing by, preparing to invade Cuba. Many of my fellow soldiers, none of whom had seen any actual combat, were excited. The troops knew that if they fought, they'd receive more money—combat pay. And it was widely thought that during wartime you could more readily make rank—that is, get promoted. And if you were promoted, you would get paid even more.

I, however, did not share some of my fellow soldiers' enthusiasm. Having worked as a busboy and a waiter at resorts in the Catskill Mountains, I had met many Cubans, and I was sure that a nicer group of men and women would be hard to find. The very idea of fighting and possibly killing Cubans was agonizing to me.

Fortunately, during those thirteen days in October of 1962, we did not have to invade Cuba. Nevertheless, I'll never forget the Cuban Missile Crisis, or the anxiety I felt as we waited.

full-time work

After I was honorably discharged from the army, it was time for me to find a job.

My mother had given up on my becoming "a professional" and was resigned to the fact that I wanted to work in television, film, or theater. She warned me that this was not going to be easy. Jobs were hard to find, especially in the entertainment field in New York City. I would have to be patient, she said; I would have to pace myself. I had to be tough and keep at it. That was the important thing, to keep at it—since it might take months.

I had seen an ad in *The New York Times* for an entry-level position as a TV executive at a network. I had to apply at the employment agency that had placed the ad, so off I went to a rather shabby office where I filled out a long questionnaire, waited my turn with a sad-looking group of people, and was finally called into a small cubicle.

As I walked in, a young man said, "Julie?"

I couldn't believe it—it was Mel, an old friend of mine from the Bronx whom I had gone to school with. As he tore up my long

questionnaire, he told me, "Don't pay this place any fee. Go see a Mr. Marth at the ABC network"—and he wrote down the address for me.

I thanked Mel profusely and set off to find Mr. Marth at ABC.

His office was at 64th Street and Broadway. Once again, I filled out a long form and waited. As I waited, I decided to take a risk—and concocted a plan.

When I was called I walked in and shook Mr. Marth's hand.

"Mr. Marth," I said, "you don't remember me, but about two years ago we met and you told me to go back and finish college, and when I'd done that, to come see you."

"Yes," he said slowly, "yes—I do remember telling you that. I'm glad you came back. There's an entry-level position available, and I'm going to send you upstairs to see the people in charge of hiring."

And off I went.

The job was in the station clearance department, with a Mr. David App. A middle-aged, very friendly man, Mr. App turned out to be in charge of what were called makegoods. These, he explained, were advertisements that had been pre-empted on network shows for major events, or around the country on local stations for local events, and had to be made up at another time.

"Let me give you an example," he said. "The Gulf of Tonkin speech by President Johnson. That day, all regular TV programming was cancelled. Our job in that case is to not give the advertisers back their money, but to get them to take a makegood in some other ABC show." This was sometimes difficult, he explained, as there were only three networks—and ABC was far and away the last of the three. "We have to keep all the money we can," he continued. "The other two networks just issue a credit to the client, but our job is to convince the clients' advertising agency to take a makegood or two in some other show or shows instead."

"And on the local level?" I asked.

He said, "Okay, let's say the high-school basketball team is in the finals, and it's going to be broadcast at a time that preempts our

programming. So we try and get them to replay our program at another time locally. Once the station agrees, we have to get the sponsors to okay it. They rarely say no on a local level, since the credit they'd get back from one station out of two hundred would amount to almost no money, and their paperwork would be enormous."

It made sense to me, but I left his office that day with my head spinning. There was a lot to remember.

I went to the lobby right away and called my mother.

"Mom," I said. "Great news. I got a job."

"Shit," my mother said.

Now, I was surprised by her reaction on two counts: one, she rarely cursed; and two, I had thought she would be pleased.

When I returned home, she explained to me that this—the speed with which I'd gotten a job—was not the way of the world. Things do not go this easily at all. This was a very rare instance, and she didn't think it was good for me to think this was the way things generally went.

I got her point. But I was undeterred in my excitement for my new job.

<p style="text-align:center">* * *</p>

I started at ABC on a temporary basis in the fall of 1964. I was twenty-two years old. Our department consisted of three co-workers, a supervisor, the head of the department, a secretary, and myself—all in all, seven people.

At Christmastime, raises were given out. My three co-workers received seven-, four-, and two-dollar raises per week, respectively. Those amounts are hard to believe now—even fifty-eight years ago they were very small. Oh! And I went from temporary to permanent status. That was *my* raise.

After a year, I was offered an opportunity to go to London and work for the BBC for a month. It was some sort of exchange program, and I happily accepted. I worked for a man whom I'll call Brigadier General Evans. He stood ramrod-straight and answered the phone in a strong, clipped British accent: "Brigadier Evans here." And he knew nothing

about TV. He couldn't answer a question. It was always, "We'll get back to you on that." Since I was there as an observer, my observations were watching him hand off any and all inquiries to underlings, all of whom kept a stiff upper lip regarding their boss.

Mercifully, I received a telex (no email then) during my first week, saying "Return immediately." My supervisor was leaving, and I was now being promoted and taking his place. I had been making $90 per week; as the new supervisor, I was promoted to $125 per week. For ABC, in that station clearance department, it was a huge raise. But here was the rub: new hires came in at $90 per week. I would stay late to teach them the business. They were on overtime; I was not. At the end of the week, they often made more than I did. When I complained, I was told I was management, and as such, did not get overtime. That didn't go down well with me. As the supervisor, I did have four underlings, and we often laughed together. (One day I came in holding a memo, and addressed my gang of four. "Who wrote this memo?" I asked. "I want to know, which one of you?" One of the guys answered, "It was…oof!"—then slumped over his desk. He really knocked the juice out of me, and all five of us had a good laugh.) But there was no question about it—I wasn't happy being management and often making less than my subordinates.

What I remember most from that first full-time job was my boss's warning about the mail boy. The mail boy had made some mistake, and I was going to let him have it. My boss sat me down.

"Let me give you some advice," he said. "Don't piss off the mail boy."

He seemed serious, and I paid attention.

Well, his advice proved to be very wise, in more aspects of the entertainment business than one. As it turned out, three of the most successful executives in all of show business started in the mail room: Barry Diller, David Geffen, and Michael Ovitz.

* * *

The year: 1965. The place: Chicago. The event: my first NAB.

The NAB stood for the National Association of Broadcasters. It was

the biggest convention of the year in broadcasting; all the television sta-tions in the United States sent representatives to it. Happily for me, the ABC network sent me, along with plenty of other network executives, to meet and greet the network affiliates.

In those days, it was one convention for everything: programming, engineering, and equipment. Anything that had to do with television was there, all under one roof in one hotel. Since I was part of the station-relations group, we hosted parties for the general managers, sales man-agers, and program directors of television stations around the country.

When I could get away, which was fairly often, I went to the floor where the film distributors were. I loved movies, knew a lot about them, and hoped to make them one day.

Since this was the '60s, all the film suites had a similar look. There were film posters all over the walls in garish colors. There was rock'n'roll music blaring in all the rooms. And young girls in skimpy outfits served as hostesses, there to lure the program directors into the suites. There was plenty of go-go dancing. But on the surface, it all appeared to be for looking only—no touching allowed. At least that's the way it was for me.

So that day I gawked and roamed the hallways and walked into every suite I could get into, which was pretty much all of them.

All of a sudden, I walked into a totally different atmosphere. In this particular suite, there was no rock'n'roll. There was music, but it was Vivaldi. There were no girls in tight-fitting outfits, just one beautiful model in a stunning evening gown. Finally, there were no posters on the walls—but there was, framed in gold, a list of titles the company, the Walter Reade Organization, represented. And the titles were some of my favorite movies: *Room at the Top, David and Lisa, A Taste of Honey, The Mark, Saturday Night and Sunday Morning,* Olivier's *Hamlet, The Red Shoes, In Which We Serve, Brief Encounter.* So many quality films that I had seen. So many that I loved.

I truly couldn't believe my senses; it was like an oasis in a desert. I wanted to be a part of this company. I asked the hostess who was in charge, and she pointed to a youngish man in a beautiful navy suit. I walked

over and introduced myself, stressing the fact that I worked for the ABC network. His name was Elliott Abrams. He was soft-spoken, and after a while he said he was interested in continuing our talk tomorrow.

When I returned the following day, he said he had an idea and wanted us to meet in New York City the following week. I was excited. After two years, I was ready to make a move. ABC had been a great place to learn, but movement up the ladder didn't seem promising. The only thing that bothered me about moving was the television film–distribution business itself. If you were in sales, you were required to go on the road fifty weeks a year, Monday through Friday. I was hoping for a management job where I could work in the office.

Our New York meeting took place at Al & Dick's Steakhouse. At the bar with Elliott, I ordered a Virgin Mary. I didn't drink, and had no intention of starting then.

Elliott told me his idea. "I have one slot open," he said. "My four salesmen cover the country, but only the large cities. I want you to try and sell the smaller markets and, since you know our films so well, put together a package of titles from our library. We'll call it Selected Cinema, and let's see what you can do."

Now it was my turn to talk. I said I loved the idea of selling. I loved the films, and I loved that he wanted me. But I only wanted to go on the road once a month. I was good on the phone, I said, and could do almost as well that way.

He immediately agreed. I couldn't believe it, so I charged on. I said I had to have $9,100 a year. That represented a fifty-dollar-a week raise from what I was then making—an unheard-of amount at ABC, where they gave seven- and five-dollar raises.

"How much is that a week?" Elliott asked.

"$175," I told him.

He put out his hand, and I shook it gladly.

And with that, I was ready to start a new chapter in my life.

see the u.s.a.

I showed up for my second full-time job at the Walter Reade Organization on a Monday morning at nine a.m., just as I had every day at ABC. My new office was above a movie theater, the 34th Street East. It was located right off 2nd Avenue, on 34th Street. The building only had four floors. I got off the elevator and walked into total darkness. There appeared to be no windows.

I had no idea where the lights were. I didn't know what to do. I slowly paced the floor, bumping into desks, and finally sat down on a chair I had smashed into. Was today a holiday? Had I gotten the date wrong when I was to start? Should I just sit and wait for some sign of life?

I waited over half an hour. Finally a secretary entered, turned on the lights, and screamed when she saw me. I quickly assuaged her concerns by mentioning Elliott's name, and she led me to his office.

When Elliott arrived, he gave me a list of all the TV film packages the company owned. "Put together a group with our best films," he told me.

Looking at his list, I realized that most of the films were unknown

in the markets I was to handle. My territory would be small to medium markets with a television station or two: all of Georgia except Atlanta, all of Wisconsin except Milwaukee, all of Missouri except St. Louis. (I did have all of North and South Dakota.) Theatrically, these films would never have played in my new territory; all of them would be a first run for television.

I chose what I thought were the most commercial of the films, forty-five titles in all. The buyers never screened the films; they simply bought them from lists and flyers showing the cast, year, running time, and reviews. My first sale was done over the phone to a station in Rochester, Minnesota. At the time, I'd only ever heard of Rochester, New York—but the TV station bought the whole group. I found out later that Rochester was the home of the world-famous Mayo Clinic, with many professional people living there who would enjoy such films.

After that I kept going—selling Pembina, North Dakota, on the phone, visiting Fargo to close a deal. Truth be told, I was turned down more times than I care to remember. But I kept at it, and soon I received my first call from the boss himself, Walter Reade.

"Julian, congratulations," he said. "I can't believe you sold a town called Waterloo, Iowa. I never even heard of it."

It was an interesting time. Many of the program directors I met or spoke to knew very little about our films. In Beaumont, Texas, I was asked about a film concerning two mentally challenged teenagers, which *Time Magazine* had named Best American Film of 1962. It was called *David and Lisa*. The question the program director asked was, "How can I play this sex film?"

In Grand Rapids, Michigan, the programmer scanned the film list, and when he got to *The Ballad of a Soldier* (a Russian film), he said, "I can't play this film." I felt he was probably against any "Commie" film. But it was a brilliant movie that had won countless awards, so I asked him why he couldn't play it. He replied, "Musicals drop dead in this market."

On and on it went, with more film ignorance than I had imagined. These programmers' job was to know film, but most of them didn't.

And it didn't bother them. But I spent hours trying to enlighten various people about the quality of the films. I was a true zealot. I believed that if I could sell them films like *Room At the Top, The Red Shoes,* or *A Taste of Honey,* I would be uplifting the programming in their market. And sometimes my earnestness and sincerity paid off...sometimes.

The days when a deal is closed are the happiest days for any salesman—but for me then, they were sadly few and far between.

* * *

Still, I was travelling around the U.S. selling movies, all expenses paid—an ideal job for a young single man, because I traveled only once a month and I was able to visit cities and towns I would never have seen otherwise.

In the 1960s, almost all television stations in America were VHF stations, meaning *very high frequency*—channels 2 to 13. There were almost no UHF or *ultra-high frequency* stations, meaning channel 14 and above. (Ironically, the higher the channel number, the lower the power.) Even in the smallest of cities or towns, a VHF television station was a multimillion-dollar investment. A transmission tower alone cost a fortune. What that meant was that inevitably, the station was owned by the corporation that owned the local newspaper and radio station. In many small cities and towns, one man or small group totally controlled the mass media. It was a dangerous situation—and one made even more dangerous in some of the situations I witnessed.

For example: Austin, Texas—a good medium-size city that had only one television station, KTBC-TV. This was unheard of in the U.S.A. in the early '60s. To give you an example of the Sunday-night programming on the station, they ran *The Ed Sullivan Show* at eight p.m, *Bonanza* at nine p.m., and *The Sunday Night Movie* at ten p.m.—the three highest-rated shows in their time slots on Sunday. What made this unheard-of was that those shows were from the CBS, NBC, and ABC networks respectively. KTBC-TV was the only station in the country that could pick and choose shows from all three networks. And the

station was owned by the Johnson family—specifically, Lady Bird and Lyndon.

Sometime in the late '60s, a second station, KHFI—a UHF station and an NBC affiliate—was allowed into Austin. It wasn't much competition, but at least it was no longer a one-station city.

Worse than that, a general manager once took me to visit his operations department. There he showed me what I considered a most shocking phenomenon. His people would daily tape the network news feed from New York City broadcasting at seven p.m., New York time, which was six p.m. Central Standard time (i.e., the general manager's time). They then edited out any story or opinion they didn't like, and played the edited tape back at seven p.m. Central Standard time. That's correct: they edited the news. The general manager told me this proudly. And, he said, plenty of other stations did it too. It was a rather sobering thought…but after all, it was the turbulent 1960s.

I was also surprised to find that in some smaller cities, the church owned the television station. I remember that the number-one station in Green Bay, Wisconsin, was owned by the Norbertine Fathers. Besides being very strict on what they broadcast, they were tax-exempt. Needless to say, they did very well financially.

Traveling to and visiting small-town America was an eye-opener for me. It was a bit tricky at times, being from New York City—and on top of that, being a Jew. (Occasionally, someone would tell me I was the first Jew they had ever met.) But I also had an experience that I'm sure was totally unheard-of in any major city, or in many minor cities—unless, of course, you were a celebrity.

I was in Marquette, Michigan—pretty high north, near Canada— and it was winter at the time, and cold. The only commercial flight out was from a company called North Central Airlines. I had just gotten caught in what was probably the only traffic jam in Marquette's history, and missed my plane.

I ran to the counter and said, "I guess I can't get on the plane?" I could see the plane on the runway through the windows, and saw that

it was about to take off. But the reservation clerk radioed the captain on the plane, and the next thing I saw was this four-engine prop plane turning around and returning to the terminal. I felt like a king or prince, with my coach returning to pick me up.

I was walking on air—until I entered the passenger cabin and was given some of the nastiest, dirtiest looks I have ever seen. There were only about eight or nine people on board. My excitement quickly died, I slumped down in my seat, and I laid low the whole trip. I later figured out that they'd only turned the plane around because I was likely the difference between profit and loss on that flight.

Sometimes, I do love capitalism.

the motion-picture
theater division

I had worked at a television network. I had learned about television syndication. I had traveled the United States to many cities and towns. Yet I still felt far away from my dream—to run a major film studio and/or produce movies.

Walter Reade had a very successful theater division, with many theaters throughout the country. I had become friendly with the head film buyer, Sol Horwitz, and the vice president of the division, Ed Schuman, and I let it be known that I would like to work with them. They both said that would be fine, but it would be a lateral move. Clearly translated, it meant I'd make the same amount of money.

But I was gung-ho for it. In my head, I was getting closer to my goal. I was leaving the world of television for the world of motion pictures. The fact that, at best, I would be involved as an "end user" never even entered my mind. I just knew I was going to be in the movie business.

And on paper, it was the greatest job in the world. Almost every

day or evening I would screen a movie at a theater. There was no such thing as DVDs or cassettes at the time, so I screened at the major studios' screening rooms, located all over New York City. Sometimes I screened at the theater where we had our offices, The Fine Arts on 58th Street. It would be at ten a.m., since the theater opened to the public at noon. Sometimes independent producers or distributors sent a 35mm print or set up a screening at one of the private screening rooms in Manhattan.

Still, it often got to be tiresome and dull. That may sound hard to believe, I'm sure. But think about it. You'll go see a film and at times be disappointed, or dislike it—even hate it. But somebody or some group thought it was good enough to open and to spend money—sometimes a *lot* of money—to make it. Accordingly, I would sometimes see dreadful films, films that would never see the light of day—or that would end up on television at three in the morning.

Well, as luck would have it, my big boss left and went to work for Ed Muskie, a senator from Maine who was running for president. So my boss Sol Horwitz and I moved up. About a year later, Sol was hired by Loews Theatres to be their head film buyer. Walter Reade, Jr. started interviewing prospective film buyers to come and replace Sol, and I asked to see him.

"Mr. Reade, I want the job," I told him.

"You're not ready," Walter Reade answered. "You've only been doing it for a year."

"I can do it," I insisted.

"Be patient. In a few years the job will be yours."

"Mr. Reade, I need this chance. I'll work day and night. I can do it."

"And if you can't? If you fail, I'll fire you. You'll have *no* job."

"I don't care. I'll take the shot. I won't fail."

Youth makes you believe you can do anything, and that you just can't and won't fail.

When I look back now at what I'd done, I shudder.

* * *

I was now in charge of buying (that is, booking) films for the Walter Reade Company's theater chain of around eighty theaters, located throughout the U.S. The company's main strength was that some of its theaters were the most important in the world.

Let me set the scene in the 1960s. A motion-picture company almost always opened a new film in New York City—specifically in Manhattan. It was often in one theater; at times it was two. One would be on Broadway, the other on the East Side. (Walter Reade had the most theaters on Broadway at that time—the Astor, the Victoria, and the DeMille—and later, added a new movie palace, the Ziegfeld, which was a bit off-Broadway but a large theater on the West Side nonetheless.) And when they launched that new film, it wasn't just for the New York City area, nor for the Northeast, nor for the U.S.A.—but for the world. This meant that sometimes, a five-hundred-seat theater could determine the success or failure of a film worldwide.

There were many unspoken rules in distribution at the time. It was also an old boys' network, and I was a young, twenty-seven-year-old, rarin'-to-go whippersnapper. Almost all the studio sales heads called me Kid, which, I can assure you, was not said affectionately. Upon meeting me they would say things like, "Where's your father?" and "How are you related to Walter Reade?" (To be fair, I did look younger than my years. My girlfriend at the time suggested I grow a mustache—to which we then added a goatee, a Fu Manchu, and finally a beard. The beard was blond, and did make me look older; through the years it has gone from blond to gray to white, so it has finally paid its dues.)

Distributers were set in their ways, too. After a lot of meetings and cajoling, I was able to convince United Artists to play their next Woody Allen film, *Everything You Always Wanted to Know About Sex**, at both the Coronet and Little Carnegie Theatres. This seemingly innocuous booking took months to accomplish. The Coronet was on 59th Street, the Little Carnegie on 57th Street. United Artists kept saying they were

only two streets apart—but they were also East Side and West Side, and the residents of each generally stayed on their side. Still, it proved to be a huge success, and it became a pattern used for many years to come.

Funny the things you remember—though in my line of work, this one makes sense. Late one night, I had been on the job awhile when the phone rang. Though I was young, I was working long hours as the head film buyer, and eleven-thirty p.m. was quite late for me. I sleepily answered; it was the big boss, Walter Reade, Jr.

"Julian, I'm very proud tonight," he said.

"Oh, I'm glad," said I.

"Do you know why?" he asked.

"No," I replied.

"Well, on the news tonight, they said the two best films playing in New York City are *Sunday, Bloody Sunday* and *Desperate Characters*. We have them both, and I'm calling to thank you."

That call meant so much to me. Turns out, it's not just plants and flowers that need watering.

Another day, out of the blue, I received a call from Warren Beatty. He had already produced and starred in *Bonnie & Clyde*, and was a huge movie star. He asked me if I'd seen *McCabe & Mrs. Miller*. I hadn't, and he asked me if I would screen it.

It was a strange request. It had already opened on Broadway at the Loews State and on the East Side at the Loews Cine on 86th Street. It had failed there, and had been pulled in two weeks.

I asked Warren why he wanted me to see it and he said he wanted my opinion of the film. Though I was reasonably inexperienced, I sure knew that Warren, a stranger, did not want just my opinion—or my opinion at all. I really had no idea *what* he wanted—but I was tremendously flattered that he was talking to me. So I screened the film, and really, truly liked it a lot. I told him so, at which point came the shocker: he told me he wanted me to reopen it at the Coronet.

Well, this was madness in 1971. The Coronet was the best or second-best theater in all of New York City. It only played the top

first-run films; the idea of showing a second-run film there was crazy. On top of that, showing a film that had just flopped would be psychotic.

But Warren promised a big ad campaign. Warren showed me the many critical champions of the film. Warren charmed, pushed, inspired, and most importantly, kept up an interesting mantra: "We're young. We're changing things. We're going to change the way films are distributed." He had done it on *Bonnie & Clyde,* which had initially flopped; now he insisted we could do it again with *McCabe & Mrs. Miller.*

And damned if he didn't convince me. And damned if we didn't gross a lot. And damned if he didn't successfully relaunch a film that had *RIP* written all over it.

It was an exciting time. Warren would be in and out of my life a lot after that. He was also responsible for changing my life forever a few years later, when he introduced me to someone who would come to be my best friend.

But we'll get to that.

elia kazan

One weekend in 1966, I decided to look up Elia Kazan in the Manhattan telephone book.

He had won an Academy Award for directing *On the Waterfront*, which (you'll recall) was the first film I ever went to alone. I really didn't think I'd find him in the phone book, but there he was—listed as a business with a Broadway address.

I couldn't believe it. I wrote down the address, and on a late Monday afternoon, I headed over.

The office building was small, and located behind the cashier's booth at the Victoria Theatre on Broadway and 46th Street. I looked at the directory. No Kazan listed. So I waited outside the theater.

Around five o'clock, Kazan came out. He was a short man, but he walked very quickly. I followed him, and even though I was much younger and much taller than he, I could barely keep up with him. I followed him for over a mile, afraid to talk to him. When he reached his home, a brownstone on 68th Street, I scurried away.

The next day brought the same scenario, with me following him all

the way home without saying a word to him.

On the third day, as we reached 49th Street and Broadway, he suddenly whirled around, pointed a finger up at me, and said, "Who are you, what do you want, and why are you following me?"

All I could do was stammer, à la Jackie Gleason in *The Honeymooners*, "Abbah, abbah, abbah."

"Calm down and walk with me," he said, turning back toward downtown. "Let's go to my office and talk."

"Fine," I said. It was my first word in English.

As we walked, he described in rapid detail the things we passed: a person who interested him, a store he frequented, a car along the street. It didn't matter what he said, because the thought that kept running through my head was *Elia Kazan is talking to me, and we're going to have a chat.*

We went into a tiny two-room office. There was a little room for a secretary, and a second room with a couch, on which he stretched out like a cat. I sat upright across from him.

"Now, what is it you want?" he asked.

"I want to work for you," I said. "I'll take no money. I just want to be around you and learn from you."

"There are hundreds of actors who are willing to do that," he said.

"I'm not an actor."

"Then tell me, who the hell are you?"

I don't remember exactly what I said, but I know I babbled on for a long time. I told him I had worked at the ABC network and was currently working at the Walter Reade Organization, a movie-theater chain. I had graduated college, served in the army, worked as a cab driver, a pin boy in a bowling alley, an usher...

"Okay, enough," he said. "You work for a theater chain. Have you ever heard of a film called *A Face in the Crowd*?"

"Sure." I said. "Andy Griffith, Patricia Neal, Walter Matthau..."

"I know who's in it, I made it. How about *Baby Doll*?"

"Sure, Karl Malden, Carroll Baker..."

"Listen to me. I'm getting those two films back from Warner Bros.

It's part of my deal with Jack Warner. Do you think you could do something with them?"

"Absolutely!" I cried, having one or two ideas at best. (At that time there were no DVDs or video cassettes, no pay or basic cable. There were some revival theatres, and there was free television.)

"Good," he said. "Oh, and before I forget, if you can sell them to television, I want no commercial interruptions. And they can't cut a frame of them. I hate to see my films on television. They always cut them up."

"Right," I said loudly.

<p style="text-align:center">* * *</p>

After that meeting, I ended up representing Kazan on those two films. A few years later, he got back *America, America,* and he gave me that one also.

Over the years, he was always there to counsel and encourage me. He inspired me, hurt me, taught me, appreciated me. I worshipped him. No person I ever met could excite me so with the sheer power of his intelligence. I would leave a meeting with him intoxicated with ideas and plans. Spending time with Elia was like taking a powerful drug, without ever having to come down.

He was a man who insisted on doing things his way—and that meant he sometimes encountered resistance. When he'd first gone to Hollywood, he told me, they hadn't liked his name. He was under contract as an actor, working for the producer Walter Wanger. One day he was told to see an executive who was in charge of new names. Kazan walked into a nicely furnished office with a large wooden desk. The desk had only two things on it: a telephone and a Los Angeles telephone directory. The man asked Kazan, "What's your name?"

"Elia Kazan."

"No, no—that will never do."

At this point the man leaned back in his chair and gazed at the ceiling, repeating out loud, "Elia, Elia, Elia." Finally, he slammed his hand on the desk and shouted, "Elliot! That's it. Elliot."

Kazan said nothing. The man than grabbed the phone directory and started flipping through the pages. At one point he stopped, and with his index finger scanned lots of names. Then he looked up at Kazan and said, "I've got it. Cezanne. From now on, you will be known as Elliot Cezanne."

"You know, there's a famous painter named Cezanne," Kazan said.

"You'll be bigger than he is!" screamed the man, pounding his desk.

Needless to say, Elia Kazan remained Elia Kazan.

As he got older, he mellowed. That unbelievable force was gone. But every once in a while, at a meeting, a little bit of it would return. I often found myself tearing up when it happened, though I never let him see it. He would have been furious.

"You think I can make it to ninety?" he once asked me, when he was eighty-eight.

"Of course," I said. "I'll throw you a big ninetieth birthday party, and you can invite all the people you want."

"Be a small party, then," he said.

My wife and I did end up throwing that party, and it wasn't small. Every time we opened our front door, another legend walked in. It was a great night. And he told me, in just the right words, how much he appreciated it.

It's now been many years since I stalked him. And there isn't a great deal of loyalty in the world of show business. But for thirty-seven years, I represented Elia Kazan with no contract—just his firm handshake.

i wish he were a stock

Unbeknownst to many, there was a NATO convention in Florida in the late 1960s. That was, of course, the National Association of Theatre Owners, which is what *NATO* stands for in the entertainment business.

I was sent to the convention as a representative of the Walter Reade Organization. There were major studio executives there, along with film exhibitors and assorted industry types. I had planned to meet with the Warner Bros.' branch manager from Los Angeles, among others. Walter Reade had three theaters in L.A.: the Music Hall, the Beverly Canon, and the Granada. All three struggled, because Los Angeles was dominated by huge chains like Pacific Theatres, Mann Theatres, and General Cinema. I had developed a rapport over the phone with the Warner Bros. guy, who was my age. As I mentioned earlier, young guys with any power were rare indeed at that time.

We had dinner and got along well. We were both from New York City, close to the same age, and found we had many things in common. We developed a close friendship that lasted over forty years. I would be the best man at his next wedding, and he was the best man at mine.

I used to say I wish he was a stock so I could buy him, I was so sure of his success. He had grace under fire, and was a thinker and a planner. He was able to map out his business moves unemotionally, and yet he was also warm and a supportive friend.

Eventually that young man became the co-chairman of Warner Bros. Studios, which he remained for close to twenty years before leaving to head Yahoo. His name is Terry Semel—and years later he and his wife, Jane, would introduce me to my future wife, Merryn.

las vegas

I spent a lot of time in Las Vegas in the late 1960s and early 1970s. The town was so different then—it certainly wasn't the family destination it is today.

Pre-Christmas Las Vegas was almost empty. As with the movie theaters, Broadway shows, and restaurants, the closer you got to Christmas, the emptier the seats were. This was the best time to go, because I could see my favorite acts in person—not on television or in the movies. Even though I was in show business, I knew I really wasn't *in* show business; by going to Las Vegas, I was able to get my fix.

The hotels on the Strip were where Frank Sinatra, Danny Thomas, Sammy Davis Jr., and other major stars performed in the main show rooms, but the lounges were my favorite. These were more intimate and free-flowing than the bigger rooms. For a five-dollar minimum and no cover, for example, I could see two of my favorite acts: Don Rickles, and Louis Prima and Keely Smith.

Rickles wasn't a name himself at the time, but he was a major attraction for the other entertainers who came to see him. I was there when

audience members Richard Pryor, Gene Barry, and Hal March were skewered by Mr. Warmth. I wasn't there when he famously went after Sinatra, who reportedly laughed more loudly than anyone else. But I could tell when I saw him that Rickles was fearless. I knew I was seeing a new kind of comedy, and a guy I thought would make it big.

Louis Prima and Keely Smith did their shows with a great band. Long before America discovered Sonny and Cher, Louis and Keely were doing a similar act, except Louis was a manic performer. He could sing and play trumpet and joke, and was always in motion. Keely, who was part Cherokee, had a great voice and was the stoic one in the act. It was so much fun that I confess to going to all three of their shows some nights.

I was in Vegas for one thing, and it wasn't gambling. I went to the Sands, the Riviera, the Desert Inn, the Flamingo, the Tropicana, and others. But it was the shows at the Frontier Hotel I remember best.

Jack E. Leonard, a fast-talking, chubby comedian, headlined in the main room. Frank Sinatra, Jr. was on the bill too, backed up by the Harry James orchestra. The theater held over a thousand seats, but on the night I was there I was one of about fifteen people in the audience. There were more people onstage in the orchestra than in the nightclub. Harry James did his whole set, as did Sinatra, Jr. When Jack E. Leonard entered from the wings, his trademark hand resting on the side of his big belly, he looked around and ad-libbed, "I could do this whole show in a Volkswagen." I cracked up and he yelled to me, "Who's the little ka-ka with the beard laughing so hard?" I was so thrilled to be insulted by him that it made me laugh even harder. It was a memorable evening.

Hilton Hotels, not to be outdone, opened their Las Vegas hotel with Bill Cosby as the headliner. This was long before his popular television show and his later fall from grace, and I was a big fan of his. He was already a star.

Cosby's opening act was a group I had never heard of. The act began with a sexy woman running out of the wings with two other girls in skimpy dresses. They were three whirling dervishes moving nonstop, backed up by a wild rock'n'roll band. I had never seen or heard anything

like it: the gyrations, the beat, the powerful singing and dancing. The rest of the audience was in shock too—I checked out the crowd and saw many stares and mouths agape among the middle-aged, all-white audience, who had come to see a star they knew and loved. They sat stunned through the whole show and applauded half-heartedly after each number, not sure what had hit them. I truly believe most of them were relieved when the set ended and Bill came out.

That opening act was the Ike & Tina Turner Revue, with the Ikettes. I felt (foolishly, as it turned out) that I had discovered a new act; in truth, they had been performing for years.

Phil Harris was another big favorite of mine at the Frontier. On the radio, he had portrayed Jack Benny's heavy-drinking neighbor. But he was also a famous orchestra leader, and in the '50s he had recorded some big hits like "That's What I Like About the South" and "The Thing." He was married to a glamorous movie star, Alice Faye, and was really funny. (In the '60s, he was also one of the voices in Disney's *The Jungle Book*. The highlight of that film for me was Phil and Louis Prima doing the song "The Bare Necessities.")

My girlfriend at the time was also a big fan, so after the show we went backstage to try and meet Phil. His dressing room was a large trailer in the hotel's parking lot, and we were, to our astonishment, let right in to say hello. I think he was surprised and pleased that two young people were fans of his. He was without a coat or tie, dressed in the same white shirt he had worn onstage, and his face was quite ruddy—he'd clearly had a few, just as he did on the *Jack Benny Show*. He was in great spirits, enjoying that high that performers get after a good audience. He was warm and funny as he reminisced about Jack Benny, his wife Alice, and other performers. When we brought up the late Frankie Remley, who had been his drummer and drinking pal, he suddenly became serious, and talked about how much he'd cared for him and how much he missed him. We stayed a little longer and got him back to laughing and clowning, and he asked us to come again.

We did, but the magic of that first meeting was never rekindled. Years later, when I returned to Las Vegas for a visit, I discovered that the lounges with big names were gone and the hotels had become enormous. The strip had become a Disneyland for adults.

I never went back.

a tale of three theaters

In 1970, I was having trouble booking the DeMille Theatre on Broadway. It was in a bad location, as far as the distributors were concerned: not Broadway, but Seventh Avenue between 47th and 48th Street, which was considered too far uptown. The fact that it had more than fifteen hundred seats, making it one of the largest theaters in the Broadway area—or that it was only thirty steps from Broadway—didn't seem to help. It had become a white elephant.

I had an idea. I went to Walter Reade, Jr. and asked if we could have dinner one evening. I'm sure he was surprised; I had recently been made the head film buyer of the company, but he and I had never socialized. We were acquaintances at best. But he agreed.

I chose the House of Chan, a restaurant on 52nd Street and Seventh Avenue. I was always early for appointments, and was especially so with the owner of the company; Mr. Reade always rode in a limousine, and he arrived right on time.

We talked mostly about business, and since it was a beautiful spring night, I asked after dinner if we might walk to the DeMille, four blocks

away. He agreed, and as we walked together, I could tell he was amazed. After a few steps he turned to me and exclaimed, "We're the only white people here."

Which was exactly the point.

I had tried in the past to convince him and others that the DeMille should play to black audiences. None of the powers that be would have thought themselves to be prejudiced; quite the contrary—I'm sure they would've have described themselves as proud liberals. But they knew that black customers patronized theaters on 42nd Street, not Broadway, and my prior requests to show a different kind of film there were constantly turned down.

Having seen this point, Walter Reade told me to go ahead and book what I wanted in the DeMille. It was what I'd hoped would happen when I'd planned our impromptu walk, and I set to work.

United Artists had a new film out called *Cotton Comes to Harlem*. (What a title for a first-run New York City theater!) With it, we broke every record on Broadway, and I was thrilled. Having done so well, we were pursued by MGM and agreed to book what turned out to be the original *Shaft*. For awhile in the early '70s, the DeMille became the hottest theater on Broadway.

* * *

The Ziegfeld Theatre was the first new movie theater built in Manhattan in many years. It was meant to be a *roadshow* house, to play special-event films with reserved seating and a "hard" ticket that cost more money than usual. It had beautiful chandeliers, twelve hundred new plush seats, a giant screen, and wonderful sound. The only problem was, it was unproven and in a bad location, which meant little foot traffic and no other theaters nearby. It was between Sixth and Seventh Avenues on 54th Street, and it competed with the Broadway theaters.

We struggled for almost two years until, using all of our power, we were able to get the new—and, as it turned out, the last—film that David Lean directed, *Ryan's Daughter*. Lean was, and even now

is, considered one of the greatest directors in the history of film. Two of his most famous are *Lawrence of Arabia* and *The Bridge on the River Kwai; Ryan's Daughter* wasn't in that class, but it had an interesting cast nonetheless: Robert Mitchum, Sarah Miles, and Chris Jones as the stars, with Trevor Howard and John Mills stealing the film in supporting roles. (In fact, John Mills won the Academy Award that year for Best Supporting Actor.)

The first weekend we opened, the manager called me at home in a frenzy. He had worked at the theater since it was built, but had never handled such crowds. I ran down to the theater, helped him set up lines for ticket buyers and ticket holders, then started answering phones, which were ringing off the hook. It was true pandemonium.

At one point, in the manager's office, the manager and I both grabbed one phone line and yelled, "Ziegfeld Theatre!"

A male voice on the other end said quietly, "There's a bomb in the theater."

The manager replied, "Oh, no—we're playing a *good* film now."

As it turned out, the male voice on the other end meant what he said a bit more literally. I've told this story for years, and all I know is that it happened on the first Saturday night at the Ziegfeld, during the premiere of *Ryan's Daughter*. Needless to say, we emptied the theater, the police came with their sniffing dogs, and we finally started the eight p.m. show at nine p.m.

After that rocky beginning, the Ziegfeld proved to be a huge success for many years.

* * *

I remember a bomb scare of a different kind at another theater of ours. It was called the Bloomsbury, and was in Russell Square, in London. (There were no air-conditioned theaters there at the time, and so we'd decided to open one; however, it turned out Londoners didn't care about air-conditioning in 1968.)

Two major theater chains controlled the city: J. Arthur Rank

and EMI. At first we lost money, but we were finally able to get Luis Buñuel's *The Discreet Charm of the Bourgeoisie*. As you can tell from the title, it was an art film—and we had put up a $50,000 guarantee, which was a lot of money at that time for a non-English-speaking movie with no major stars.

That first weekend, I was a nervous wreck. Sunday morning, New York time—which was the afternoon in England—I called London.

"How did we do, Stuart?" I asked our managing director.

"Oh, Mr. Schlossberg," he said, "it's a bomb."

"It's a bomb?" I cried.

"Absolutely," he said calmly. "It went like a bomb."

"It went like a bomb? Are you sure?"

"Yes sir, I'm sure."

This went on for a while until I asked for the Friday and Saturday night grosses. They were enormous.

"Why are you calling this a bomb?" I screamed. "These are great numbers!"

At which point he dryly explained to me that in England, if something was a success, they sometimes said that it "went like a bomb."

As Oscar Wilde shrewdly observed, England and America are two countries separated by a common language.

my first feature film

In the early 1970s, I was living with my girlfriend Milly Sherman, who also worked at the Walter Reade Organization. On a vacation, we had rented a beach house in Westhampton, on Long Island. We both loved the sea and spent the early mornings, with no people around, walking in the water near the ocean shore, talking away. On one particular morning, we were reminiscing about our favorite Sid Caesar–Imogene Coca sketches from an early TV show called *Your Show of Shows,* when I went quiet in thought.

"What's the matter?" Milly asked.

"I was just wondering if Max Liebman, the producer, is alive," I told her.

"Why?"

"Maybe he has some of those shows."

"And if he does?"

"Well...maybe it could make a good movie." When we got back to Manhattan, I found a phone listing for a Max Liebman. I called that Monday, and a male voice answered. He said

that yes, he was the man who had produced the show. I asked if we could meet; he agreed. When I hung up, I said to Milly, "You and I are meeting Max Liebman tomorrow."

The next morning, Milly and I knocked on the large steel door to Liebman's office. A small elderly man answered and led us into a large musty room. Then he smiled and waited. I told him about our current job at Walter Reade, and my earlier background at the ABC network. I then asked, rather tentatively, "Do you have any copies of *Your Show of Shows*?"

He said softly, "Follow me."

We walked down a short corridor to a closet door, which he opened and pointed inside. "Here are all 156 ninety-minute shows," he said.

I was astounded. He had actually preserved all of the kinescopes! This meant there was a real possibility that we could make a movie—and so began our process of screening all the programs to find the sketches we might use in a feature film.

Though the original *Your Show of Shows* was ninety minutes, and each show contained dancers, singers, and guest hosts, plus commercials, we stuck to screening only comedy sketches. Then, Max, Milly, the show's star, Sid Caesar, and I tried to agree on what to include.

There was a lot of arguing over the choice of sketches, but with some of the sequences, we were all in agreement. Milly remembered a sketch we had missed, which was a Swiss clock with human figures, breaking down. That eventually replaced a weak sketch that never worked, no matter where we placed it. The first time I saw the sketch entitled "This Is Your Story" a hilarious take-off on the TV show, *This Is Your Life*, I knew two things: one, it would definitely be in our movie, and two, it was funny enough that it should end the film.

One of the big problems with the decision-making process was when Milly and I felt something was dated. Sid or Max, and sometimes both, would sometimes want to include something that was twenty years too late. There was one sketch with Sid playing a woman dressing, miming putting on a girdle. "Women don't wear girdles anymore," I argued. "Do you hear that laugh track?" was their constant reply.

At last, we had our sketches—and in the end, everyone had to compromise. Milly and I so admired both Sid and Max, but we were the ones financing the project, and we knew we were more attuned to the current film audiences because of our experience booking theaters throughout America.

We finally agreed on the order of the sketches, and picked a title. (That wasn't easy. Max wanted to call the film *Tis to Laugh*; thankfully, Sid vetoed that one.) We decided to call it *Ten from Your Show of Shows*. At Sid and Max's insistence, we filmed Sid, acting as a crazy German professor, to be the host and narrator—but we had a feeling it wouldn't play with new audiences, and we were right. When we sneak-previewed it for the first time with a paying audience, it was clear the new footage had to go.

The headline we used for the ad was "Hail Caesar." We expected to get great reviews, and we did—but though I was thrilled that all the reviewers loved it, I was shocked when the public didn't show up. I received some very pleasing congratulatory calls, but the lack of turnout left me with no idea what to do next in show business.

But it was quite an experience nonetheless. Our opening night was a benefit for the Lexington School for the Deaf. Many young hearing-impaired children attended. In the lobby, after the showing, they mobbed Sid Caesar—and the most amazing thing happened. The children were all using sign language with each other when Sid suddenly began to sign along with them. He knew how to speak sign language—I forget why, but he did.

The kids were astounded and overwhelmed, and many began to weep.

And so did Milly and I.

the radio show

One day, not long after that, I received a call from Jon Doyle, who was in charge of the New York City theaters controlled by Walter Reade. I was sure he was calling to congratulate me on *Show of Shows*, and I welcomed the call. I liked Jon—everyone did. A schmoozer with a Texas drawl, he was the go-to guy for tennis-tournament tickets, Broadway shows, baseball games, and more. I waited to hear his compliments.

He surprised me with what he said instead.

"Julian, you should have your own radio talk show," he told me.

"Thanks," I laughed. "Okay with me. What's your plan?"

"My friend is the sales manager for WMCA talk radio," he explained. "They want to do a show on movies. You'd have to speak to the public on the phone and do interviews, but I know you can do it."

I was then thirty-two years old, and I had never been on the radio. But I was interested. We went over to WMCA and met with the general manager and Jon's friend, the sales manager. When I told him I was interested, the general manager said, "Good. You'll go on today as a guest on *The Leon Lewis Show* at three p.m."

It was now two-thirty p.m. Not much time to prepare.

Fortunately, Leon was gracious and charming. I told stories, I talked about current films, I talked about classics, I laughed with Leon, and then we talked on the phone with the public. I was on fire, and I stayed a full hour.

At the end of my guest shot, the two men who ran the station were waiting for me in the hallway.

"Very good," they both said. "We want you to do just one more show."

"Fellas, this is it," I said. "That's the best I can do. If what you heard isn't good enough, I can't do any better."

They said they'd get back to me.

"Don't worry," Jon whispered when they'd gone. "It's in the bag."

"Why?" I asked.

"They're dying on Sunday night, and I told them we'd get movie stars to come on with you."

Well, I did know a few movie names, and so did Jon. And he was right—they did say okay. They had one stipulation: they insisted I change my last name. That didn't work for me. I knew that Schlossberg was sometimes hard for people to pronounce, but this was New York City. A lot of Jewish folks live there. I refused, and they eventually gave in.

On a Tuesday, Jon told me we were on for Sunday.

"Wait a minute," I stammered. "It's Tuesday! We need a guest—we need some sort of outline!"

"Don't worry, Julian," Jon said again. "It's in the bag."

We were scheduled from eight to nine p.m.—prime time Sunday. My first guest was film producer Stephen J. Friedman, whose big hit was *The Last Picture Show*. We had known each other awhile, and I knew he could talk—plus, he had a new Sidney Lumet film opening called *Loving Molly,* starring Anthony Perkins, Blythe Danner, Beau Bridges, and a newcomer named Susan Sarandon. We had a lot to talk about. I thought it would be a piece of cake.

But being a host on the radio is not the same as being a guest. The

guest doesn't have to worry about the pace of the show. Or the commercials. Or the time left. As the guest, you almost always know more about the subject than the host—but the host has a lot of work to do.

At some point, I knew I had to open the phones to the public. I wondered whether anyone would actually call in. I had told my parents and girlfriend to phone in with questions if no one dialed the station, so it wouldn't be too embarrassing. When all seven of our lines lit up at once, I was relieved.

I went to the first line. "You're on WMCA," I said.

"Julian?" a male voice asked.

"Yes."

The caller let out a huge Bronx cheer. (This is done by sticking out your tongue and making a noise that sounds a lot like flatulence.)

"Thank you for calling," I immediately answered.

Though there was a seven-second delay and I knew no listener had heard the call, I started to sweat. My hand was shaking as I pushed line number two.

"Hello, you're on WMCA."

"Mr. Schlossberg?" another voice whispered.

"Yes."

"Fuck you!"

"Well, thank you, sir, very much."

I was now a basket case. Fortunately, the rest of the callers were all polite. Though I would be on WMCA for seven years, and later WOR for two more, I never, *ever* had that kind of rudeness again. But what a baptism by fire!

When the hour was mercifully almost over, my producer told me, "You have one minute left."

I panicked.

"Good night," I said immediately, "and I'll be back next week."

Pause.

To my horror, I realized that fifty-five seconds were still left in the show.

"You're listening to WMCA," I ad-libbed. "We are 570 on your dial." Pause.

"My name is Julian Schlossberg"—this was probably the only time I've ever been glad my name was so long—"and the name of our show is *Movie Talk*." Pause. "Stephen J. Friedman has been our guest." Pause. "His new film, *Loving Molly,* opens this week."

Finally, it was nine p.m. I was drenched in perspiration.

That was a nerve-wracking experience, but it did get better. Within six months, I was given another hour. Then another. Then another. Within a year, we were on from eight o'clock to midnight—four hours. Then I was offered one more hour. I had to refuse. Eight to midnight was enough.

The show turned out to be a good example of the power of word of mouth. I did what apparently few hosts did: I actually watched the movies, read the books, and went to the plays. And as a result, the guests told each other and their PR people, "This guy does his homework."

Though I never quit my day job at Walter Reade, I loved doing that radio show, and I met a lot of people on it—some of whom became lifelong friends.

booking "movie talk"

Both Jon and I tried to cajole as many stars as we could onto the program. It wasn't always easy. I remember Jackie Mason, during a commercial break, turning to me after having talked to the public on the phone for a while, and asking, "What kind of a schmuck would call a radio show on a Sunday night?"

That, clearly, was one way of looking at it.

On another occasion, I heard that Ethel Merman was staying at the Algonquin Hotel. I called and asked for her, and was put right through. The phone was answered with a large, "Yes, what is it?"—the unmistakable sound of Ethel Merman.

"Ms. Merman, my name is Julian Schlossberg. I do a radio show in New York City on WMCA, and we want to dedicate the entire four hours to you and your career. Broadway, radio, TV, movies—discussing your amazing life in show biz."

"How much do you pay?" she asked.

"Well, it's radio, so we have no budget."

She then sang, "Good-bye," stretching out the *bye*, and hung up.

Sometimes, there were other difficulties. A few famous people showed up drunk. I remember the writer Irwin Shaw was smashed before we went on the air. He staggered to his chair, slurring his words. I was worried. What was he going to say and sound like on air? But an amazing thing happened: after I'd introduced him, he spoke clearly and intelligently. I relaxed. Then when I went to a commercial, he started slurring his words again.

That was the pattern for his entire interview. Drunk off the air, sober on the air.

I had to ask two famous actors to leave the program because they were so clearly intoxicated. One actress brought a fifth of booze into the studio, and drank from the bottle. But most of our guests were sober, and many of them were a lot of fun.

I was thrilled to have Bob Hope on a few times. We kidded and joked together, and he told great anecdotes. I was only one of three shows he did in New York City besides TV's Johnny Carson and Mike Douglas.

After one of his visits, I thought I would try to get a little more personal with him. On his next appearance, after plugging his new TV special, I said to him, "You were one of six sons, and the fifth born. Did you sometimes get lost in the crowd?"

He started to say, "Well, with four older brothers—" and then he stopped and stared at me. There was dead silence for a long moment, and then he let fly some passing quip.

We finished the interview, and he never appeared on my show again. I had apparently gone too far.

Other guests were more candid. It surprised me, for example, when Jack Nicholson admitted, "Every time I start a film, I don't know if I still have it." When I told Robert Duvall what Nicholson had said, he agreed, saying, "Part of that is being the star of a film, and knowing it's all riding on you."

Another time, Donald O'Connor was my guest. He was just terrific, and gave a great interview. I ended the show by saying, "Donald

O'Connor, you've spent fifty years in show business. You've done films, TV, theater—and in all that time, what would you say was the highlight of your career?"

"Talking to you, Julian," he quickly deadpanned.

For a moment I was taken aback—and then I howled with laughter. It was the only time in my nine-year radio career when I was unable to sign off.

Talk about "Always leave 'em laughing!"

edward g. and me

Five nights a week in primetime, a famous New York City broadcaster, Barry Gray, was on WMCA. When I first joined the station, he barely deigned to talk to me at the monthly staff meetings. His guests were often powerful politicians and well-known authors and entertainment names; my guests were the likes of George Burns, Bette Davis, Anthony Hopkins, and Jane Fonda.

After a while, I found with some surprise that Barry was starting to warm up to me. I was a fan of his show, and was flattered when his attitude changed. Later I learned that he had been checking up on all the other hosts and who they had on.

One day, he asked if we could meet. He wanted to propose that we co-host a TV show called *The Schlossberg-Gray Report*. With my contacts and his, he said, we could have a special program.

"Notice," he added with a wry smile, "I'm giving you top billing."

I laughed. "You should, since *The Gray-Schlossberg Report* sounds depressing and ominous," I said.

He continued to smile.

Right then and there, I remembered a role in one of my favorite films, *Double Indemnity*. Edward G. Robinson played a great character who has a strong belief he shares with Fred MacMurray. Pointing to his chest, he says "If the little man in here feels something, I always listen."

Well, the little man in me didn't feel good about Barry's offer. I didn't particularly like or trust the guy; I didn't think we'd get along, and we had no chemistry. But how to turn him down and not make an enemy? After all, he was an important broadcast name, highly respected and with high ratings. He'd been on WMCA for over twenty-five years.

"Barry, thanks so much for the offer," I finally managed. "But I have a full-time job—forty hours a week Monday through Friday, plus four hours on Sunday when I do my show. I couldn't possible take on anything else."

He grimaced, told me I was blowing the chance of a lifetime, and walked out, shaking his head at my foolishness.

After that, at staff meetings, he reverted to his initial coldness, and I laid low except to nod hello. (Often, he ignored the nod.)

Years went by, and one day, seven years into doing my show, I got a call from the owner of the station. He wanted to know if I had co-produced and co-directed a movie opening in New York City. I said yes—the film he was referring to was *No Nukes*—and he told me it was a conflict of interest, since I was talking about it on my show. I asked him to meet, and he reluctantly agreed.

At our meeting, I explained that I had taken no money and worked on *No Nukes* because I was concerned about the danger of nuclear energy. Besides that, even if the film made millions, all the money would go to various anti-nuclear groups—I couldn't make a penny from it.

He nodded, saying he would take that information into account and get back to me. He then surprised me by admitting that it was Barry Gray who had alerted him of this "serious problem."

This all took place on a Thursday. I had Malcolm McDowell booked for that Sunday, but on Friday, I was told over the phone that after seven years, I was finished. I asked them to let me sign off, to give

me the chance to thank the station and my listeners. My request was turned down.

Barry Gray had waited for his chance, and now he had finally had his revenge. I was temporarily heartbroken. But I knew I'd been right to go with my gut and turn down co-hosting his show.

Years later, I would go back on the air with *MovieTalk* on WOR Radio. But too much time had gone by, and I had lost the excitement and enthusiasm. After about two years, I gave notice and left.

Thomas Wolfe had been right: you really can't go home again.

cruise control

Over the years, I spent a lot of times on ships—mostly cruise ships. My first cruise was on the Rotterdam, owned by the Holland America Line. As you can imagine, it was a Dutch ship, and most of the crew were from either Holland or Indonesia. (Indonesia had been a Dutch colony, and I guess despite its independence, it provided lots of labor for Holland America.) Having recently produced *Ten from Your Show of Shows* with Milly, I was invited to speak about the film on board after it was shown. For that, Milly and I were permitted to travel for free for a week in the Caribbean.

The onboard theater was beautiful, with hundreds of seats and state-of-the art equipment. I was very excited about explaining how Milly and I had come up with the idea of making the film, how we'd chosen the sketches, and our work with Sid Caesar and Max Liebman.

The weather was beautiful the day of the screening, which was scheduled for three p.m. It ran for ninety minutes, and I got to the theater right before four-thirty p.m. Then the lights came up...and there were only five people there, out of eight hundred on board! Two

of the five were from the kitchen staff; the other three were passengers.

I got onstage and asked the five to come down to the first row, where we had a lively discussion. It was clearly a disappointment. But Milly and I ate well, slept well, and visited some islands—while paying nothing. All and all, a big plus.

The second time I went, it was for what was called a "jazz cruise." It was again on the Rotterdam, again to the Caribbean, and again with Milly. It lasted one week, and here was the entertainment: Count Basie and his orchestra one night, Lionel Hampton on the next, Oscar Peterson on the third, Cannonball Adderly on the fourth, and two singers—none other than Sarah Vaughn and Joe Williams—on the last. Each evening, for five straight nights, one of these great jazz artists was entertaining us—and they all performed two shows a night, at six-thirty and eight-thirty p.m.

I made a deal with our waiter, and each night at six o'clock Milly and I would both run down, eat quickly, and go to the six-thirty show. Then that audience would all leave and go to eat, and we'd stay in our seats. Then the folks who had eaten during the six o'clock seating came in for the eight-thirty show. We were the only two people on board who saw both shows each night—and they were sensational.

* * *

My strangest experience on the high seas was on a cruise called "A Cruise to Nowhere." New York City was about to get a new newspaper, *The New York World*. The owners decided to rent the brand-new *Queen Elizabeth II* for the weekend and invite important advertising clients to join them. I was then working for the Walter Reade Organization with all its theaters, and while the major film studios paid all the advertising costs, the New York City first-run theaters placed all the ads—so (forgive the pun) on paper, we were the client.

There was gambling on board, along with lots of fine food and drinks. Many people Milly and I knew from the New York streets were now with us on the ocean. We embarked on a Friday night—then

returned Sunday afternoon, having gone up and down the Atlantic Ocean to nowhere. And when we disembarked, we were all given the very first *New York World*.

Now here is the strangest part of the story: they never launched the newspaper. After renting the *Queen Elizabeth II* for the entire weekend and lavishly entertaining more than five hundred people, the paper's owners were never heard from again. That Sunday paper we were handed on our way off the ship was the first and last time they printed a newspaper, and I was never able to find out what happened afterward.

*** * ***

During the mid 1980s, there were great cruises to Shanghai, Beijing, Pusan, Korea, and Japan. My mother had travelled to Europe and throughout the United States and Canada, but had always wanted to visit mainland China—and it seemed now was her chance. My father had died a few years before, she was now a widow, and one of her female friends agreed to go with her.

They planned the trip for a year. But two months before they were to leave, my mother's friend passed away. My mother was crestfallen, both about the loss of her friend and the loss of her chance to China; she didn't want to go alone.

I told her I'd go with her. She demurred, pointing out that it would be almost four weeks that I would be away. But I insisted. I owned the company I worked for then, and I was sure my wife at the time, Beverly, would want to go too. On top of that, I told her, I wanted to pay.

Mom finally agreed, and so did Beverly. Then one day, before we started making the preparations, Mom called again.

"You're going to get all my money when I die," she said. "So since I consider you a smart boy, how do you think I'll be happiest spending it: now, or leaving it to you?"

Mom ended up paying, and it was a great trip.

paramount pictures

Throughout my business career, I had one goal: I wanted to run a major studio. With this goal, I had produced my first feature film, worked at the ABC network, syndicated movies, and been an exhibitor. But most importantly, I had taken the Ziegfeld Theatre from white elephant to the highest-grossing theater in the U.S. (not counting the Radio City Music Hall). In one year, we had played *That's Entertainment*, *Earthquake* (with Sensaround that shook the theater) and *Tommy*. We had grossed an average of $60,000 a week—more than $3 million that year. For its time, it was a remarkable amount of money, and in the business I was hot. Four studios came after me, and I experienced the famous Warhol fifteen minutes of fame—but only within the film business.

All of those offers were for production vice president, and all of them required that I move to Los Angeles. I was ready to leave my comfortable home at Walter Reade, but not to move to L.A. I disliked the city and what it did to people from New York; somehow they changed, and not for the better. Living and working in a stilted atmosphere, they became stilted. Obviously, it didn't happen to all of them—but far too

many. The importance of status—their cars, their houses, their tennis courts—was a strong undertow for many. I was aware that I could very easily be swept up by that undertow, and I was frightened of it. So I turned down all of those offers.

Barry Diller, then the head of Paramount, asked to see me. Knowing I wouldn't move to Los Angeles, he proposed that I work three weeks in New York and one week in Los Angeles per month. He himself had to do two weeks in New York and two weeks in Los Angeles, because the owner of Paramount Pictures at that time was Gulf & Western, which was headquartered in New York.

He made me an offer I couldn't refuse.

My contract stated that I report to Barry. Very soon, he let me know that someone I knew well was joining as the new president, and he, Barry, would now be chairman of the board. The new man was David Picker, a former president of United Artists. I was comfortable about now reporting to both of them.

My very first week, Barry called me into his office and said he wanted me to fly to Rome in two days and screen a new film, *1900,* starring Robert DeNiro and Burt Lancaster. It was directed by Bernardo Bertolucci, an Italian director who had achieved worldwide fame by making *Last Tango in Paris,* starring Marlon Brando. Because of my background at Walter Reade with Bergman, Fellini, and Truffaut films, I was being sent to convince the maestro to cut his film for the American audience. As it was, his film ran five and a half hours and took the whole day to screen with only a lunch break; his contract stated that the running time could be no longer than three hours and fifteen minutes.

At the end of the long day, I met with Bertolucci in the back of the screening room. Upon hearing that we needed a shorter version for the United States, he turned around and walked out to a waiting car. We never met again. I admit I had not responded well to the film, and eventually it was released in a three-hour, fifteen-minute version. It did very little business, but it made for quite a first week in my new job with a major studio.

george c. scott

An ex-marine with a reputation as both a drinker and a brawler, George C. Scott was a great movie and Broadway actor, and a good friend of mine. His most famous film roles were starring in *Patton* and co-starring in *Doctor Strangelove*, for the former of which he was nominated for the Academy Award for Best Actor. When he was nominated, he stated that he didn't believe in comparing and competing with other actors, and wouldn't accept if he won. He won anyway—and, as promised, he refused the award.

George was unique among the major movie stars that I knew. He actually asked how *you* were and what *you* were doing. I know this sounds like a knock against movie stars, but that's not my intention. Without sounding like an apologist, they often just don't have the time. Their lives, their whole existence, is about them. It's a very heady wine, and most people gladly drink it. Some stay sober, but most are surprisingly unhappy. But that's a whole other story.

George and I had first met on my radio show. He and his wife, Trish VanDevere, had gone across the country publicizing a movie they owned

and were starring in, *The Savage Is Loose*. Mine was the last show they were doing. They stayed for hours, and we became friends.

Because of Trish, I saw George a lot for a while. We all took offices together in Los Angeles at Tony DuQuette Studios, which were off Santa Monica Boulevard and at one time had been a silent movie studio. Our offices were surrounded by trees and beautiful flowers and bushes. It was like a private oasis. (Anne Kramer was my assistant. She was an exceptional right-hand person who kept the office running smoothly. At one time she had been married to producer-director Stanley Kramer, a true dynamo. Working with me, by comparison, must have been a walk in the park.)

George was a very complicated man. He had plenty of demons, but when sober, he was a gentle and concerned friend. He was very much against my going to Paramount, for example; he felt I was totally miscast for any major studio. I remember walking with him around his beautiful home in Greenwich, Connecticut. He tried hard to dissuade me from taking the job. But I had made up my mind, and when he realized that, he relented. His last words on that subject were, "I hope I'm wrong."

<p style="text-align:center">* * *</p>

I was surprised when George called me to have dinner one day. That was very unusual for him. He had never called to have dinner; either Trish called, or we would go out after one of his performances. So I felt something was up.

As it turned out, George was rehearsing a Broadway play and knew of my friendship with the director, Arthur Penn. He wanted me to talk to Arthur on his behalf. He was frustrated and unhappy that Arthur wasn't giving him any direction. George was strong, quite sober, and angry.

I said I'd see what I could do. I realized, even while George was venting, that there was very little or nothing I could do, but he was powerful, and—well, you just had to have been there.

So I met with Arthur. Having absolutely zero to do with the show—which, incidentally, was the original *Sly Fox*—I really didn't know how to approach the subject. But Arthur did.

"Kid, I think I'm driving your friend George crazy," he said.

"Really, Arthur?" I asked ingenuously. "How come?"

"Well, he's looking for some direction."

"Well, why not give him some?"

"Listen, you're talking about one of the greatest actors in the world," Arthur said. "He'll find his character, and it'll mean much more when he does it. It'll last much longer if he discovers it. And if by some chance he can't, I'll be there. But he'll find it."

"Can I tell him that?"

"No—stay out of it."

Well, I did—and George found it, and never asked about Arthur again.

<p style="text-align:center">* * *</p>

George had grown up with a father he feared. He said to me one day, shaking his head, "Can you imagine, Julian—I was just visiting my father in the hospital. He was all skin and bones, and probably weighed ninety pounds, and sitting there I was still afraid of him."

He himself was a formidable presence. Once, when he was starring in *Death of a Salesman* on Broadway, we made plans to have dinner after the show. He had also directed the production, and portrayed a great and tragic Willy Loman himself. The only problem with the production was that when Willy wants to keep his job and goes to see the boss's son, who now runs the company, George was so powerful and angry in the role that the man who played the son looked like he would have given up his company just to get out of his office alive.

It was perhaps to dial down this ferocity that George had decided to play Willy bald. When I met him backstage, I pointed to his head, telling him that he'd forgotten to take his bald cap off.

"No," he said quietly, "I shaved my head for the role."

And off we went to a nearby restaurant.

During the meal, I remember the autograph hunters were afraid of George. They hovered near the booth, trying to work up the nerve to

approach. In the middle of telling me a story, George put up his hand like a traffic cop: *Stop*. The autograph hunters all froze in their tracks, then fled.

George never missed a beat in his story.

Once we were alone, I asked George to tell me his favorite movie role, sure that I knew the answer would be *Patton*. Without a moment's hesitation, he said it had been *Dr. Strangelove*. As I've said, a complicated man.

<p align="center">* * *</p>

George and Trish came to the wedding reception held in Los Angeles when I married Beverly, my second wife. I once painted Easter eggs with them in Connecticut, too, and they asked me to fly to Los Angeles and give them notes on a two-character play they were appearing in. In addition to being on my radio show together, they came on separately as well.

George once made a surprise entrance on my show while I was live on the air. The guest at the time was James Farentino. George was appearing with him, and came by to give moral support. When I cut to a commercial, he said, "Trish is out of town. I hope it's okay that I came unannounced."

I was thrilled.

<p align="center">* * *</p>

The most memorable time I had with George was at the BelAir Hotel in Los Angeles. Trish, George, Beverly, and I were having dinner, and I don't normally drink, but we were all so relaxed and enjoying ourselves so much that I started to imbibe—screwdrivers, and a lot of them. So many, in fact, that at the end of the evening, George and I found ourselves, arms around each other's shoulders, singing songs of the '40s as we strolled down a beautiful garden path.

I was having a great time, and at the end of the third or fourth song, I said, "This is great. I have to do this more often."

Suddenly, George grabbed me, with his two big hands on my shoulders.

"Listen to me," he growled. "This is *not* great. I don't want you thinking drinking is great. Promise me you won't do this again."

No one on planet Earth ever sobered up so quickly. With George C. Scott holding me tightly and staring into my eyes with his great power, I promised quickly—and I never did get drunk again.

paramount, 1976–1977

The Paramount job encompassed lots of aspects. As vice president in charge of worldwide acquisition, I would be contacted by independent producers as well as companies with finished films from all over the globe, some of whom I knew from my years at Walter Reade. And as the only vice president of production in New York City, I had many motion-picture producers, directors, and writers calling to submit books, plays, and screenplays for my consideration. It was a hectic time.

I told all potential sellers the truth: I couldn't okay any deal. All I could say was "No," or "I'll get back to you." But here's the funny thing, the business was filled with people trying to impress each other and exaggerate their importance, and somehow it got into some people's heads that by saying that, I was showing that I must really have power. (Obviously, few people admitted the truth of their position—and after all, I was a *vice president*.) Some reverse or perverse thinking prevailed, and they would wink or smile as if to say, "We get it—we know what you're *really* saying."

Once, Barry let me know that a Paramount film was going to be

shot in New York City. It was a low-budget film, and he wanted me to represent Paramount on location in Brooklyn. It starred mostly unknowns, except for a young TV actor who had been one of five co-stars on a successful series.

On the first day of shooting, we were shocked at the size of the crowds that gathered. We were unable to shoot on the street, there were so many people. So much noise—too much excitement! We needed crowd control. We had to call in security and finally the police department.

The young man causing all the tumult, as it happened, was John Travolta. The TV program he was on was called *Welcome Back, Kotter*, and the film we shot would become *Saturday Night Fever*.

I had absolutely nothing to do with its success. My only contribution was that occasionally, after a scene where there was a lot of cursing, I would go talk to John Badham, the director, and would remind him that for TV, we'd need less salty language. (There was no pay TV or basic cable then, which meant less graphic language was mandatory.) He always complied.

David Picker asked me to accompany him to meet Robert Stigwood, the producer of *Saturday Night Fever*. We were going to hear the music that was being proposed for the soundtrack. We listened, thanked Stigwood, and left. David asked me what I thought; I told him I loved it personally, because it reminded me of the early rock 'n' roll I had grown up with in the '50s, but this wasn't the popular music of the mid-'70s and I felt it had no chance.

Well, that soundtrack became a number-one album. It made the Bee Gees a worldwide phenomenon. And the film was a big hit.

That same year I met with Alexander Salkind, an independent producer in Cannes. He gave me a script to read by Mario Puzo, Robert Benton, and David Newman, and suggested we meet again in two days.

I read the script and loved it. It was based on a famous comic strip. David Picker was flying over to join me in Cannes, and when he read it, he didn't share my enthusiasm. Besides that, he didn't want to be in business with Salkind.

So, sadly, we passed on the film—which you'll know by the name *Superman*.

Another time, Mike Nichols called. He wanted to talk to me about a musical he was presenting but not directing, and said he would bring the director and composer to present the show. The songs were played and sung, and much of the script read for us. I promised to get back to him soon.

I was excited. The musical was based on another comic-book character, Little Orphan Annie, and was called *Annie*. I didn't fall in love with the show, though I liked the song "Tomorrow." But I was excited about being involved with Mike Nichols, one of the most important directors in the world. And the deal was nothing for a major studio, even in the mid-'70s" one-third ownership for $300,000.

Still, I couldn't get a second new Paramount president to agree—and we passed. (More about his tenure later.)

This seemed to become a pattern for me at Paramount. Whatever I wanted was turned down. Some productions turned out to be huge hits; others were moderate successes or moderate failures. There were no disasters or bombs, as with many executive records.

But I was unhappy almost all of the time.

"mikey and nicky"

One day, Barry Diller called me into his office and told me there had been a lawsuit on a Paramount film that had now been settled. The film was called *Mikey and Nicky*. It starred Peter Falk, John Cassavetes, and Ned Beatty, and was written and directed by Elaine May. Barry explained that it had been made under the previous administration, and he wanted me to screen it.

I did, and I found it a powerful and disturbing film. While it was clearly a drama, it had some real humor in it. But those who knew Elaine May from her previous films—comedies like *A New Leaf* and *Heartbreak Kid*—would be surprised and possibly shocked at its starkness and grit.

Barry asked me how I would distribute it. I said it had to be discovered by the critics. I felt we should open it at one theater in New York and Los Angeles and go slowly around the rest of the country. He agreed and said he would keep me in the loop on the film. Knowing that kind of film was my expertise, he seemed pleased that I'd liked it so much.

In my office a few days later, I received a call from Elaine May. We had never met or even spoken on the phone, but I was so happy to be

able to tell her how much I liked her film. She told me that our mutual friend, Warren Beatty, had told her to call me—that I was okay for a studio executive. Clearly, *okay* appeared to her to be a big compliment, which made me wonder how strong the competition was among the other studio executives.

I told her there was going to be a sneak preview of her film in Washington, D.C. She requested that we not use her name in the sneak-preview ad—it was okay to use Peter, John, and Ned's names, but she feared that with her name the audience would come expecting a comedy. (I should add that besides the two previous mentioned films she'd directed, Elaine had been half of the great comedy team of Nichols & May. They had appeared as guests on many network television shows, and their own show had run on Broadway for a year to sold-out houses. They stopped performing together when they were on top, but a lot of people still remembered their comedy work.)

I promised I would make sure that they didn't use her name. But when I came to a meeting regarding *Mikey and Nicky*, I found that her name was being used in the ad after all. I told David Picker, the new president, that Elaine didn't want her name mentioned, and he assured me it was okay. I said I had recently talked to her, and she was adamant. He told me not to worry.

On the night of the sneak preview, we turned a lot of people away. At the beginning of the film, there are some very funny moments, and the audience roared at those. They were clearly having a great time. Then the film turned tough and rough, and the audience was outraged. They had been duped. They had seen Elaine's name on the ad, and though they'd had a good time at the outset, lots of things were now happening that clearly were not funny. By the end, many had exited in a huff.

Picker and some other Paramount executives and I met in the manager's office with Elaine.

"Do you know what a liar is?" she asked me immediately.

"What?" I said.

"You promised that my name wouldn't be in the ad."

I said nothing.

"I overruled him," David Picker said. "He did tell us you didn't want your name in the ad."

"You're still a liar," Elaine said to me.

Though I was somewhat exonerated, I still felt two feet tall. In the short time I had gotten to know Elaine, I was crazy about her. I had always respected and admired her talent—I had seen her Broadway show, heard and loved her records, seen her films, and watched her on TV. I had also truly loved *Mikey and Nicky,* and now I liked her personally.

She barely spoke to me the rest of the night, in the car or on the plane back to New York. I went home dejected and depressed. I had let Elaine down. And Warren. And even her ex-partner, Mike Nichols, whom I had known long before I knew Elaine.

Fortunately, Elaine eventually forgave me. I think she realized I had been put in an untenable situation. She and I remain close friends, in fact, and now I produce all her plays on and off Broadway. But at the time, I was truly devastated. It was one of the worst nights of my life.

Paramount decided to open the film at the end of the year—December, 1976. I argued against that date—this was *not* a Christmas film. Those two weeks or so were when some of the biggest grosses were realized—though generally that was true of big commercial movies, not American art films. But I lost that argument.

Elaine and I were talking again by that time, and I told her everything that was happening. Christmastime for her film was bad enough; on top of that, a tagline was used in the ad that, though certainly unique and gutsy, was not exactly going to have people lining up at the theater. The line was, "Don't expect to like 'em." Even as I write it out all these years later, I'm still amazed it was used.

Later, after I left Paramount, I was able, with the help of Peter Falk and Elaine, to gain ownership of the film and re-release it in theaters. We used a totally different ad campaign, along with some unbelievable quotes from major critics at the time. Vincent Canby of *The New York*

Times re-reviewed it and said he had been mistaken when it was first released. We did business in major cities, and many years later the brilliance of the film was finally recognized.

flirting with the paranormal

I met Shirley MacLaine when she was a guest on my radio show and, as sometimes happens, there was instant chemistry. We really hit it off and started to pal around together. When she was in New York City, we would go on what we called "movie marathons." We'd begin with lunch, then catch a two o'clock movie, followed by another at four-thirty. It was now time for dinner. Generally, we would go to one more film around eight p.m. It was a lot of fun.

Shirley is a person who can do many things well: act, sing, dance, write—even cook! She's truly "a woman for all seasons," and someone whose friendship I've long treasured. When I was at Paramount, Shirley and her then boyfriend, the writer Pete Hamill, brought me a screenplay Pete had written about another dynamically talented woman, Amelia Earhart. I liked it a lot, but was unable to get it green-lit. I know Shirley would have been terrific as Amelia.

Shirley's interest in psychic phenomena is well known. At that time, I had not been much of a believer in that sort of thing. But when I became friends with Shirley, I came into contact with it first-hand.

114

When I was invited to go to China, I was in a bookstore at the L.A. airport before departure. As strange as this will sound, I was *propelled* to a stand where one of Shirley's books in paperback, *Out on a Limb*, was being sold. There was no one in the store but a cashier behind a desk. Something like that never happened to me before or since: it really felt as though something was guiding me to the book.

I bought the book, slept on the plane, and was therefore wide awake later in my hotel room in Beijing. I started to read Shirley's book and couldn't put it down; even before I finished it, I was anxious to talk to Shirley about so many of the things I was reading.

So when I finished the book, I thought I would try to phone Shirley. I thought I remembered her home phone number in Malibu. At that time, all of the numbers following the area code began with 4-5-6; I knew the next four ended in two zeroes, and I was pretty certain of the missing two digits to complete the call. So I dialed—and a female voice answered the phone. I asked to speak to Shirley, and the voice murmured, "Who's calling?" When I said my name, she replied, "Julian, it's Shirley. I never answer this phone, but this time I had a feeling I should."

We talked for over an hour. She was shocked that I was calling from China; she had been there years before to do a film with Claudia Weill called *The Other Side of the Sky*. For its time, it was an eye-opening documentary. I hung up, feeling great—and more than a little uncanny—about having reached her the way I had.

This story has a rather surreal ending, too. About fifteen minutes later, there was a loud pounding on my door. I opened it, and there stood a large man and a large woman with scowls on their faces. The woman thrust a piece of paper at me, then said in broken English, "You... must...pay." It was a bill for my call to Shirley.

"Of course I'll pay," I said.

"Now!" she yelled.

"Now?"

She nodded. I took out some money and paid. The large man never said anything. It was an expensive call, but worth every last yuan.

* * *

That kind of thing just tends to happen with Shirley; I've seen it more than once. Years later in New York City, she asked me if I had ever put any actor under contract. I said no, but was curious why she was asking. She said she had just finished shooting a film and there was a young girl in it who she felt would become a major film star. The film was *Steel Magnolias* and Shirley was spot-on, as the girl, Julia Roberts, did indeed achieve stardom.

But Shirley hasn't been my only point of contact with the paranormal. Far from it.

As I mentioned before, I was close friends with Terry Semel, co-chairman of Warner Bros. We had known each other for many years in 1980, when he and his wife Jane hosted a party in Los Angeles that I attended.

There I met Merryn Jose and her mother, Maureen Traenor. Both Merryn and her mother were professional psychics in London, and at the party Maureen said to me, "You'll be with my daughter."

I laughed to myself, since I already knew I was nowhere near being with her daughter. I did have a few dates with Merryn afterward, but while I was interested in her, she told me she was already in a relationship.

But Maureen was right, and fourteen years later I married Merryn.

With Merryn and Maureen, I entered a whole new world. Spiritually, holistically, and metaphysically, my life changed. And because I had always been interested in and fascinated by other dimensions, I started talking with them about those kinds of experiences.

One day, early in our marriage, I asked Merryn if she'd ever heard of Betty Hill. She had, and knew of Betty's claim of having been "abducted," along with her husband Barney, by aliens.

Well, I had met Betty Hill in Tokyo years before I met Merryn, and I had found her to be far from crazy or delusional. On the contrary, she was a quiet, unassuming New Hampshire social worker. She had given me a book, *Interrupted Journey,* about her experiences, and I'd stayed

up all night in my hotel room, fascinated as I read her retelling of being on a spaceship, communicating telepathically, and being experimented on. We had been in a small tour group together, and the next day I asked her question after question. I was left with a definite conclusion: whether it had all happened or not, Betty believed it had.

So I asked Merryn if she would like to meet Betty Hill, and she said emphatically that she would. So I set out to find her.

When I found her and called, Betty didn't remember me at all. She knew she had visited Japan in 1969, but that was all. And she added, "I don't want to be interviewed, or even talk about my experiences. I'm still hounded by government officials and the news media."

I was about to give up when I had an idea. "Betty, I can prove to you that we met," I said. "Remember, we were five people on a tour bus, and we went to Mount Fuji. The guide told us that it was generally covered with clouds, so we shouldn't be disappointed—and indeed it was, and we started to drive away. Then the driver stopped the bus and started pointing and yelling to us. For just a few seconds, the clouds had cleared and we were able to see Mount Fuji right to the top."

She acknowledged that she must have met me, as we had been on that bus together. And that's how Merryn and I got to see Betty Hill, who was now a widow.

We dined together at her local seafood restaurant, in a booth that could easily have seated eight people. With only three of us there, it seemed comical.

I said to Betty, "I know you've been asked these things many times before, but we are interested, because my mother-in-law has had some unexplained experiences."

"Okay," Betty said. "Ask what you want to know."

We both began to bombard Betty with questions.

"What did the aliens look like?"

"Their eyes were very black, their lips bluish, and their skin grayish."

"Were you afraid of them?"

"Initially, I was. But the one who seemed to be in charge, whom

I called 'the leader,' kept assuring me in English that no harm would come to us. Barney, my husband, was also on board, in another room."

Merryn started to make her own inquiries. Some of them were about her mother's visitation. I sat back and waited a while before I asked, "What did they want of you?"

"Once we were aboard their aircraft, another being I called 'the examiner' said he wanted to do some tests to see the difference between him and us. The leader was in the room as well, now as an observer."

"What tests did they do?"

"The examiner took hair samples, checked my hands and fingernails, and looked in my mouth, down my throat, and in my ears. It was a full physical. They were interested in my nervous system and gently used needles that didn't hurt on different parts of my body. Both of them were quite interested, especially when I would involuntarily twitch or jump when their needles touched parts of my body."

"So you were never in any physical discomfort?"

"At one point, the examiner said he wished to do a pregnancy test. He picked up a needle about five inches long and assured me there would be no pain. He inserted it in my navel, and I was filled with enormous discomfort and started moaning. They both looked concerned, and the leader immediately waved his hands in front of my eyes. The pain was gone in a flash. They then decided, to my delight, to stop all testing."

At the restaurant, we discussed other things. Years before, there had been a TV film starring James Earl Jones and Estelle Parsons as Barney and Betty Hill. She wanted us to know that she had never wanted to go public with the story; she had been afraid that she and Barney would lose their jobs. They were an interracial couple in the early 1960s in New England, and that in itself had not been a great idea to publicize. They had both been seeing an analyst. Barney was having recurring nightmares, and Betty was agitated and found herself upset a lot through the dreams she was having. Under hypnosis, working with a psychiatrist, their experiences were revealed; the story may initially have leaked from the psychiatrist's office to a Boston newspaper. That, however, was two

years after the incident had occurred.

After our meal, we went back to Betty's house. She wanted to give us a copy of her book, *Interrupted Journey*. We noticed (but didn't comment on the fact) that her home was painted a bright canary yellow on the outside.

As we were saying our goodbyes, she said, "I want you to know, I found the whole UFO experience one of the most exciting parts of my life."

She told us that before she departed, she had asked the leader, "How can I find you again?" He had replied, "Don't worry. We'll be able to find you."

Betty said, "I painted my home bright yellow so they would have no trouble finding me."

Later that day, we looked in Betty's book and found inscribed:

To Julian and Merryn,

From Mt. Fuji to Ports N.H.

Good to see you again.

Betty Hill

backstage with george c. scott

When so many of your friends are part of the same industry, it can be difficult not to mix your business and personal life. I tried hard to keep those things separate, but particularly during my time at Paramount, a lot of extreme demands were made of me, some of which threatened to disrupt my friendships with other people in the movie business. One example of this had to do with George C. Scott.

I have vivid memories of visiting George backstage when he appeared on Broadway in *Sly Fox*. (George liked me to "pop in whenever I was in the area," as he had done one Sunday night on my radio show.) He had recently starred in a soon-to-be released Paramount film, *Islands in the Stream*. It was based on a book by Ernest Hemingway and had been directed by his *Patton* director, Franklin J. Schaffner, whom George affectionately called "that stubborn Dutchman."

The issue was, George had the right to approve or disapprove any image used of him, and though he was prominently shown in the main ads and the poster, the Paramount advertising executives had so far been unable to get an okay from him. Barry Diller, then chairman of

Paramount, knew of my friendship with George, and asked if I could get his approval of the ads. Reluctantly, I agreed; and armed with a large poster and a number of full- and half-page ads, I dropped by to visit him, entering through the backstage door as usual.

Backstage was always a hub of activity. Stagehands, stage managers, understudies, and actors all scurried around, waiting for the curtain to go up. Some actors did warm-up exercises but George would just sit in costume, night after night, quietly playing chess with his dresser. I marveled at how he could get up from the table with no preparation, walk onstage and still be sensational. Elia Kazan once said to me he'd thought in the '50s that Brando was the best American actor; now, decades later, he felt George was.

At intermission, I showed George the ads, and he asked what I thought. I said I liked the image being proposed, because he had a white beard in it and looked a lot like Hemingway. I was nervous about how he would respond, but George approved the ads on the spot. I asked him to sign his initials to them, which he did, laughing.

I was relieved on all counts. I had been successful in my mission for Paramount, and my friendship with George had not been compromised.

il professore meets the kid

Sometime during the mid-1970s, there was a very successful concert-promotion company in Buffalo, New York. When major acts like Frank Sinatra and The Rolling Stones would only play a handful of dates in the United States, the company was almost always included.

One day, I met with a young man who was one of the owners of the company. He said that because of his extensive contacts in the music business, he had purchased two movies to distribute in America. One was a film with Paul McCartney performing with his group Wings; the second was a British comedy called *And Now for Something Completely Different*. It seemed to me that the young man was on his way to offering me the distribution rights in some sort of a deal.

I couldn't have been more wrong. The purpose of his visit was in fact rather surprising: he was wondering if I would teach him the motion-picture business.

I was taken aback at first, and then learned that he already knew of my teaching background. (He later ended up attending many of the lectures I gave at my own class series.) I agreed to tutor him, but I set

some ground rules. He could sit only on the couch facing me, and could listen to all my calls quietly, take notes, and ask questions after I hung up. I also permitted him to attend my office meetings. And finally, I agreed to introduce him to many executives, some of whom could help him then and others in the future.

Why did I do it? Was he offering me anything in return?

Not at all. I did it because I liked him. He was a street kid from Queens, and I was one from the Bronx. He was smart and funny, and like me, he loved movies. When we first met, he was on rock 'n' roll time, which meant he was always late. It took me refusing a few times to meet with him, but I did break him of that habit—at least with me. (On our last meeting a few years ago, he told one of his employees, "You think I'm tough? Try working for him.") He never offered, nor would I have accepted, any money. He was willing to do pretty much anything I asked of him, but frankly there wasn't much to do. Most times we would screen films together and go to lunches.

In the years we worked together, I never saw his dark side. He had a lovely girlfriend, and only seemed to want very badly to be in and learn the film business.

One day, he asked me if I wanted him to get my radio show sold in Buffalo. I said I did, and he quickly made it happen. He then proceeded to sell it in other cities like Boston, Providence, and even Jacksonville. In a way, that's what I got in return for mentoring him: he distributed an hour-long version of my radio show. But I clearly had helped him. Over the years, every time we met—which wasn't all that often—he would shout, "Il Professore! You were the one who taught me the film business."

Eventually, I ended the relationship with him. I had introduced him to the owner of a feature print laboratory, who went out of his way to help him. When my mentee was late in paying his bills, the owner called me, very upset. "I extended him credit only because he was *your* friend," the man said. After we spoke, my mentee paid the bill, but I was annoyed at how he had behaved. It struck me as surprisingly disrespectful.

But that behavior didn't stop him from rising high in the business. When we had first met and I was at Paramount, I also had a company that still represented Kazan's movies, which I'd named Charlou, after my mother and dad—Charlotte and Louis. One day, he came to me and asked if I would mind if he did the same thing. His parents were named Miriam and Max, and he wanted to call his company Miramax. I readily agreed, surprised he felt the need to ask.

I never saw, or even heard about, any of what he was later accused of. He was clearly a guy from the hood, but I was surprised and saddened to read about the extent of his abuse.

In all those years, never in my wildest imagination did I expect Harvey Weinstein to hit either the heights he attained, nor the depths he descended into.

the end of the line

The time I spent at Paramount Pictures would turn out to be the two worst years of my life. But that wasn't as much about Paramount as it was about the studio system itself. All the studios, despite producing movies, were a pure corporate structure where perpetuating your power and trying to expand it was the coin of the realm.

It wasn't completely about money; most of the people at the top had plenty. In fact, when I complained, I was reminded that I was the third highest-paid executive at Paramount. Nor was it that money didn't count—or stock options, or bonuses. But nothing was more important than keeping your power and, if possible, expanding it, no matter whom you had to hurt. I experienced more duplicity in those two years than in all the other years of my business life.

I did recognize one truth during that time: it was hard for me to exist at a major studio. I felt I might have had the knowledge and the taste to make good films, but I hated the system: the lying, the chicanery, and the fact that making movies was not the priority. Obviously, moviemaking was a factor, but it was just one more ingredient in an inedible soup.

So one year into my two-year contract, I asked Barry Diller to make a settlement.

Barry was and remains the smartest executive I've ever met. He was honest, to a fault sometimes, and had a persuasive way about him. Throughout my entire time working for him, I admired him and found him truly funny. He had a gifted sense of humor and a great shy smile. I don't think in those days he laughed or smiled a lot, but we did do that a fair amount together. However, he absolutely refused to let me out of my contract.

"Barry," I said to him, "we often settle contracts with someone for fifty cents on the dollar. That's all I want. Just let me out."

He shook his head. "I'm keeping you until the last day of your contract," he said. "I'm going to convince you that this is where you belong."

A few days later, however, he called me into his office. "If you're really serious about leaving," he said, "you should let Michael know."

Michael Eisner had recently been named the new president of Paramount Pictures. Barry was now chairman of the board, and David Picker was vice chairman. My contract was specific: I only reported to Barry Diller. I wanted that stipulated, because Barry had been my champion. He wanted me, as he put it, "under the tent with him." And I knew enough about studios to know to stick with the guy who hired you—especially if he's top dog. I had earlier agreed to add David Picker as well, but that, I figured, was the end of it.

As part of this whole situation, however, Barry wanted to amend my contract to read that I would now report to him and Michael—no longer Picker. The idea made me nervous. Michael was smart, verbal, and charming, but we had no chemistry together. To this day I'm not sure why, but we were simply not made for each other. (It was also Michael who had turned down *Annie*.)

Reluctantly, I agreed—good team player, and all that—and into Michael's office I strolled.

"Barry wants me to tell you that at the end of my contract I'm leaving," I said. "Actually, I want to leave now but Barry won't let me."

"Why are you leaving?" he asked.

"Because I'm not happy."

He leaned in. "Who is it?" he asked. "Fox? Columbia? Universal?"

I was stunned by his reaction. The concept of *happy* made no sense to him—it had zero to do with anything! Ah, but another studio—that's the ticket. Why else would I be leaving?

And then a strange thing happened. Norman Weitman, whom I had known for years, was in charge of sales, and had originally recommended me to Diller. He was temporarily out on sick leave, to be gone for a few weeks, and Barry asked if I would step in and run sales in his absence. I agreed, and started working with the various division managers around the country to set up our next three big films: *Marathon Man*, *King Kong*, and *Black Sunday*.

(Incidentally, I was also contacted at that time by Alan Parker and David Puttnam, who had directed and produced a film that was sitting on Paramount's shelf. It starred a young, relatively unknown actress named Jodie Foster, and was a spoof on gangster films of the '30s. Kids were playing all the roles; their machine guns shot whipped cream instead of bullets. The film was *Bugsy Malone*, and on David and Alan's request, I made sure that if a theater wanted *Marathon Man* and *King Kong*, they were "encouraged" to take *Bugsy* too. Needless to say, I quickly became David and Alan's new best friend.)

There was huge excitement about the new *King Kong*. Despite pretty bad reviews, it was a huge hit and ushered in a new star, Jessica Lange. But before its release, a top-secret sneak preview was held in Denver, Colorado. I flew in on the Gulf & Western private plane, and watched the audience go crazy for the film and some of its great special effects.

After the sneak, we were all in a hotel suite, looking over the executive preview cards. By now, *Marathon Man* was a big hit, the new *King Kong* looked great, and *Black Sunday* (though its terrorist-attack plot wouldn't end up resonating with audiences) was rumored to be the best of the three. We were hot as a film company, and for the first time in a long time, I was pretty excited to work there.

Then Barry called me aside and said he had some sad news: Norman had died. I was in shock. I had known Norman most of my career, and I knew his wife and two daughters. His death was sudden; he had been only forty-eight years old.

Within minutes, I went from a true high to a real low. I went into the bathroom and sobbed—for Norman, for his family, and for myself. Truly unhappy, I now saw how unsure I was of what was going to happen next.

I washed my red eyes with cold water until they were clear, then walked back into the suite. Barry beckoned to me.

"I want you to call all the division managers now, and tell them what's happened," he said.

It was then past midnight Denver time. "I'll be waking most of them up," I protested. "Can't it wait until tomorrow?"

"No," he insisted. "They should hear the news from you—their boss."

Uh-oh, I thought. *I don't want to be their boss, I want to go back to production!* I had already spent too many years in sales and exhibition. But I did as I was told, waking and shocking most of the division managers. They all asked if I was taking over, and I said I didn't know. It was true that I didn't, but I had a pretty good idea of what Barry was intending would transpire.

Sure enough, back in New York, Barry asked if I would be the new head of sales. I said no, but told him I had some great suggestions of people from the outside whom he could hire. He demurred, saying he wanted to keep it within the company, and asked whom I would suggest. I told him I thought there was only one person who might be able to do it, but though he was now our West Coast division manager, the guy had spent most of his time in Canada.

That man's name was Frank Mancuso. I can't say he got the job because of my say-so, but he was the only person I recommended. He went on to run two studios: Paramount and, later, MGM.

* * *

Given the chance to be in charge of a studio, I probably would have been one of the biggest flops—if not one of the biggest successes—in film history. Here are some of the things I would have tried to get implemented.

At that time, movie critics really mattered. Maybe too much. As a result, I would have never used their names in the newspaper ads; the ads wouldn't read *Pauline Kael* or *Judith Crist*, they would say *The New Yorker* or *New York Magazine*. The critics possessed too much power, and I would have hoped to spark a trend that the other studios might follow.

I also wanted to allocate part of every year's production budget for to eight to ten new directors from theater, television, or film school, to make short films of ten to twenty minutes each. From that group, I'm sure we would have found one or two really talented "new" film directors, and any one of them would then be assigned a low-budget film next time. But even forty-five years ago, the studios pretty much only wanted to produce films that had big breakout potential.

Finally, I wanted to make every vice president at the company be involved at least once in the making of a film. It was shocking to me that almost no executive at any studio had ever made a film. Many had never been in an editing room, been involved in color correction, sat through a sound mix, or even watched a whole scene being shot over and over again. It never ceased to amaze me, the ignorance most executives had about the "product" they were making.

Paramount had introduced me to some of my best friends in the industry, many of them lifelong friends: Elaine May, Herb Gardner, Marlo Thomas, Charles Grodin. But my two-year contract was coming to an end. I knew I wasn't going to run any studio.

It was time to figure out my next move.

what next?

Barry, as I said, didn't want me to leave Paramount. When I told him I wanted to produce films, he said to do it there, with them.

I hesitantly said yes. But then I received the contract. From my point of view, it was awful. The good news was, I was to be given a salary, offices, an assistant, and a secretary. The bad news was, my contract stipulated I could only make G- and PG-rated films—no R-rated ones.

I also had to give Paramount first look at everything I did—which was quite fair. If Paramount turned it down, I could go anywhere else I wanted—which was eminently fair. If any other studio or venue picked up the proposed production, they would be charged half of Paramount's expenses that had been paid to me—which was totally unfair. In essence, if I went to Columbia or Fox and they wanted to work with me on any project, they had to pay Paramount a premium for the right. That didn't count the costs they would have to cover for whatever book, play, or screenplay I would be submitting.

Needless to say, I declined to sign.

Dick Zimbert, Paramount's senior vice president of business affairs,

called and said we should meet. We scheduled an early dinner and for quite a while, we talked about everything except why we were meeting. (That seems to be how lunches and dinners go in the business.)

Finally, he said, "Look, just sign the contract. Barry wants you with us. It'll be great."

I explained a half-dozen problems I had with the contract. As I continued into the seventh, he interrupted me.

"Julian," he said, "we all know you march to a different drummer."

"Dick," I replied, "I'm not even in your parade."

We parted with nothing resolved. Two days later, he called to warn me that Paramount would sue me if I didn't sign. They had already begun building my suite of offices, and had hired the assistant I wanted. This put me in a funk. I was proud of my reputation. I had been working for fourteen years; I had never been involved in a lawsuit. I didn't know what to do. I couldn't sign that contract, but I was afraid of getting sued.

Elaine May had been married to an analyst, and suggested I see his friend, another analyst that she knew. His name was Milton Wexler, and his patients were a who's who of Hollywood, including studio heads. Elaine said he would know what to do.

I was in a true tizzy, so I called and set up an appointment. In his office, Milton asked me a simple question: "What are you most concerned with?"

"My reputation," I said. "I'm afraid of being sued and having it ruined."

Milton smiled. "Oh, if that's the case, no problem," he said.

"What?" I screamed.

"I'm sure they won't sue, but let's say I'm wrong," he said. "Think of it. It'll *make* your reputation. You're so talented and smart, Paramount will sue you in order to keep you. And again—by the way—it won't happen."

He was right. They never did sue me. I was so relieved.

When I asked Dr. Wexler how much the session had been, he told me sixty dollars. (That's how many years ago this was!)

I paid him with three twenty-dollar bills, saying, "This is the best sixty dollars I ever spent."

now what?

At this point, I was thirty-six years old—a man without a company. I had to find the next place: some new idea, the next move. I'd had a great beginning and showed lots of promise, and now I had no idea what my future would be.

I received a call from David Begelman, the president of Columbia Pictures, who said, "I heard your deal with Paramount fell through." (It had only happened the week before.) "I want you to fly to Los Angeles and have lunch with me next week," he went on. "My office will arrange everything."

Within hours I'd received a first-class ticket at my home, along with the name and telephone number of the limousine company in New York City that would take me to JFK Airport and the name and telephone number of the limousine company in Los Angeles that would pick me up. I would be staying with a friend, so all my costs were covered.

As was my habit, I arrived at lunch a few minutes early. David arrived a few minutes later. As we shook hands, he held on to my hand, looked into my eyes, and said, "We will not leave this table until we've

made a deal for you to produce films at Columbia."

I was a goner. After the horrendous past two months dealing with Paramount, someone actually wanted me—so much so that they'd flown me out first-class, limousines included, and were now demanding that we make a deal!

And the deal David and I negotiated was a very fair and lucrative one. (Once again, to show you how long ago it was, my contract had to be approved by the Columbia board of directors. Why? Because all contracts over $100,000 needed their approval.)

It was a two-year contract. I received a large producer's fee and fifty percent of the profits. Third parties' share (the stars', director's, and writers' profits) would come out of my fifty percent, but I had a floor of 22½ percent that was the least I could earn.

I was thrilled, and a few days later David called me to say, "Good news. The board approved your deal. You'll receive your contracts very soon."

Then came the shocking news.

"Julian," he went on, "I will be leaving the company. But don't worry, everyone is excited that you'll be coming here."

"But David, I'm coming because you're there," I said. "I want to work with you."

"I know. But Alan is here"—Alan Hirshfeld was chairman of the board—"and he's really excited you're joining the company."

This was very troubling to me. I had really been looking forward to working with David. He was the only man I ever met who made you believe, in any meeting, that you were all that mattered: Russia and China might have been at war, but that would have been secondary to what was happening with you at that moment. Earlier in his career he had been a wildly successful agent, and I could see why.

He was very mysterious about why he was leaving. I figured he was going to another studio as chairman—but it turned out he had been accused of forging checks. He was rumored to be a huge gambler. A little while later, despite the charges, he took over MGM Studios, then left and ran a company called Gladden Enterprises. (His troubles would

continue to plague him, however: ultimately, he ended up in a hotel room alone and shot himself to death.)

So now my head was spinning. David was leaving—but a contract was coming. I'd lost my mentor—yet Alan wanted me there.

And then the contract arrived. It was worse than the Paramount contract! So many restrictions and requirements. Again, I went into a funk. Leon Brachman, an attorney for Columbia, called me and assured me that I need not worry about the clauses.

"They mean nothing," he said. "They're meaningless. Just boilerplate."

"Great," I said eagerly. "So take them out."

"I can't."

"So they must mean something."

"No, no, Julian. They don't. Ray Stark"—that was Columbia's biggest producer—"signed it."

"Really, Leon—sight unseen, just give me half of Ray's deal, and I'll sign."

Once again, I was at a stalemate. As my dance with Leon was going on, Columbia had paid me for two weeks. When I finally said no, I sent them back the money. (Leon called me and said that in his thirty years in the business, no producer had ever sent back any money.)

Incidentally, during those two agonizing weeks, Alan Hirschfeld called me as well. He wanted me to know how happy everyone was that I was coming—and to let me know that he too was leaving and going back to Wall Street in a new job in a month.

Next I received a call from Stephen Bach, a vice president at United Artists. He had heard I might want a producer deal.

"Stephen," I said, "right now there are six major studios. I have just alienated one-third of them. If we make a deal, I'll eventually say no, and will have increased my bad will to half of all studios. Let's stay friendly, and I'll stay at one-third."

He agreed, and found it funny.

But I wasn't laughing. I was back to square one, and starting to wonder where I would end up.

My personal saviors, during this time, were Herb Gardner and Elaine May. Herb and Elaine both took me out to dinner and encouraged me to start my own business. I was frightened; I'd always had a home and a paycheck. But I never forgot what they said: "You open up the store, and we'll help you fill the shelves." So it was two fine writers, who both believed in me, who gave me the confidence to try it on my own.

And as luck would have it, I would soon get the chance to do it.

<p style="text-align:center;">* * *</p>

I flew to Los Angeles for some meetings regarding possible productions. After a disappointing breakfast at the Beverly Hills Hotel, I was walking through the lobby on the way to the parking area when I bumped into an old business friend, Allen Klein.

Allen owned a company called ABKCO. He was a smart, savvy record executive, and was also involved in the film industry. At Walter Reade I had done a lot of business with his company, and he played all his films with us: *The Concert for Bangladesh*, *El Topo*, and *La Grande Bouffe,* to name a few. He had managed Sam Cooke at his height; he had also managed The Rolling Stones and The Beatles. In his time, he was a phenomenon.

When we ran into each other, he asked me what I was doing there, and why I looked so glum. I brought him up to date with both Paramount and Columbia.

"So what are you doing right now?" he asked.

"My next meeting isn't until lunchtime," I said.

"Come with me," he replied. And I returned with him to the Polo Lounge, where I watched Allen have a large breakfast.

"Here," he said, handing me a paper napkin, "write down the most important parts of the deal you want. Let me try to advise you how to get them."

I wrote down the same needs I'd said so many times before: salary, an office assistant, a secretary, and the freedom to make films without so many restrictions.

try not to hold it against me

I don't get shocked very easily, but what he did next flabbergasted me.

He took the napkin, looked it over quickly, and calmly said, "I'll give you this."

"little me"

Just like that, I now had my first consulting job with ABKCO—my first job where I was truly working for myself. On top of that, all of my expenses were covered. I now needed a company name.

My last name is German: "schloss" translates in English to "castle," and "berg" to "mountain." I thought *mountain* was too grandiose a name for a new company—besides which, my old employer Paramount Pictures had a mountain as its logo. So I decided to make it a hill, and that's how I got the name of my new company, Castle Hill.

At times, during the twenty-eight years I owned the company, I was asked, "Are you from the Bronx?" Almost always it was because there's a street named Castle Hill Avenue in that borough. I lived many miles away from it growing up, and the name had nothing to do with that avenue. But those questioners were half-right—I was a Bronx boy.

From fourteen years of working full-time, I had a structure. I knew my job, my responsibilities. With Castle Hill, I had Elaine and Herb's support, Allen's backing, and three Kazan films to represent. But it wasn't a full-time job; I had lots of time on my hands. I needed an idea,

a structure, some kind of plan.

I had a dear friend, Bill Chaikin, who was then president of AVCO Embassy Pictures. During a dinner, I told him about my new company and my desire to produce motion pictures.

"We own Neil Simon's *Little Me*," he said. "Do you know the play?"

I said I did, and had seen it on Broadway.

"Well, I'll give you a free option for a year to try and get it made."

"Any chance I could have it for two years?" I asked. "It may take a while, it's been around a long time."

He laughed. "Okay, eighteen months," he agreed. "Now let's have dessert." And that was that.

But what to do now? Neil was a huge name, but *Little Me* had not succeeded on Broadway—and it was a sixteen-year-old play. I needed help.

Then I had a thought, and I set about to contact Neil. He had been on my radio show and we had met at various functions. I got his phone number, called and told him my idea, and he agreed to write the screenplay. I was euphoric.

There was a renowned independent agent working at that time named Irving Lazar. He represented presidents, dictators, movie stars— some of the most famous people in the world. His strength was mostly in working with authors and writers on book deals and screenplays. He worked very quickly and was able to procure large fees from both publishing companies and film studios. His nickname was, aptly, Swifty.

Through a friend, I contacted him to let him know I had gotten the film rights to *Little Me*. I explained that on Broadway, it had starred Sid Caesar playing seven different roles. My idea for the movie was just the opposite: take the greatest comic actors in film and give them each a role. My dream cast at that time included Peter Sellers, Richard Pryor, John Belushi, Bill Murray. I had already spoken to Neil, and he loved the idea and had agreed to write the screenplay. I felt this would be a "go" project for any studio.

Swifty said he couldn't start for a few weeks, but would represent it and me. I was on my way.

Out of nowhere, I then received a call from the most powerful pro-
ducer in Hollywood. His name was Ray Stark. We had never met, but
I knew he had produced many big Hollywood films, including *Funny
Girl, The Way We Were, Smokey and the Bandit,* and *The Sunshine Boys.*
I told my secretary to put the call through, wondering what he could
be calling me about.

"Hello," I said tentatively.

"Julian!" the voice on the telephone shouted in my ear.

Thinking quickly, I yelled back, "Ray!"

"What's this I hear about you wanting to do a film of *Little Me?*"

"It's true, Ray. Neil's agreed to write it."

"It's a piece of crap."

"Well, I obviously don't agree," I said, trying to keep my head. "In
fact, I'm meeting with Peter Sellers' people in two weeks."

"Listen, kid. Fly out to see me in L.A. first. I'll try to help you make
it happen. But it's no damn good."

"Ray, I'm not looking for a partner."

"Neil does all his films with me."

"Let me check with Neil. I'll call him at his office."

"No, he's at home. Do you have the number?"

I didn't have it, but my new best friend did—and cheerfully gave
it to me. I called Neil right away. It was true. Neil said he would feel
"more comfortable" if Ray were involved.

So I flew to L.A. Ray himself met me at the baggage claim. He
drove a Rolls-Royce. He asked if I liked Chinese food, and when
I said I did, he took me to the darkest, seediest Chinese restaurant
in downtown Burbank. Over some of the worst food I ever ate, we
hammered out a deal. We would split all the fees fifty-fifty. After
a lot of haggling, we determined that the credit would be "Rastar
Presents a Julian Schlossberg Production," and both of us would be
producers, with my name first in the producer's block before the
director's credit.

Ray spent most of the time telling me how bad the project was.

"Then why do it at all?" I asked. He shrugged and said only, "I do all of Neil's films."

Peter Sellers' agent, Marty Baum, said Peter would probably be very interested—but, of course, it would depend on the script, the director, the fee, and the dates.

Then I got a call from Neil. He was withdrawing. Ray had had his way.

Undaunted, I contacted Larry Gelbart. He loved the idea and the property. He was in. Then I called Swifty (who also represented Larry). True to his name, the next afternoon I was with him and the head of Warner Bros. productions. We were off by $25,000 on Larry's fee; I said I would pay it out of my producer's fee if Warner Bros. wouldn't, and Warner Bros. asked me to call the following day.

I was again euphoric. Either Warner Bros. or I would make up the $25,000. We would have a deal.

I was in my hotel room, feeling higher than a kite, when the phone rang. It was Larry.

"Julian," he said, "I've been thinking—I can't win. If it's a hit, it was Neil Simon's. If it flops, I screwed up a Neil Simon property."

My heart sank, but I tried not to show it. "Larry, I'll give you a good answer in a few minutes. Let me collect my thoughts. I just walked in the room."

I paced the bedroom. I paced the hallway. I paced the bathroom. (That wasn't much pacing.) Then I called him back.

"Larry, I agree with you. I wish I could come up with some good reason to counter."

"Let me tell you something, Julian," he said. "There was absolutely nothing you could have said that would have changed my mind."

By now, my options were running out. I got a call from a man named Allan Carr, who had produced *Grease*, and we danced around for a while, but it never happened.

Now, more than forty years later, it still hasn't been made into a motion picture. Some projects are just like that—no matter how hard

you try, they just can't seem to get off the ground. I still think I had a fine idea to use great comic actors in it. But as of this writing, old Ray was right.

consulting for abkco

My job consulting for Allen Klein and ABKCO put me in many different roles. I read film scripts as he was producing movies. He owned some films for distribution, like *El Topo* and *Holy Mountain,* and I sold them.

He had totally financed *The Greek Tycoon,* starring Anthony Quinn and Jacqueline Bisset. Because of that, he had final cut. I screened it and felt he needed to do some editing on it. He agreed, and we worked with an editor and revamped the film. After that he was able to sell it to Universal, and amazingly, it was successful.

Allen Klein was very litigious, and was involved in many lawsuits. But only once in all the time I consulted for him was I involved in one of them. He asked if I would appear on his behalf as an expert witness on motion pictures, in a lawsuit with The Beatles.

They were arguing that their film *Let It Be* was not worth much money. It had been shot badly in 16mm; it was a documentary (and in those days, they did not gross much money); it had gotten bad reviews in London, and mixed-to-bad reviews in the U.S. It was now

not being released at all. Allen wanted it released, because he owned a percentage of it.

I didn't know the details of the case then—nor, to this day, do I know them now. I just knew that despite its drawbacks, the film was indeed worth a considerable amount of money. It was the last film made by The Beatles, and in it, they performed many songs. That in itself was enough to make it valuable.

Allen and I both went to the courthouse at Foley Square. Allen asked me to sit outside the courtroom and wait on a bench until I was called. I don't know if that was Allen's, his lawyers', The Beatles' lawyer's, or the judge's idea. I sat alone, calmly reading the newspaper, for over an hour. I wasn't nervous at all. I would, after all, be testifying in an area I knew well.

All of a sudden, the courtroom door flew open and Allen came running out. Throwing his arms around me, he said, "I'm going to win. I'm going to win." I was happy for him and asked him what had happened. He said The Beatles had just had their expert witness appear, and they'd asked him if he knew a Julian Schlossberg. He said he did. The lawyer had then asked, "What do you think of him?" and he told the court, "He's the most knowledgeable man I know in the motion-picture business."

Most knowledgeable? *Me?* I would never have thought that—but this was certainly one way of getting it across to me.

While I sat there absorbing what Allen had said, he said, "We're going to win. Just go in and tell them your opinion."

And that's what I did. Allen won the suit, and I'm sure I helped. I don't think that was the only issue, and I never did find out any more of the details. Still, I was floored to have been thought so highly of.

"nurse anna"

Carlo Ponti was a famous Italian producer who discovered and married Sophia Loren. He made a lot of movies in the '50 s, '60's, '70s, and '80s, some of which played in the U.S., while some only played in Europe. Some of them were excellent; others were not.

I was involved with one that was not—but that wasn't the end of it.

The film was called *Nurse Anna*. It starred Ursula Andress, the beautiful lead who was first seen emerging from the sea in a sexy bikini in the first James Bond film, *Dr. No*. Her co-star in *Nurse Anna* was Jack Palance, before he had his comeback in the *City Slickers* movies. The film had a simple premise: a rich old man in Italy is dying, and his kids want his money. But he just won't die, so Ursula is hired to seduce him and kill him with lovemaking.

Ursula and Jack spoke English; the rest of the cast were dubbed. The production values were top-notch. It was shot in a beautiful villa in a great location. The photography and sound were fine.

But the film was not good. It wasn't funny. It wasn't dramatic. It wasn't interesting. And so it was never released in the U.S.

I screened the film and had an interest in buying it. My company, Castle Hill Productions, was built on newer films that often weren't very good and classic films that were. When you own a film library, the classics aren't enough; the library must constantly be replenished. Films with names help; long films, meaning two hours and over, had a better shot. Why? Because with so much additional footage, you were often able to cut the film and make it better. I was able to cut a film in my head as it played, and though I could never make a bad film good, I could often make one playable. Never in thirty years did I hit a home run, but I did have one triple, and a lot of singles and doubles.

So *Nurse Anna* seemed like a good bet. Besides having names in it, it was over two hours long, and I was cutting away in my mind as I screened it. At that time, the late '70s, pay TV was making a splash, and one of the attractions was to be able to show nudity on television—tastefully, of course. Free TV couldn't do that. And Ursula, God bless her, took off all her clothes in the middle of the film and swam nude in the rich man's pool. (It was one of the not-so-subtle methods she employed to excite him; she also did a striptease for him, and was quite beautiful in all of her scenes. Jack Palance, fortunately, kept all his clothes on.)

I bought the film "outright," which included all rights for fifteen years in the U.S. and Canada. Buying it outright meant that I paid a license fee once, and whatever I made thereafter, I kept. Ponti, who I'm sure couldn't believe that anyone would buy his film in the U.S., took the deal.

I scheduled a second screening. There were of course no cassettes or DVDs at that time—just six twenty-minute double reels of 35mm film. When I watched the film a second time, I was surprised. It was still bad, but it didn't drag as much as I remembered. As I was leaving the screening room, the projectionist, an old friend of mine named Mike, came out to say goodbye.

"Julian, I'm so sorry," he said. "I screwed up."

"What did you do?" I asked.

"I forgot to put on reel four. I'm so sorry."

I burst out laughing, told him not to worry about it, and asked him if we could screen it then. Inwardly, I had to admit I was rather shocked. How could I not have noticed that twenty minutes were missing? But we screened the other reel, and I eventually took out seventeen minutes of it. Mike had inadvertently started me off on my editing with a giant jump.

The first thing I decided was to retitle the movie *The Sensuous Nurse*. That was much better than *Nurse Anna*. (Some wise guy I was working with suggested *Nursula*, but I rejected that.) The second thing I decided was to open the film, before the opening titles, with Ursula at the pool nude. That would grab the film buyer and the audience. (I also kept that scene in the film where it had been originally, and no one complained.)

I ultimately cut thirty-eight minutes out, and when we released it, I had my first and only triple. Every pay-TV system in the U.S., about twenty-one at the time, bought it. Many of those systems were "stand-alones" which means they were only in one city. Los Angeles, for example, had three—On TV, Select TV, and the Z Channel. I sold all three. Then video cassettes came out, and we just kept selling. It was an amazing success story.

Throughout the entire time I owned Castle Hill Productions, my mother kept asking me, "Can't you find another nurse movie?" Regrettably, I never did.

But it was sure nice to have found one.

the influence of robert duvall

John Cassavetes called me to say he had seen a terrific documentary called *We're Not the Jet Set*. It was made by the actor Robert Duvall, and he wanted to know if I was interested in screening it. I was, and that's how Bobby Duvall and I met.

When I saw the film, I loved it. It followed a Midwest family as they worked the rodeo circuit. There was country music and a compelling story. You grew interested in the family members and were able to enter a world few people had ever seen.

Bobby was terrific to work with. His passion and dedication to the film were extraordinary. Nevertheless, he had so far been unable to find a distributor or to get any New York City theater to open it.

We opened the film in New York City, where it received good reviews and did some business. We also played some theaters around the country. It played on some cable stations as well, and all in all had some good exposure. In the process, Bobby and I became friends.

A few years passed and through Bobby, I met the playwright Horton Foote, who adapted for the screen one of my favorite films,

To Kill a Mockingbird. Through the two of them, I then met Paul Roebling, who had produced a film called *Tomorrow.* Adapted from a short story by William Faulkner, it starred Robert Duvall in one of his finest performances. (That's saying something, considering he is such a consummate actor.)

I brought the film back theatrically and sold it to home video, and then to television. It was a successful revival. For many years thereafter the film sold moderately well, grossing, say, $15,000 a year.

Then, at the 1983 Academy Awards, Horton Foote won Best Screenplay and Robert Duvall won Best Actor, for *Tender Mercies.*

The next day we printed up flyers that read, *Academy Award winners Robert Duvall and Horton Foote's film,* Tomorrow. That year, we grossed over $100,000, and proved that when you own a film library, you never know its true value. How could I have predicted that years after picking up that film, its principals would win the Academy Award daily double?

Another good case of this was a film called *Across the Tracks,* which starred Rick Schroeder and Carrie Snodgrass. Schroeder was later cast to co-star on *NYPD,* a popular television show, at which point the film became more valuable. However, his male co-star in the film, an unknown actor at the time, would bring the movie's value up even more. His credit for *Across the Tracks* read *Introducing Brad Pitt.*

You just never knew, from year to year, what might happen with your film library.

<p style="text-align:center">* * *</p>

Horton and Bobby had come to me originally with the script of *Tender Mercies,* asking me to produce it. I really liked it, and was happy to try to raise the money, but I wasn't doing very well at "getting the dollars" when I received a call in L.A. from Barbara Kopple.

Barbara had made a great documentary called *Harlan County, USA* that I had plugged on my radio show. I had also introduced her to her soon-to-be distributor, Don Rugoff, and his film company, Cinema V. After that, she and I had become friends. Now she wanted me to

produce a musical concert film that she already had the money for.

This was, forgive the pun, music to my ears. I have always believed in show business that a bird in the hand is worth two hundred in the bush, and so far I wasn't doing well with *Tender Mercies*. Here, then, was my chance to produce a film. I called Bob and Horton to tell them of my opportunity, and we parted well.

I flew back to New York City and met Barbara and Danny Goldberg, the man who was to be my co-producer. He was from the record business, and by his own admission knew nothing about film. For my part, I knew nothing about the music business, and we bonded pretty quickly. Throughout the year, as we worked together, we were known as "The Bergs."

Danny was a great partner. We ended up producing and directing the film along with our editor, Tony Potenza. The fine cameraman, Haskell Wexler, had lined up a great group of fellow cameramen, and everyone worked together for nothing, shooting five nights at Madison Square Garden. We also shot a huge outdoor anti-nuclear rally at Battery Park. Barbara interviewed the musicians backstage, and also did the sound. Another project then brought her to Cuba—which was pretty rare in 1979—and Danny and I took over.

The footage we shot would ultimately become the film *No Nukes*. It starred many major musicians: Bruce Springsteen, Jackson Browne, Bonnie Raitt, the Doobie Brothers, James Taylor, Carly Simon, and Crosby, Stills, & Nash, to name a few. Once we figured out our story line, we were on our way. That became somewhat easier when Elaine May came in to help us. She and Mike Nichols were starring in *Who's Afraid of Virginia Woolf?* At the Long Wharf Theater, and she came into our New York editing room on her one day off to work with us. Without Elaine's help, we would never have had such a fine film.

We shot the film in September of 1979, and opened at the Cinema 1 in New York City in July of 1980. In those days, films were on separate double reels, so at eleven a.m. on our opening day, with the first show at noon, both Danny and I could have been seen running up Third

Avenue, sweating and straining, with cans of films in all four of our hands. Fortunately, the show went on right on time.

Danny and I worked eleven months for no pay to produce that film. It was grueling work, but I was committed to it from start to finish. It was in many ways the perfect combination for me: the music I liked, a director whom I felt was important, and a cause I was genuinely concerned about.

Eventually we sold the film to Warner Bros. But to this day, I am as proud of *No Nukes* as of anything else I ever did. And Danny and I became lifelong friends.

good times at cannes

Almost everyone I ever spoke to in the film business said they hated the Cannes Film Festival. Too many people—too many parties—too many Frenchmen (and -women)!

Not me. I attended the world-renowned festival for more than twenty-five years, and I loved it every time. Besides the movies that were shown there, it was held in the south of France, on the coast of the Mediterranean, with beaches and beautiful views. And the food!—some of the finest restaurants in the world were within driving distance. So free movies from eight a.m. until midnight, continuously showing in theaters along the Rue D'Antibes—a stunning locale—great cuisine—it was more than enough for me.

This, of course, was the late '60s and '70s, when only a small group of Americans attended in order to buy and sell films. The terrace at the Carlton Hotel was the place to meet—no matter where you stayed, everyone met there. In the beginning, there were large film theaters at Cannes; then came the multiplexes, and suddenly there were five or six times as many screenings.

I'll never forget my first year there. On the Carlton Terrace, I was to meet a Richard Davis, a Russian living in Paris who was exporting movies to the U.S.A. He owned the Fine Arts Theatre in New York, and also distributed foreign films. Two of his biggest hits were *Rififi* and *Diabolique*, two French films that were each remade years later as major studio movies. Richard spoke English poorly, and even though he lived in Paris, the French in Cannes often couldn't understand his French. Once, when we were having lunch on the Croisette—the main street of Cannes, facing the sea—Richard couldn't get the waiter to understand his French. They started shouting at each other, and Richard stood up to make his point. As he rose from the table, his pants fell down. He continued yelling as he pulled up his pants, but to me he said, "You see how mad he has made me. I've lost my pants."

Despite his eccentricities, Richard became my guide when I first came to Cannes, was generous with his time, and ended up introducing me to a lot of people.

One day when we were having coffee on the Carlton Terrace, a stocky man with a bulbous nose and a heavy accent screamed across to Richard. Richard jumped up, yelling back, "Sam!" Just like in the movies, the two men walked across the crowded Carlton Terrace towards each other, then laughed, kissed, and embraced as only Russians can. When they separated and went their own ways, Richard returned to the table where I was watching.

"Who was that?" I asked.

"Sam Spiegel."

"Sam Spiegel, oh my God," I gushed. "He's a legend."

"Yes," Richard said, then paused. "I piss on him."

I think that was as surprised as I've ever been. I expected a lot of comments, but not that one. By that time, Spiegel had produced *The African Queen*, *Bridge on the River Kwai*, and *Lawrence of Arabia*; you couldn't get much bigger. Yet Richard, who obviously cared for him, had also a certain amount of disdain for him.

As I've grown older, and I hope a little wiser, I've realized we often

have mixed feelings about business associates—though perhaps not always to the extent I've just described.

* * *

Many companies, and even some producers—Sam Spiegel included—brought their yachts and ships over to Cannes, where they would host parties, luncheons, dinners, and meetings. A small launch would take you from the dock at the Carlton to your destination in the harbor. I found it all very glamorous and exciting.

But the best of all was when I used a ship as my hotel. It was called the Sea Goddess, and it was a beautiful vessel. I had that trip to Cannes paid for, as well! Here's how I managed to do it.

There was a group called the World Business Council who wanted to take their members to the festival. Their members were CEOs of corporations, all over the age of forty. A friend named Barry Yellen contacted me and asked if I could get some film celebrities to come to Cannes, all expenses paid. Their only obligation for the week would be to be interviewed for one hour…by me.

That trip ended up being a blast. I got Alan Arkin and Elaine May to come, among others; Barry also asked me to interview Arthur Hiller, the director of *Love Story* and *The In-Laws*. Vincent Canby, the *New York Times* film reviewer, asked me if he could come to the interview with Elaine; Elaine okayed it, and Vince wrote a wonderful column from Cannes saying that it was one of the highlights of the festival that year. In the middle of her interview, I remember Elaine asking the audience if they would like her to interview me at the end of the week. The audience responded with a resounding yes, and sure enough, we did our reverse interview at the end of the week. It was all so spontaneous and fun.

* * *

Over the years, I saw many sides of the famous film festival. I lectured in Cannes. I was interviewed on Radio Luxembourg in Cannes, and was on German, French, and Italian television. I met and spent time

with movie stars, studio heads, writers, directors, and producers there. It was a great part of my career, and I always enjoyed myself when I went.

Some of the experiences I had there were hilariously superficial, the way everyone knows Hollywood can be. I once walked the red carpet at Cannes for a film very close to me. (More on that later.) What a time that was—I've never experienced anything like it. The crowds, the cheering, the photographers, the flash bulbs. But here's the funny thing: the crowds had no idea who any of us were. They were cheering because that was their job. They saw photographers taking pictures, they saw our little band of men in tuxedos and ladies in gowns, and they went bananas. I can't imagine what happens when true movie stars show up!

otos

Over the years, I have often had what I would call *OTOs* with show-business luminaries. OTOs, in T.V. lingo, used to stand for *one time only*. The term was often confined to specials: they aired once only. During my personal OTOs, you just exchanged pleasantries with a person, and that was it.

Some of them, however, you just don't forget.

* * *

Michael Colgan was the artistic director of the Abbey Theatre. He had filmed all of Samuel Beckett's plays, some with major film stars. We met at a French restaurant in Manhattan one late afternoon to explore an arrangement for my company to distribute those films.

Although we were having a delightful time talking, it was quickly apparent to me that making a deal with him wasn't going to be easy. After so many meetings with so many people over so many movies, one knows pretty quickly when that's the case. I could tell that Michael was funny, smart and difficult.

All of a sudden he jumped up from our table and ran toward the front of the restaurant. I turned around to see him bringing over an older man who was obviously a friend.

"Julian, I want you to meet Harold Pinter."

"Happy to meet you. Would you like to join us?"

When he sat down, I asked him if he'd like something. He said he would, and I ordered some wine. We talked for some time, and he asked for a second glass of wine.

When the wine came, Pinter held up his glass and toasted me: "Julian, I will never forget you."

"Harold," I answered, "you'll forget me in the morning."

We laughed heartily, I never made the deal with Michael, and I never saw Pinter again.

* * *

One evening, when I was sitting at my desk at the Walter Reade Organization, the phone rang. It was pretty late at the office—after seven p.m. I picked up the receiver.

"Hi, fella," a familiar, gravelly voice said. "This is Governor Rockefeller."

"Hel-lo," I stammered.

"I haven't gotten my season pass to your theaters," the Governor continued. "Can you check on it?"

"Yes—yes of course," I muttered, and he hung up. The exchange had lasted only seconds. Still, I was astonished on two counts.

First, the governor himself had called. Second, I was surprised that Nelson Rockefeller even cared about his pass. To this day, I have no idea why he called personally—but from that moment I began to appreciate the prestige of the season pass.

And we're taught that we live in a democracy!

* * *

I was working at Paramount Pictures when we premiered *King Kong,*

produced by Dino DeLaurentiis. The opening party was held in New York City at the executive restaurant atop the original Gulf and Western building at Columbus Circle.

The star, as I mentioned before, was an as-yet unknown actress named Jessica Lange. This was her first film, and both my girlfriend at the time, Milly Sherman, and I were taken by her beauty and her talent. At the party, we told her so. We three were among the youngest people in attendance, so we ended up dining together and talking. She was so nice, so smart, so nervous, and so vulnerable.

We were together for the whole dinner at a small table. For dessert, though, Dino asked her to join him. The last thing we said to her was, "You're going to be a star. Just try to remain as nice as you are now. It won't be easy."

*** * ***

A friend and supporter of mine, Bill Chaikin, wanted me to meet Cliff Perlman, president and CEO of Caesars Palace in Las Vegas. Bill, at that time, was on the Board of Directors at Caesars Palace; Cliff had a film that he was producing and that needed distribution. So a meeting was arranged in L.A. I went with Mel Maron, who was the head of sales and marketing for Castle Hill Productions.

We were led into an office and told to sit on a sofa. The sofa faced a desk that was far away. *Very* far away. In fact, I have never had a meeting where the parties were so far apart. There were individual chairs and tables between us. We could see Mr. Perlman, but it was over quite a distance.

He asked about our company. We told him our history, our current films, our upcoming films, and how we treated each film with care. It was our standard pitch, and it was often effective.

Then, abruptly, Mr. Perlman broke in. "I'm trying to get Ally Sheedy," he said.

Mel and I, stunned, just looked at each other. I asked Mel, "Do you know who Ally Sheedy is?"

"No," he said.

"Neither do I," I said.

Silence.

Feeling like I needed to say something, I said to Mr. Perlman, "Well, we may not be the brightest distributors around, but we're the most honest."

Needless to say, we didn't get the film.

Ironically, some time later, I produced a play, *Triptych,* which starred Ally. She was a terrific person. Wish I had known her when I was sitting in Cliff's office!

* * *

I wanted to produce a film based on a novel by Dashiell Hammett, *Red Harvest.* The Hammett estate was controlled by Lillian Hellman. I had never met her, but since we had mutual friends, they arranged for me to visit her in a hotel suite in Los Angeles.

I arrived on time and was shown in by a lovely female assistant. The assistant said she was so excited to meet me, as she was a big fan of *No Nukes.* She was in the middle of describing one of the highlights of that film when we heard a voice screaming from another room, "He's here to see *me!*"

I was quickly ushered in to see Ms. Hellman.

We talked for a long while. Sadly, the property I wanted was already under contract, but I enjoyed her company. She smoked continuously, coughed a great deal, and was quite funny.

That was my only encounter with Lillian Hellman—but it wasn't the end of her impact on me. Three years later she died, and then, strange as it may seem, she came into my life almost on a full-time basis, as you will read.

some enchanted evening

In Hollywood in the late 1970s, there was, in Ed Sullivan's words, a really big party. Anybody who was anybody attended. It was held on the night of the Academy Awards at the Bistro Gardens in Beverly Hills. The hosts were Swifty and Mary Lazar.

So since I was now a client of Swifty's, I received the coveted invitation. I remember clearly that I was the only person at the party I'd never heard of. Now, more than forty years later, I can still vividly remember some of my seven tablemates. First, Yul Brynner sat across the table, staring at me and wondering, I believe, *Who the hell is this guy.* To my left was Mia Farrow, shy and quiet; to my right, Ginger Rogers, heavily made up and anxious to talk.

My interest, however, was in Mia.

I had never understood her allure. Frank Sinatra, Woody Allen, Andre Previn, and many other powerful and talented men have all been, at one time or another, besotted with her. I just didn't get it.

Within two hours of talking with her, I got it. If you believe, as I do, that the world is divided between nurses and patients, Mia was the

ultimate patient. She appeared so vulnerable, so kind, so smart, so funny, you just wanted to be with her and take care of her.

She was spending time on Martha's Vineyard that year, and coincidentally, I was part owner of the only four movie theaters on that island. I offered her passes. A few more hours together, and I would have given her half my share in the theaters. I was smitten. Oh, and I didn't mention: she glowed. It was as if she had a key light focused on her. Being around her was clearly one of the highlights of the night.

At one point in the evening, while I was giving my attention to Mia, Ginger tapped me on the shoulder. I didn't want to turn away, but I also didn't want to be rude. So I turned toward Ginger, who was saying, "Julian, I want you to meet—" and just at that moment, I saw a beautiful large head bend down and smile at me. A tanned man with silver hair, impeccably dressed...

I vaguely heard Ginger finish her sentence with "—Cary Grant."

Now I'm not generally at a loss for words, and by that time in my life I had met a lot of famous people. But I was stunned. I hadn't been told I was going to meet him, or that he would be attending. I didn't even see him coming over to say hello to Ginger or hear that famous voice behind me—since I had been deep in conversation with Mia. No: turn around—*bam!*—Cary Grant lowers his head and says, "Hi, how are you?"

God knows what I said. It was a shock. I had always loved the guy from afar. I truly believe, to this day, that he was never appreciated as the great actor he was. He could do comedy. He could do romance. And you sure believed him in every role he played.

As with Mia Farrow, his magnetism was instantaneous and undeniable. That's just how it is with some of these stars—and why meeting the two of them that night, ever so briefly, could make for an evening I would never forget.

Oh, and incidentally: it took me many years to realize that the best relationship for me was to be a part-time nurse and a part-time patient—and I luckily found that with my wife, Merryn.

"it had to be you"

I had always wanted to produce a Broadway play. I saw my first show in 1955, and was totally hooked. It was *Peter Pan,* starring Mary Martin. It's hard to believe that at thirteen years old, I was screaming to Mary onstage (along with hundreds of other kids), "I believe, I believe," but I was. This belief was the remedy to help the fairy Tinker Bell survive, and damned if she didn't make it. (It seemed even in 1955, there were kids who didn't believe in fairies. So the kids at the Winter Garden Theatre, eight times a week, brought Tinker Bell back to life.) I believed in miracles then, and I still do.

And it's a good thing, because anyone would have to believe in miracles to produce in theater.

Twenty-six years later, I was having dinner with Renee Taylor and Joe Bologna. They had written a play called *It Had to Be You* and wanted me to produce it on Broadway. I knew absolutely nothing about producing on Broadway—at that point, I had only produced *Ten from Your Show of Shows*—and I told them so.

"So you'll start with our play," Renee said.

I hadn't read their play, so they wanted to perform it for me at their apartment. Joe's mom would be the only other person there. I said I wanted to bring my mom too. They agreed, and the three of us (two moms and me) roared from beginning to end. It was funny, touching, and original. I told them on the spot that I'd do it.

Now, to do it meant raising the money. I had never raised money, but I had an idea.

As I mentioned before, I was by now consulting for ABKCO. Allen Klein, who owned the company, had a pretty bad reputation in the record industry, and that was really saying something. At that time even the good guys in that industry were no bargain. (Having been involved in almost every aspect of the entertainment business, I found that the people in the music business were the worst people to do business with. Next came motion pictures, then television and radio; the most ethical, interesting, and sophisticated people were the theater people. This hierarchy has changed since, and now you'd just better be really careful in any and all areas. Simply raise a great deal of money and pray every day.)

Before I had consulted with ABKCO, I had done a lot of business with Allen's company. It was always one hundred percent honest and aboveboard. I once asked Allen, "How come we've done all this business together, and never once have you tried to screw me?" In the motion-picture and record business, this kind of question would elicit a scream of indignation from the person asked, no matter how amoral or two-faced: "Me? You think I'd do that? I'm upset. I'm hurt. I'm outraged. How dare you!" Allen, on the other hand, just smiled and said, "Everybody's got to have a friend." No denials, no feeling insulted, not a speck of defensiveness.

(Not even when it came to putting it in this book. When I asked him if he minded if I told this story, he said, "I don't care who you tell.")

So Allen was my idea. He was a gambler, a showman, and a guy who was his own board of directors. I thought he'd be perfect to ask.

The next time the reading was at my house, with Allen in attendance, and Renee and Joe were great again. Allen took me over to a corner.

"This is really funny," he said. "Do you really want to do it?"

"I do, Allen, but I know zero about theater."

"Neither do I," he said, "so we'll learn together."

And learn we did.

<center>* * *</center>

The play was produced in 1981, when lots of movie stars were on Broadway: Elizabeth Taylor, Lauren Bacall, Donald Sutherland. And I can't say it went off without a movie-star moment among our own cast. One night, I received a call at home from the stage manager.

"Renee won't go on tonight unless you come to the theater now," the stage manager said. "She won't speak to you on the phone—only in person."

I hopped into the first taxi I could find, quickly went backstage, ran up a staircase when I heard screaming, and opened the dressing-room door without knocking. Renee had a cheap lamp in her hand, and (I guess) was about to throw it.

"Renee, stop!" I yelled. "You're confused. You're not Elizabeth Taylor; she's across the street. You're Renee Taylor."

Renee, God bless her, fell onto the couch laughing. She was a great audience and really loved any kind of funny situation, and this certainly qualified. I never did find out what the problem had been, but she went on and did well as always.

<center>* * *</center>

For years, Clive Barnes had been the first-string critic at *The New York Times*. He was the man. And he loved *It Had to Be You*, writing, "It's the funniest show on Broadway." You couldn't get a better review.

So why was I so glum opening night?

Well, Clive had left *The New York Times* two or three weeks before we opened. He had since become the critic for *The New York Post*, which is where he had written his glowing review. *The New York Times* sent his replacement, a former movie critic named Frank Rich, to a Saturday

performance before we opened.

Renee and Joe had never been better. The audience stood and cheered at the curtain call, which was rare in 1981—but Frank skewered the show anyway. "When you go see a comedy you should laugh," he wrote. "I didn't laugh once."

Fortunately, for the most part the television critics agreed with Clive. Allen, true to his nature, kept the play open for four months.

All these years later—I hope objectively now—I still agree with Clive.

cannes, part 2

The writer Sidney Sheldon was a guest on my radio show. I was enthralled with his stories of Hollywood and of writing films for Cary Grant and Fred Astaire. In turn, I think he was taken with my enthusiasm and the fact that I loved his stories. And I truly did—he was a great storyteller.

He also wanted to meet my friend, the producer Joseph E. Levine, and that was something I could easily facilitate.

As it happened one year, Sidney, Joe, and I were all going to Cannes at the same time. Joe invited me for drinks on bestselling author Harold Robbins' yacht, and I asked if I could bring Sidney. He called back and said it was okay with Robbins. It would be just the four of us and our ladies.

As the women were shown the yacht by our gracious hostess, Grace Robbins, the men—of whom I was the youngest by at least twenty-five years—sat around a table having cocktails.

Holding my drink in the air, I said, "I can't believe I'm on a yacht at the Cannes Film Festival with three such legends."

Joe looked at me. "Kid," he said, "we'd all give it up to be your age again." The others agreed.

It wasn't the first time I was reminded of how fleeting are fame and fortune. But to have these three men agreeing with each other, that they would rather be me as a young man, was a life lesson—and one that I never forgot.

*** * ***

One year at Cannes, my then wife, Beverly, and I were joined by Terry Semel and his wife Jane. At that time, Terry was the co-head of Warner Bros. and already one of my closest friends. I was looking forward to showing them some of the highlights of the south of France, and had lined up day trips, reservations to some of the finest restaurants, and a favorite town—Eze, unknown to most Americans—to be visited. I think we spent one full day together before Stanley Kubrick called Terry from London, at which point Terry and Jane, who were taking their first vacation in years, had to leave—and all the plans I'd worked on for months were kaput.

But in our one day together, the Semels had introduced us to Harrison Ford and his then wife, Melissa Mathison. She was a fine screenwriter, having written *E.T.*, *The Black Stallion,* and others. She was warm and outgoing; he was friendly but somewhat shy.

A day or so after the Semels departed, we were on our way from one party to another. (There was always lots of partying in Cannes.) When our car was brought out, I noticed Harrison looking for his car. I waved and he came over.

"Can I grab a ride with you?" he asked, smiling. "My car isn't here, and I'm late for a party in my honor."

"Sure," I said, and off we went. The car was a stick shift, and had a small back seat. I hadn't driven a stick shift in years; it was nighttime and there were hills; and none of us knew exactly where we were going. So there was this huge movie star curled up in the back seat, lurching backwards and forward as I tried to shift correctly. And I have to say,

he was terrific. He laughed, he joked, he kidded me about my driving. And we got him to the party *almost* on time.

I didn't want to go in when we got there; I rarely went to parties unless I was involved with them directly, and Beverly was a little nauseous from the drive. Of course, on the way back, the ride was smooth. No lurching. Easy shifting. And I never saw Harrison Ford again.

"widows' peak"

One of the best parts of running a film-distribution company was never knowing who might be calling with something interesting or provocative. Sadly, that went hand-in-hand with getting a lot of phonies, liars, con men, and cheaters, too.

After a while, I became reasonably adept at sniffing those fellows out (yes, they were always men). Sometimes it required my doing my due diligence by calling a friend or two to check out the person or some of his so-called credits. I rarely, if ever, was burned, because I didn't take many chances: I figured I was gambling enough when advancing money for a film, or having twenty people on the payroll, or spending money on prints and advertising. It almost always started with a phone call.

On one occasion, I was told it was Prudence Farrow calling. I immediately knew the name. Besides being Mia's sister, she had become famous because of The Beatles. (John Lennon wrote the song *Dear Prudence* after meeting her at an ashram in India where the Beatles were studying Transcendental Meditation.) I did wonder why she was calling me, and after a few moments of pleasantries she asked for an

appointment. I readily agreed and she arrived the following day.

I was as charmed by Prudence as I had been when I met her sister. She was a lovely, intelligent, and soft-spoken woman. She asked me if I had ever heard of a writer named Hugh Leonard and I said yes, having seen and loved his play *Da* on Broadway.

"Well," she said, "he has agreed to write a feature film involving an older woman, a younger woman, and a confidence trick, set in the early 20th century. Mia has agreed to play the younger woman and Maureen O'Sullivan"—the Farrow sisters' mother in real life—"will play the older woman. You would be the producer and I, the executive producer."

She had with her a copy of Hugh's treatment, which I said I would read quickly. It wasn't many pages, and she assured me it outlined the entire story and elaborated on the major characters. We made an appointment for the following week, and as she was leaving, I asked how much the screenplay would cost if I agreed to go forward. She quoted a reasonable sum, and I was so intrigued that I read the treatment as soon as she left. It was a delightful caper and well written, and—as this was 1983—having Mia Farrow starring would be a big leg up.

I called my dear friend and soon-to-be partner on many ventures, Meyer Ackerman, and asked him to read the treatment as soon as he could and join me if he was so inclined. He called soon after and excitedly told me he was in. My investment cost was immediately cut in half.

By the time Prudence arrived for our next appointment, Meyer had reduced our investment to twenty-five percent each. He had found two businessmen who would put up the other half, thus completing the entire cost to have a film written by a man with many plays and screenplay credits. It was, I felt, a good gamble.

When Hugh's writing contract arrived, it had some clauses we'd never discussed—but that wasn't a big surprise, since the initial price was so reasonable. I agreed to pay him some additional money on the first day of principal photography. Why? Well, by then we would have raised the entire cost of the film, and I would simply include this extra amount in the budget.

Armed with a fine screenplay and Mia's name attached, I then started the arduous task of first finding a director and then procuring the financing. For a while, Bruce Beresford was interested in helming, but that didn't end up happening. Some so-called independent producers said they would put up half the budget if they could buy us out for just the money we'd invested. We weren't even tempted by that.

It ended up taking ten years from the time we signed Hugh Leonard for the film to be made. Many other producers worked on getting the financing needed. I'm listed as executive producer. (I'm not the only one, but even in those days that was not unusual.) I also received my original money back, along with a small profit and the knowledge that I had made the movie happen.

Widows' Peak received fine reviews and did moderate business. The cast ended up being Mia Farrow, Joan Plowright, and Natasha Richardson in the leading roles—and it took so many years for the film to see fruition that Mia Farrow went from playing the daughter to playing the mother!

It's a funny thing about the film business: why some films get made while hundreds never do, and how some projects get done quickly while others are years and years in the making.

"going hollywood"

In the 1980s, there were some major changes in the television business. HBO, Showtime, and The Movie Channel were expanding rapidly. New basic cable channels were now broadcasting. And pay-TV stand-alones were proliferating throughout the country. Stand-alones, as I mentioned before, were just what the name implied: new pay channels that opened for a single city's population. There turned out to be close to twenty separate buyers for pay TV alone.

With that in mind, I decided to try to make a documentary about Hollywood to sell to these systems. I felt I could do it reasonably inexpensively if I used mostly public-domain footage. (Public domain meant there was no copyright owner, which meant the footage could be purchased for very little money.) I could also use some films I represented from the 1930s. And so *Going Hollywood: The '30s* was born.

At that time, I was living bi-coastal. I set up an editing machine in the living room of my L.A. rental. (My editor was from New York City. I couldn't afford to put him in a hotel or motel, so he ended up residing in our second bedroom.) It was a hectic time—I was running

Castle Hill by day and editing at night, while constantly flying back to New York to do business and my radio show.

With the documentary, there was a lot to do and it was all new to me: gather the footage, select the scenes we wanted to use, cut them all together, get a script, and find a host. We screened hours and hours of public-domain footage. It took months.

Eventually we found some fine film of many of the major stars at that time: Shirley Temple, Mae West, Laurel and Hardy, John Wayne, James Cagney, Bette Davis, Clark Gable, Joan Crawford, Fred Astaire, and the Marx Brothers. *My Man Godfrey*, a public-domain film, was perfect for depicting the 1930s Depression, as it portrayed the very rich and the very poor. Another film I had, *Stand In* with Humphrey Bogart, showed labor versus management, even including strikes. And we featured all the various forms of film entertainment that had been shown to millions of people needing relief. (During that time, eighty million people attended movies weekly. Remember, there was no television!)

Elaine May and I lived within walking distance of each other in Los Angeles. I was constantly showing her the footage I was gathering, and she, as always, had many ideas on how to use it.

"You probably need a host who can narrate this program," she said. "Who do you have in mind?"

I always answered with the famous line, "I'll get back to you." But finally, it was indeed time to find a host. I wanted a name—someone with a distinct voice who had worked in Hollywood in the 1930s. We went through some lists of actors. Since we were making our film in the 1980s, the '30s were now fifty years ago—who was still alive? Who hadn't retired? Who was still vital?

Robert Preston was an actor with an incredible voice who had starred in *The Music Man* on Broadway, and in the movie adaptation. He had also recently appeared on my radio show. I found that he had acted in three or four films in the 1930s, including Cecil B. DeMille's *Union Pacific*. Off the air, he had told me that he too was bi-coastal— and it turned out we both lived in Brentwood, California.

We'd exchanged home phone numbers, too, and I decided that when I next went to the West Coast, I'd call him. By the time I did, it was the same week he was nominated for the Academy Award for Best Supporting Actor in *Victor/Victoria*. When I proposed he host and narrate the program, he asked good-naturedly, "How much do you pay?"

He laughed when I told him. "So this turns out to be my first offer since I've been nominated for the Academy Award?" he asked.

Still, he agreed to do it—but for only one day. He also wanted "one additional thing." *Uh-oh,* I thought, *what could that be?* But it was simply a martini after we wrapped.

Elaine was excited when I told her I had gotten Robert Preston, so I hesitantly asked her if she would consider writing his narration. She laughed and said she would, under two conditions: one, she would take no credit, and two, nothing she wrote could be changed without her consent. I happily agreed, and she tailor-wrote it for Bob's cadences.

When we wrapped, I had more than one martini ready for Bob, but all he wanted was one. He was terrific to work with, and I enjoyed directing him. (And he didn't require much direction.)

The film sold well, too. We made a nice profit from it, and it continues to be seen around the world.

* * *

A few years later, I decided to do another *Going Hollywood* documentary on the 1940s, specifically the war years—how the war affected Hollywood, and how Hollywood affected the war. This was going to require a bigger budget. There were few films from that time that were in the public domain, so licensing would cost money.

Despite our success on the '30s film, I had trouble raising the money. Most people I went to said there had been many films on this same subject. My answer was always, "But not my film." I explained that I would get a named host. I would have many known actors on camera. And I would distribute the film for no charge until the money was returned.

It all fell on deaf ears, and I ended up financing the film myself. I

was able to get the number-one box-office male star during World War II, Van Johnson, to host. At the time, he was painting a great deal, as many actors do, and appearing a lot on episodes of *Murder She Wrote*. I was thrilled to be able to get him. Once again, I went to Elaine to write, repeating that there would be no credit (of course) and no changes to her script (of course). Van, like Bob Preston, required very little direction, and instead of with a martini, we ended the day at a Chinese restaurant.

While we worked on the film, some of the stand-alones I'd originally wanted to sell it to went out of business. (Indeed, by the time I wanted to do *Going Hollywood: The '50s*, almost all of them were gone, and my idea of doing a *Going Hollywood* series had to be shelved.) How could I raise money without buyers on hand?

I was very nervous about financing this, and shared my concerns with Elaine. She reminded me how I'd convinced her to do it: I'd said, "I can't give you a chunk of money upfront, but for many, many years, you'll be receiving money on this film." That immediately cheered me up, and we were able to get a lot of actors to talk about this period of Hollywood's Golden Age: Sylvia Sydney, Dane Clark, Vivian Blaine, Douglas Fairbanks Jr., Gloria DeHaven, and Jackie Cooper.

And *Going Hollywood: The '40s* was indeed a success. It was sold all over the world and received wonderful reviews. Warner Bros. distributed it on home video. And as I had promised Elaine, we ended up having a nice income from it for a long time.

"orphans"

In 1985, I received a call from Peter Falk. Peter, as you probably know, starred in the wildly successful TV series *Columbo,* playing the titular disheveled and self-effacing detective. We had gotten to know each other because of *Mikey and Nicky,* and he asked me if I had seen a play called *Orphans* currently playing in New York. I had not, so he invited me to see it with him that weekend.

When we got to the theater that night and were seated, Peter told me he had just been asked to replace the lead, John Mahoney (who later played the father on *Frasier).* He wanted to see the production for himself before he decided.

For my part, I thought it was a terrific play—well directed and beautifully acted. And that's what I told Peter when he asked.

Peter was a lot like the Columbo character he portrayed. He'd think, he'd ask questions, he'd pause. (He often even wore the raincoat from the show, or one similar to it.) After the play was over, he headed off to the airport. I knew he had liked the play, but I also knew he hadn't decided what he was going to do. I had nothing to do with the play,

so it didn't matter to me, except as his friend, whether he did it or not.

As it turned out, Peter didn't replace in New York, but he did star on the West Coast—specifically in Los Angeles and San Francisco—in profitable runs. Albert Finney ended up starring in the movie version, leaving *Orphans* with a fine pedigree.

Years later, an agent representing *Orphans'* playwright, Lyle Kessler, called me. He asked if I had ever heard of the play, and I said I knew it well.

"Would you like to revive it?" he asked.

I had never produced a revival. I had also decided I would only do new plays. So I said, "Let me read it since many years have passed."

It held up. Breaking my rule, I said I was interested, but first wanted to meet the writer. He lived in Los Angeles, but it so happened that he would be in town the following week. So we met, and we got along. I had a good idea who should direct it; his name was Matthew Warchus, and we had worked together on *The Unexpected Man* after he had directed two phenomenal hits, *Art* and *God of Carnage*. Lyle and I agreed, so I called Matthew in London, sent him the play, and got his agreement to do it.

Now we needed a star. So like all producers, we compiled a list of names with the casting director. We all needed to agree on the names, so after some jostling and haggling, we had our starry list. Many of them were true "wish list" names, not grounded in reality. But hope springs eternal, and it got all of us excited.

The New York theater community is a very small group of people. And word often gets out on what's being contemplated for the future. And so Lyle, our playwright, heard that Al Pacino wanted to talk about starring. (At this time we were thinking about Nick Nolte, and had just found out he wasn't available for more than a year.)

So—great! Pacino! Born to play the role!

I called Al on the phone, and we set up a late-afternoon meeting at the Café Luxembourg in New York. We sat and talked about many things, ate salads, and finally got down to the point of the meeting. He

said he wanted to first do a workshop of the play. That sounded all right to me, as long as we would then do a commercial production soon after.

Now I'm about to make this a much shorter story than it was in reality. Al, to his credit, did not want to commit to anything but a workshop. He wanted, he said, to make sure the play worked. I said it worked as both a play and a film. It wasn't a new piece—it had been a success.

At this point, Al could have said yes, agreeing to do the play sometime after the workshop, and then delay and delay. But he was honest, and so was I. I told him I was a commercial producer: I didn't produce workshops, I produced plays.

This dance ended up going on for months. Finally, Lyle asked if he could have the play back. (I had it under option.) He wanted to go with Pacino. Matthew Warchus, like me, wasn't interested in just doing a workshop. So we exited.

Al did get his workshop—and never did the play.

scorcese and fellini

Martin Scorcese called our office. I can't say that we knew each other very well, but he had appeared on my radio show, and I had interviewed him for a film I produced called *Hollywood Uncensored*. He wanted me to know that Fellini's last two films were available for U.S. distribution—one was called *La Luna*, and the other *Intervista*. (These titles translated to "the moon" and "interview" respectively.)

I screened them both, and though I didn't respond to *La Luna*, I liked *Intervista* a lot. It starred Marcello Mastroianni and Anita Eckberg, who had been the stars of Fellini's early hit *La Dolce Vita*. At that time, Ms. Eckberg was considered by many to be the most beautiful woman in the world; in *Intervista*, Fellini and Mastroianni pay a "surprise" visit to her home, where we find she has aged and gained weight.

But within the movie, an amazing thing happens. A cassette of *La Dolce Vita* is put on, and Eckberg watches herself as a young, gorgeous woman. And Fellini, with the help of his cameraman and director of photography, shows us a radiant and dazzling older Anita Eckberg viewing the film. It is one of the most extraordinarily moving moments

in any Fellini film, and it's done with warmth, style, and love.

Marty and I presented the film, in Italian with English subtitles. *The New York Times* gave it a rave review, and we did business.

It meant a lot to me to present a Fellini movie with Scorcese. I was proud to be associated with both of them. But I also knew how to answer the question often posed in elementary school tests, "Which one doesn't belong?" The chance to be associated with these two titans of film was an incredible privilege for me, and one I will never forget.

joseph e. levine

From the 1950s to the 1980s, his name appeared on more films than that of any other person in the world. In an age of conglomerates and "business as usual," he was the unusual—the last of the great movie moguls, Joe Levine.

I knew Joe for more than twenty years. We traveled the world together. I saw him be charming, cruel, funny, depressed, loving, and angry—but always with a fantastic sense of humor that resonated deeply with me. He would often talk about his impoverished childhood. "Where I grew up, we were so poor that you had to go down the hall to the bathroom for a breath of fresh air," he would say.

Growing up in Boston, he had been a newspaper boy. In those days you had to get a license from the city to sell newspapers, which came in the form of a metal button. He still had it, and always kept it on his desk, no matter how many times he changed his office.

Joe was the most complex and simplest man I ever knew. He achieved all his fame and fortune in the film business, but never lived in L.A. He had no education, but recognized Andrew Wyeth's talent before

most of the art world did, and ended up owning the largest collection of Wyeths in the world. He applied this intelligence to his advantage in choosing screenplays. "Listen, kid," he would say. "Most people in this business think I can't even read." He out-promoted, out-advertised, and out-spent the major studios, and was able to help get Sophia Loren the Academy Award for Best Actress despite the fact that she'd appeared in a foreign-language film—an unheard-of accomplishment at the time.

And he had no illusions about the business he was in. "Sometime in the 1960s, I got religion," he once said. "Everyone told me to make family films. So I made eight of them. Even my own family didn't go see them."

(We were once in London together when Joe, who was loved by the British press, met with reporters to talk about a new film he had just purchased, *The Night Porter*, which no one had yet seen. When a very cultivated female reporter asked him, in a clipped British accent, "Mr. Levine, would you call *The Night Porter* a family film?" Joe replied with dignity, "It depends on your family, dear.")

Joe was the most unaffected man I ever knew. We were very familiar, and had the practice of always kissing each other hello. Once, at his office, we were involved in a high-level executive meeting, and I was the last to arrive. There must have been at least ten businessmen in the room, and I came in and shook everyone's hand as the introductions were made. When I sat down, Joe glared at me and said, "What's the matter with you"—gesturing to the men—"just because they're here?" I got up, and as we had always done, I leaned over and we kissed hello.

* * *

I once asked Joe how he had come to make *The Graduate,* starring the then-unknown Dustin Hoffman. He told me Mike Nichols had directed a play, *The Knack*, at a theater that Joe owned a piece of, and they had met and Joe had asked him if there was anything Mike wanted to direct for his first film. Mike gave Joe a copy of the book *The Graduate.* After Joe read it, Mike asked what he thought of the story. When Joe said he hated it, Mike said, "Well, I guess that's that."

"No," Joe said. "I believe in you, and if you want to make the film, I'll back you."

Then, while *The Graduate* was being prepared, Jack Warner, head of Warner Bros., called Joe and asked him for a favor: would Joe consider letting Mike Nichols out of his *Graduate* contract to direct Warner Bros.' *Who's Afraid of Virginia Wolff* first? Without hesitation, Joe said sure.

When he told me this, I was even more touched by Joe's humanity. "That was very generous of you, Joe," I said.

"Yeah," Joe said with a smile. "I let him learn on Jack's money."

(That sharp business sense stood him well. A few years later, Jack Warner sold his studio in Burbank—with all its sound stages, its enormous real estate, an extensive film library, and a great name—for $32 million. Two years later, Joe—with no real estate, no studio, a meager library, and virtually no company name—sold his company for $40 million.)

* * *

Joe Levine had a rich, full career, with many accomplishments to be proud of. Being his friend, I also knew a few of his regrets, such as:

Letting Dore Schary, then head of the Anti-Defamation League, talk him into calling Mel Brooks's first film *The Producers* instead of *Springtime for Hitler*, its original title.

Not being able to film *The Poseidon Adventure,* even though he owned the property. (When he sold his company, he became an employee of a conglomerate and he couldn't convince them to finance the film.)

Not being a younger man when the pay-TV and home-video explosion took place. (He was in his late seventies by then, and often said he would have been making thirty films a year if he was just in his sixties.)

Joe was truly a powerhouse force in my life. He appeared on my radio show at least ten times. He lectured at classes that I taught, and occasionally we went on the lecture tour together. He did two interviews on TV with me. He and his wife, Rosalie, threw a wedding party at the Plaza Hotel for my former wife Beverly and me. (He always said if

I ever got married again, he'd throw the party.)

We even flew to his hometown of Boston to launch my radio show. On the plane, we hit some bad turbulence, and Joe grabbed my arm and said, "If I die because of your *fakakta* radio show..."

Near the end of his life, we didn't see each other as much as we had in the past. He claimed it was because I had become rich and didn't need him anymore, but that wasn't at all true. I was newly married, running my own company, and spending a lot of my time in L.A. But facts didn't matter to Joe. He was convinced.

Nevertheless, one day he called me and said, "Kid, you ready for another dog-and-pony show?" This was his way of saying we would lecture together again—this time at Tufts University. We spent the day before the lecture in Boston, and the next day Joe, then seventy-nine years old, appeared before hundreds of students—many of whom had never heard of him. By the time we had finished, he had charmed them all.

On our way home, at the airport, Joe said, "You know, I feel alive again. I love doing this. Will you do it again with me?"

"Sure," I said—and a curious thing happened. His eyes got moist, and he just stared at me for what seemed like a long time. Then he said what he had often said in the past, but deliberately: "I love you, kid."

As he turned to leave, I said to his back, "I love you, too, Joe."

And I never saw him again.

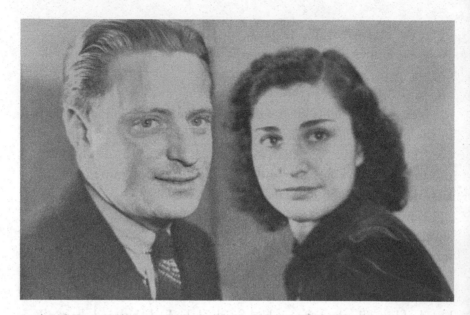

Dad and Mom

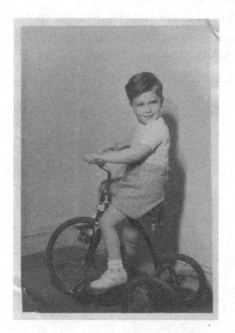

Even as a kid driving myself into a corner

During my Little Lord Fauntleroy period

Merryn marries me

"A woman for all seasons"
(at Hampton Court)

A happy moment with Elia Kazan

A few of my favorites. (top L to R) Debra Monk, Alan Arkin, Valerie Harper, Elaine May, Marlo Thomas, Bernadette Peters, Herb Gardner (bottom L to R) Merryn, Me, Mom courtesy of Joe Vericker/PhotoBureau

Celebrating with Elaine May

Hanging with Marlo Thomas

On set with Twiggy

Dining at home with Ted Sorenson

Talking with President George H.W. Bush

"the golden age of comedy"

Both radio and early television continued to have an influence on me, long into my career. Radio, of course, fueled the imagination. You were out on the prairie with the Lone Ranger, frightened listening to The Shadow, and walking down the steps with Jack Benny to visit the money in his vault. And early television had given birth to my first production, *Ten from Your Show of Shows*.

Now running my own company, I found myself wondering what else I might bring back that could attract an older audience, and perhaps engage a younger one too. The concept had worked for me in college with *Blackboard Jungle,* and then with *Your Show of Shows.*

And then I remembered Steve Allen, the man who had started *The Tonight Show.* (And that was before Jack Paar, Johnny Carson, Jay Leno, and Jimmy Fallon!) I had to try to find him—and before long I did find him through his attorney, who arranged a meeting.

At our first meeting, Steve told me how much he had enjoyed *Ten from Your Show of Shows*, and said that was why he had agreed to meet. I explained that I wanted to do something similar with *The Tonight*

Show, if he still had copies of those programs. He said he didn't have many, but he did have lots of copies of his Sunday night NBC show.

That was good news to me. Growing up, I had loved that show. While some of my peers were watching *Maverick* on ABC and others were watching *The Ed Sullivan Variety Show* on CBS, I was glued to my TV laughing at the wild antics of Steve and his sidekicks. The regulars included stars like Don Knotts, Tom Poston, and Louis Nye; other major comics like Mel Brooks, Bob Hope, and Jerry Lewis made guest appearances.

I explained to Steve that I would have to screen the shows and recommend to him the sketches I wanted to use. It would be a collaboration, but since I was going to personally finance the venture, I had to have an equal say. He said he understood, but would have to check the contract I was prepping with his lawyer. I remember thinking *Oy vey,* but dutifully sent a copy and waited.

Well, talk about a rewrite. Having sent the contract equivalent to a short story, I got back *War and Peace!* But I sent that tome to my attorney, and eventually the two lawyers reached an understanding that I could live with—equal collaboration remained.

It was easy to agree on certain sketches: Big Bill Allen (the sportscaster who continues to crack up), the famous "man on the street" interviews, Mel Brooks and Carl Reiner's hilarious "2,000-year-old man." This was proving to be even easier than finding the gold in *Show of Shows.* In fact, we had so many famous comedy names and so many funny sketches that I suggested to Steve that we do two one-hour TV specials. He wondered why we couldn't do one movie instead. I explained that fifteen years had elapsed since his show had played, and we couldn't be successful nowadays theatrically with an old TV show. The price of a film ticket had increased greatly, plus there was now competition from pay and basic cable and video cassettes. Reluctantly, Steve agreed.

During the screening process, Steve would often recall some wild and crazy sketch, and almost always I loved it as well. After we chose all the segments, I had to get the performers' releases. We offered a

stipend and a "favored nations" clause in the release. ("Favored nations" means that everyone will receive the same amount of money, no matter how big they are.) I dreaded the prospect of sending this release to the manager or the agent or the attorney or all three—but to my surprise and delight, it went relatively smoothly. Eventually, all signed.

So now we had lots of pearls, but we still needed the string. Steve was the obvious solution. He would be the host. In addition, because he played the piano well, we contacted the folks at Steinway to provide us with a finely tuned new piano for a film credit. I hired a director, Anthony Potenza, who had previously edited many of my documentaries. I found a New York City studio, and the director and I conceived of the set, mostly featuring the Steinway with blow-ups of pictures from the two shows.

Steve, a prolific writer of music, lyrics, and books, wrote the wraparounds and even played the piano at certain interludes. He was at all times totally professional. But we never developed much of a relationship. For me, that was unusual. By this time, I had spent twenty-five years in the business. Almost to a person, the people I chose to work with—especially those I held in high regard—became friends of mine. Sometimes, it even went beyond the work. But not with Steve. (Nor with Sid Caesar. Apparently, early TV comic stars were not my strong suit.)

We shot in New York City for a few days. On the second day, Steve called to say he wasn't well. I ran over to his hotel, called my doctor, and got Steve into a cab to the doctor's office. He had food poisoning. I brought him back to his hotel, went to the pharmacy to pick up his prescription, raced back to his hotel. The next day, Steve returned and expertly shot the rest of the wraparounds. He was even more friendly with me than usual—his own way of saying thank you, I suspect.

We sold the two specials to HBO/Cinemax and many other cable systems. One was called *Steve Allen's Golden Age of Comedy* and the other was *Steve Allen's All the Best*. It was distributed on VHS cassette and proved to be a success.

* * *

At this point, it seemed to me that I had a winning formula. What else could I bring back from TV? But the business is not always predictable, and my next effort in that direction would not prove so successful.

Ed Sullivan's *Toast of the Town* was owned by his family, and they were planning to do many specials, which they eventually did. I couldn't think of any, and then one day I received a call from a representative of Milton Berle. He said Mr. Berle had seen my specials and wanted to know if I wanted to do the same with his Texaco Star Theater.

I said I was very interested, but needed to speak directly with Mr. Berle. The next day he called himself, and immediately told me to call him Milton. He was complimentary about both *Show of Shows* and the Steve Allen specials. I thanked him, and he confirmed that he had many copies of his show, which he agreed to send me.

I couldn't wait to view these shows I had grown up with. Berle had been so big on Tuesday nights at eight that restaurants around the country closed during that time, rather than be empty. He was and deserved to be known as Mr. Television. And to kids like me, he was Uncle Miltie. So it was with great excitement that I started watching the one-hour shows when they arrived. Milton often appeared in drag, and there was lots of slapstick and plenty of low humor. The live audience howled and clearly loved it.

But it was now forty years later. The magic that television had offered was gone—and to me, sadly, it just wasn't funny.

I felt terrible telling Uncle Miltie's representative that I was sorry, but I wouldn't be producing Mr. Berle's show. But I knew it was the right move for me. I decided to quit while I was ahead.

summit studios

"I would like to meet with you," the voice on the phone said. This was spoken in a thick Italian accent.

It was sometime in late 1988, and it was not unusual for me to receive a request for a meeting with a European. Much of my background had been in exhibiting European films, then buying and selling them at Castle Hill.

However, I had no desire to take this meeting. First, I didn't know the man; and second, though he needed me to come to his hotel, he could not—or would not—tell me why he wanted to see me. So I told him to forget it.

But he kept calling. So I stopped taking his call. Finally, he left a message explaining that he wanted to hire me as a consultant. Since his hotel happened to be near where I was going to be lunching one day, I agreed to a late afternoon appointment—but, I warned him, just for fifteen minutes. I thought it was a waste of time.

Sergio (not his real name) was totally prepared. Because my time was limited, we dispensed with the small talk. He reached into a black

attaché case, pulled out a large folder, and handed it to me.

It contained page upon page of information about me. This was before the Internet, and I marveled at the work that had been done. But I was also more than a little annoyed at how much he (and probably others) knew about my mortgage, my apartment, my maintenance, my bank accounts, my medical records.

He explained that he was representing a group that wanted to start and fund the largest motion-picture studio in the world. When I asked if he had any idea how much money that entailed, he replied, "Money is no problem." They had done their research: they had allocated $360 million for the first year, just for production. That would make them number one in the world in their very first year, as far as film expenditures.

"So what do you want me for?" I asked.

"We want you to run the new company."

I laughed. "There are many people much more qualified than I am," I said.

"No," he replied, "not for what we want. Your background is unique. You have been a film distributor. A film exhibitor. You've worked for a major studio in film production. You have dealt with the European and Asian filmmakers. You've had a radio show about film, and you've been recommended by both studio heads and producers."

"Okay," I cut him off. "I see you've done your due diligence, but where's the money coming from?"

At this point, fifteen minutes had elapsed. "Do you have the time?" he asked with a slight grin.

"Oh, all the time in the world."

"The government of Singapore is part of the funding," he said. I shook my head in disbelief as he continued. "They hired Columbia University to find out how they could become better known in the world. Are they a city? A state? A country? Well, in truth they are all three. The report came back and said that the fastest and best way was either by partnering with a sports figure like Muhammad Ali or Pele, or by producing motion pictures. They've decided on motion pictures."

"And they have enough money?"

"Please let me go on. Hong Kong, in 1997, is becoming part of mainland China. Taiwan, since 1949, is a very volatile country. The only stable capitalist Chinese country in the world is Singapore. So the government has been embarking on a program to grant citizenship and a passport to any Chinese personage who turns over one million dollars, interest free, for twenty years. They have many millions of dollars now, and more coming in, especially from Hong Kong."

"Well, you said Singapore was part of the group. Who else is involved?"

"I've already told you more than I should. Are you interested?"

I sure was, and I'm sure he knew it. I had wanted my shot at running a studio, and here, out of nowhere, was my chance.

"Yes, I'm interested," I said, "but I already have a successful business. I'm my own boss. I will cost the investors a lot of money, and even more importantly, I insist on autonomy. I don't want government bureaucrats questioning me. If I'm hired, I have to decide on the movies we will make, the stars, the directors, and everything else."

"Of course," he said. "You will have all that."

"What's the next step?" I asked.

"Tell me who your lawyer is, how much you want for your company, who you want to hire, who..."

"Sergio," I interrupted, "wait a minute. Let's see if we can make a deal first. Let's do this step by step."

"Fine, I'll call you tomorrow. You will take my call, right?"

We had spent two hours together. This was too good to believe.

I knew whom I wanted to represent me. He was one of the most celebrated and powerful attorneys in Hollywood, and one of the few lawyers who was tough with the studios. Most of the studio heads feared and disliked him. I'd had a personal relationship with him for years, though we had never done business together. I hadn't been able to afford him—but perhaps I could now. His name was Bert Fields.

Sergio called the next day. He knew of Bert.

"Is he a deal maker or a deal breaker?" he asked.

"Deal maker," I answered, "but a tough one."

"Okay, but I may have gone too fast. My people want to consult with you, and will pay you for the privilege. We need time to put all the wheels in motion."

Well, I thought, *that didn't take long to fall apart.* Head of the studio one day—the next, a paid consultant. Who knew what tomorrow would bring? This was sounding more and more like a scam to me.

"C'mon, Sergio," I said. "What happened to the largest film studio in the world? And me running it? And the city, state, or country of Singapore?"

He laughed amicably. "Let me have your bank account number," he said.

"You have that already."

"Not the wire transfer number."

"Okay, I'll send it to you."

Strange as it may seem, this wasn't a scam either. The money was sent to me, and I began looking for projects.

I flew to Los Angeles, where I went to an office building on Santa Monica where I was instructed to go. There was an entire floor of mostly empty offices. I was given a large one with a view. I met a man from Singapore, and a second man from Italy. Both had accents, but did not speak English well.

Meetings were held, and I vetoed everything proposed. I continued to run Castle Hill. That was part of my deal.

Then Sergio called to tell me everything was set. All the money was in place. We just needed a major studio as a partner to distribute the films.

I called my good friend Terry Semel, the co-chairman of Warner Bros. I told him about everything, and he said he'd check it out. Within twenty-four hours, he said, "This is totally legitimate, and I feel it's your chance of a lifetime. By the way, we're interested in being in business with you."

Wow! Warner Bros. wanted us—or at least our money.

But there was another wrinkle. On a subsequent phone call I found out that we needed to co-produce three films with a major studio. I had been telling Sergio that it would take at least a year to have a major film released. My new people wanted to move faster—hence the three-film idea.

Terry agreed to the plan. All scripts currently shooting or about to shoot were sent to me. I read them all. The only one that truly excited me—and incidentally, remains one of the best scripts I ever read—was *Goodfellas*. Now I needed two more. Terry and I had already worked out the deal: Warner Bros. would keep U.S. and Canada, and our company would have the rest of the world in perpetuity. Warner would distribute for us at a reduced fee, and we would put up half the budgets.

I agreed to the second Steven Seagal film, an action thriller, since it was relatively inexpensive and Seagal's first film had done well overseas. (More action than talk—and action is understood in all countries.) Finally, Terry suggested we take Chevy Chase's next comedy. I hadn't responded to the script when I read it, so I reread it. I still didn't respond to it. But Terry insisted. "We were going to shoot it on location in most of your territories," he said. "Believe me, *National Lampoon's European Vacation* will do great."

So I had my three films. It was time to bring in Bert Fields to negotiate what would turn out, not surprisingly, to be a major negotiation. Meanwhile, the word was now out that a new studio was starting. Suddenly, I never had so many friends: movie stars, producers, agents, directors, writers. I had gone overnight from a wallflower to the belle of the ball.

It was an exciting time. Every script that had been sitting on writers' and/or agents' shelves was now coming in. I was reading so many that I told Sergio I had to hire two executives and a head of business affairs immediately. I gave him a budget for all three, and it was approved. (They had been paying for two secretaries—one in Los Angeles and one in New York—from the beginning.)

Then Bert called.

"It's taken months, Julian," he said. "We are almost there. But there's a deal-breaker, from Warner Bros.' point of view. Your people are insisting that their company logo go first on the screen."

Our company's name was Summit Studios, along with the words "of Singapore." (Columbia University's study had been adhered to.) So they wanted *Summit Studios of Singapore* and *Warner Bros. Presents,* in that order.

I talked to Sergio about this until I was exhausted. "Warner Bros. is an old and well-known name," I argued. "We're new and unknown. Warner Bros. started sound in films; we did nothing. Let me speak to someone and talk some sense to them."

But it fell on deaf ears. Finally, I called Bert again, and suggested that maybe Warner would let us be first overseas only. No such luck. "They've rejected that," he said.

Things were falling apart. There were starting to be other problems internally, too. The Italians and the Chinese in the Los Angeles office were at odds with each other, with me in the middle trying to soothe each side. The Chinese did not like to be yelled at by the Italians. Their leader confided to me, "No one in my life, including my wife, talks to me that way." I explained that Italians were emotional people, who talked with their hands and raised their voices to make their point. For their part, the Italians told me that the Chinese just stared at them. They had no idea what they were thinking or feeling. They seemed to have nothing but disdain for the Chinese, and no longer wanted to meet with them.

And then…silence.

Sergio stopped calling. The men in the Los Angeles office were suddenly gone. I couldn't reach Sergio or any of his people; neither could Bert. But it was clearly legitimate; it had gone on for a year. Bert had been paid. I had been paid. I had flown to Singapore with Warner's head of business affairs, Jim Miller, to announce the new company. Sergio and his people had been there as well. Bert told me there was only one other partner, and he wished to remain anonymous. He was, I would later learn, the richest man in the world at the time, the Sultan of Brunei.

Still, it was all over now—as quickly as it had begun.

I never saw or spoke to Sergio again. We had traveled the world together. I knew his wife well, along with many of his friends. I even knew his favorite restaurants in New York City, Los Angeles, and Rome.

Five years passed. Then one day I opened a large manila envelope marked *Personal and Confidential.* It was a menu from the Post House restaurant in New York City—Sergio's favorite. There was no letter or note with it.

I examined it for a while and then, finally, I saw on the bottom of the back, written in small letters, *Thinking of you.*

Not enough, apparently!

To this day, I've never found out what happened to the whole venture. As far as I'm concerned, it was just another case of easy come, easy go in the film business.

"in the spirit"

Bill Chaikin and I were good friends; as I mentioned before, it was he who had given me an option on Neil Simon's *Little Me.* He lived in Los Angeles and was semi-retired. In the mid-'80s, while I was bi-coastal, we saw a lot of each other.

I went to him with a comedy script that I wanted to produce as an independent movie. I had Peter Falk in the cast, who was then starring in *Columbo,* as well as Marlo Thomas and Elaine May. There were roles for other actors uncast at that time. The budget was low—I think $1.5 million. Bill was a member of the Hillcrest Country Club, and arranged for me to meet with many of his wealthy friends there.

There were about fifteen men present. I made my pitch about financing the project. The minimum investment was $100,000, and the maximum was $200,000. All the actors would work for scale. All money that was earned would be returned to the investors until their investments were fully realized, then they would receive fifty percent of the profits. Peter, Elaine, Marlo, and I would own the other fifty percent.

I explained that Castle Hill would only be the distributor if I was

unable to sell it to a major studio or mini major. However, unlike with many independent films which never get released, I was guaranteeing distribution.

We needed a director. Marlo knew of a great acting coach, Sandra Seacat, who had worked with some of the biggest stars in Hollywood. She had previously been an actress, and now she wanted to direct. We met and hit it off, and she was hired.

We had three more important roles to cast, too. Sandra knew Melanie Griffith and sent her the script, and she agreed to be in the film. Marlo was friends with Olympia Dukakis, who also happily joined our group. And Elaine's daughter Jeannie Berlin, who had co-written the script, signed on too.

I was excited to be producing my first commercial motion picture. By this time, I had made documentaries and compilation films. But this was the real deal: stars, crews, shooting schedules, locations.

Still, I knew it was a risky venture. We had a first-time director, a first-time director of photography, and two first-time line producers. We chose Sandra because we were confident she would be a terrific actors' director; we chose Dick Quinlan as our director of photography because he was a top lighting director and gaffer. And my then-wife Beverly and I, as the film's producers, felt we knew enough to handle the job. But along with our stars, none of whom had ever acted in a low-budget film, it was a lot of firsts.

We needed an exterior of a house that could double for a Beverly Hills mansion. We also needed a home with lots of grounds that we could use for both exterior and interior shooting, and that could double as an ashram (or spiritual retreat). And finally, we needed two apartments, where lots of scenes took place.

An old friend of mine, Joe Friedman, was in charge of the New Jersey Film Commission. Joe found the Beverly Hills home in, of all places, Newark, New Jersey. The ashram was a house for sale that had been stripped of all furniture; for a reasonable fee, it was ours for ten days. Joe even found us the two apartments. We were all set.

Not so fast.

We had some exteriors to shoot on the grounds of the ashram, so I had one of my assistants call Newark Airport to find out the flight schedules of all the airlines flying overhead. (The sounds of aircraft could drown out the dialogue, or at the very least impair it.) We had a beautiful day to shoot. No rain. No clouds. No fog. Nevertheless, it took hours to get two important scenes. It was crazy: every time we would start shooting, the sound man would signal trouble. Sometimes we all heard the noise; other times, he picked it up in advance. We finally got the scenes completed quietly. But despite all the time we had spent on the phone with Newark Airport, the plane traffic did us in.

W.C. Fields warned, "Don't work with children or animals." We had no children to deal with, but we did require some dogs. That didn't appear to be complicated. We hired a dog handler, and he brought his two dogs. In one scene, the dog on cue had to jump into a hole. Another scene required it to lie dead. And in another scene, another dog had to wander into a garage as if it were lost. When we were shooting the dog jumping in the hole, the handler was unable to get him to jump in on cue. He jumped in too late. Then he dove in too early. Finally, the trainer rubbed chicken on the actress in the hole, guaranteeing the dog would respond on time. The dog was still unable to do it on cue.

Laurie Jones, who had co-written the script and had a small role in the film, owned two dogs. She had brought one of them onto the set. "I can get Franklin"—her German Shepherd—" to jump in on cue," she said. We said okay, let's give it a try. The dog trainer stood by, and by the look on his face, doubted this plan would work. But Franklin did it right on the first and second take, and we were done.

The second scene required the same dog to lie still, as if he had died. The handler said it couldn't be done; we would see him breathing. Again, Franklin did it on cue. We sent the handler packing.

Laurie then brought in her second dog Stanley, a part black Labrador whom she assured us could easily wander in on cue. When we shot that scene, Stanley was superb. I dubbed him "One-take Stanley," and we

all thanked Laurie, who had saved us time, aggravation, and money.

We finished shooting. Then we edited for a year. Low-budget films are not easy to do well. We had to cut corners, compromise a lot, and work with stars not used to performing in such primitive conditions.

We were able to sell the film to Warner Bros. They had all the foreign territories in the world; we kept the U.S. and Canada. The investors got most of their money back. And so did Peter, Elaine, Marlo, and I, all four of whom had put up our own money to complete the film.

We were going to open in New York City in 1990. I asked Elaine if she would write a promo for the film. She said she didn't exactly know what I meant. I said, "You know—the story of the making of the film." She asked if I could send her a few examples, which I did.

After she watched them, she said, "They're a bunch of crap. They all talk about how much fun they had making the movie. I'll write one, but it won't be like that."

She did write and direct one, with all of us in it. It was better than the movie! All the cable systems ran it—HBO, Showtime, The Movie Channel, and many others. (It's still on the Internet. Just search for *In the Spirit Promo*—I think you'll enjoy it.)

I admit, that experience took a lot of energy and left me exhausted. I had raised the money, line-produced the film, worked almost every day in the editing room, and then gone out to sell the movie. I remember at the beginning of filming telling Terry Semel, "You can make films independently for peanuts." He had answered, "Yes, I know. But see if you'll want to do it again when it's all over."

He was right. I didn't want to do it that way ever again.

And I never did.

midlife crisis

Passages was a best-selling book by Gail Sheehy. It described the different life phases we go through as we mature. All of us experience those benchmarks, those periods when changes occur in our lives. Sometimes the passages are major, and sometimes minor—but they're often memorable.

When I was producing the movie *In the Spirit*, my second marriage was on the rocks and I was under a lot of pressure. I had two very attractive assistants, and the three of us joked and flirted with each other constantly. It was harmless and fun, and a release for all of us.

One Monday morning I arrived very early, and was surprised to find one of the ladies already there. It was a good two hours ahead of the call time. As soon as she saw me, she said, "I thought about you all weekend."

"That's funny," I replied, "I thought about you too. What did you think about?"

"I thought how great it would have been if you had been my father."

Dead silence.

"Are you all right?" she asked. I'm sure I had turned as white as Casper the Ghost.

"I'm fine," I said. "Just fine. I'm just going into my office now to be alone. No calls, please."

I closed the door and put my head in my hands for a while. I kept thinking, *Is it possible that this girl, whom I see as a potential romance, could think of me as a father figure?* I did the math: I was forty-six; she was twenty-four. Of course, I *could* be her father. But to quote William Bendix at the end of his radio and television show *The Life of Riley*, "What a revolting development this is."

For the first time in my life, I realized I was a middle-aged man.

the big o and his daughter

An American convention is held yearly, called NATPE—the National Association of Television Program Executives. Castle Hill would attend religiously, along with buyers and sellers of films from all over the world. We would either take a suite in the main hotel where it was happening, or have a booth on the convention floor.

In 1991, in Los Angeles, two men walked into the Castle Hill suite without an appointment. They said they represented an unreleased film that Orson Welles had starred in and directed. I asked if it was *Chimes at Midnight,* which I knew hadn't been seen for years. They said no, and added that this one had been in storage for almost forty years.

I said I could be interested in distributing it. Welles was a great filmmaker, but had directed very few films. They then added that all of the worldwide rights were available.

I asked what the name of the film was. They refused to tell me, then left the suite, promising that they'd be in touch. I was disappointed. But since neither of them were in the film business, I had no idea if this was real. (And by the way, if they *had* been in the film business, I

almost certainly would have felt the same way—but at least I could have checked them out.) All I knew was that they were lawyers who would be returning to their hometown, Chicago, right after our meeting.

Our company was somewhat unique. We represented the films of some of the great movie directors—towering talent like Alfred Hitchcock, Elia Kazan, John Ford, and Ernst Lubitsch. Few independent film distributors had those kinds of names. With us, an Orson Welles film would be in good company.

I wanted badly to represent a Welles film. But I wondered: was any of this real? Why couldn't they tell me the title? Were they meeting with other distributors?

A week went by, and no news. Two weeks—nothing. By the third week, it was looking bad. After a month, I gave up hope.

Then one day I was told I had a phone call from a Miss Welles. I didn't know who she was, but I took the call anyway. She explained that she was Orson Welles' daughter and would be in New York City the following week and wanted to meet. We set up an appointment.

I was prepared to greet what I envisioned to be an older woman who, considering her father's girth, would be, well, plump. (Remember, there was no Google to check people out at this time.) Instead, into my office strode a tall, willowy young blonde who reminded me of a model. (In fact, it turned out she *was* a model.) Beatrice was the youngest daughter of Orson Welles and an Italian countess. She lived in Las Vegas, and was the founder of a cosmetic line and a designer of jewelry. She had been directed to me by the two attorneys I had met at NATPE.

She told me the film was *Othello*. I knew Welles had made *Macbeth* and his version of *Falstaff—Chimes at Midnight*. I didn't know of *Othello*. The film was in black and white, and Welles played the lead. Though there was a full cast, I didn't recognize the other actors.

I learned that there were two men in Chicago, Michael Dawson and Arnie Sachs, who were working on the restoration of the film. Edward Stone and Don Leibsker, the Chicago attorneys, were the restoration's executive producers, and the entire score was in the process of being

re-recorded. Welles had started making the film in Italy three years after World War II had ended, when sound recording was sadly inferior in the industry. So up-to-date equipment would be necessary, these forty years later. It had taken Welles four years to complete the film. He kept running out of money and had to use his salary as an actor from *The Third Man* and *The Prince of Foxes* to continue shooting and editing.

When the restoration was complete, the film was sent to me to screen in New York. It was a fine film, with an excellent new score re-created note for note. Sadly, however, it was often out of sync. In some parts, the actors' lips moved but dialogue could not be heard. Beatrice and I had dinner afterwards, and I said, "This cannot be shown in its present form. We need to record an entire new sound mix, and the film must be put in sync." Beatrice agreed.

Now came the task of finding a top sound mixer. Lee Dichter is one of the best sound mixers I know. He has worked with the top New York film directors—Mike Nichols, Robert Benton, Woody Allen, and Nora Ephron, to name just a few.

I called him to ask if he could look at *Othello*, but he stopped me cold and said, "I'm totally booked for over a year." Knowing his high professional acumen, I had an idea. I asked whether he would at least look at the first reel and give me some advice. Reluctantly, he said he would, and on the given date we screened the reel.

The first few minutes of *Othello* are breathtaking. There is no dialogue, but the photography is unbelievable—incredible visuals of a funeral procession, with Welles as a corpse being carried on wooden wheels; a man in a cage being pulled up the side of a huge castle—and operatic voices plus a full orchestra accompanied all these magnificent images.

Lee is an artist. I knew he would be in awe of what was on the screen. Sure enough, he turned to me and said, "You son of a bitch! I *have* to do this film. But I can only work weekends and some weekdays for a few hours after six p.m."

I thanked him. I was relieved, ecstatic—my plan had worked.

It took many months to complete the movie. Our enhanced version

of the film was accepted at the Cannes Film Festival. In 1952, it had won the Grand Prix at the festival; in 1992, we played out of competition at the Palais. As I described earlier, we walked the red carpet. It was a great sendoff for the film, and Welles' genius was rediscovered.

It was truly a highlight of my professional life. That evening after the screening, we had a party nearby to celebrate, and the actress Emma Thompson made it a point to find me and let me know how grateful she was for what we had done. She had just come to the party to tell us that, and she left immediately afterward. I'm still touched when I think of her kind gesture, and remember what our work can mean to the people within our industry.

After doing some research, I was able to find out some of the film's history. Despite winning the Grand Prix in Cannes, no distributer in the United States had wanted the film. Three years had gone by. Then in 1955, United Artists had agreed to open the film in New York City only. It played at the Paris Theater and did no business. Despondent, Welles had put the negative in storage, where it had languished until Beatrice, the Chicago gang, and Castle Hill brought it back to the world.

Beatrice did many interviews and was a big plus in getting us publicity. One day she called me, upset. She told me she'd had an interview with the largest paper in Las Vegas, and they'd written about her childhood, her parents, and her company.

"Why are you so unhappy?" I asked. "It sounds like a fine article."

"The last line is not what I said," she told me.

Regarding interviews, I was used to hearing that sentence coming from many people's lips, including my own. So I asked, "What exactly is the last line the reporter wrote?"

"She quoted me as saying, 'She's most excited about the new release of her father's film, *A Fellow*.'"

Hard to top that one!

michael palin

Michael Palin, of the Monty Python troupe, had starred in a new film called *American Friends,* for which he had also written the screenplay. His co-star was Alfred Molina. I had screened the film in London and had liked it, so I made a deal to open it theatrically in New York and Los Angeles and had been told Michael would do some publicity in both cities. His first stop was New York, and we arranged to have breakfast at the Ritz Carlton Hotel on Central Park South.

This was in the early 1990s. We were both on time and immediately started kidding around. At one point he said, dead seriously, "I've always wanted to make a movie called *Conan the Librarian.*"

"I know the tag line to the ad," I answered quickly. "It should read, "Don't Forget to Return the Book."

That was it. I can point to that moment as the time our friendship cemented.

American Friends did reasonably well—enough for us to sell it to home video, pay and basic television, and then into TV syndication. It was a modest success for my company, but a big success for my

relationship with Michael.

About this time I traveled to London and began dating my future wife, Merryn, with whom I would ultimately share the rest of my life. Our very first double date was with Michael and Helen Palin. After that, we saw the Palins on every visit to London. And it was Michael who encouraged me to see two plays then showing in the West End, both of which would help my producing career: *City of Angels* and *The Beauty Queen of Leenane.* (More about that later.)

Inevitably, when Michael came to New York City, we'd have a fun dinner or lunch together. Sometimes it was in our home, and sometimes at restaurants. He would always regale Merryn and me with stories from his many travels all over the world. His series of adventures were broadcast on A&E television, where viewers would learn of exotic and faraway destinations, with Michael as their guide and host.

We dined together in London as religiously as we did in New York. We never failed to enjoy our time together. And then, suddenly, it stopped. We lost touch. I can't say how or why. But I can say I have found that such breaks are common in the entertainment field. You eat, sleep, and drink alongside someone on a film for months; you rehearse a play for six days a week, for more than a month, and perform it together even longer. During that time, you are inseparable. And when the play or movie is over, often so is the relationship.

I first began to recognize this phenomenon one night when Rod Steiger appeared on my radio show. I had reminded Rod about his famous scene with Marlon Brando from the classic movie *On the Waterfront,* in which Rod plays the boxer Brando's older brother. In a poignant and powerful scene, one of the most heralded in movie history, Brando says painfully to him, "I coulda been a contender." I asked Rod, "Do you and Marlon ever reminisce about the film?"

"Mr. Brando and I haven't spoken since we made the film," he replied.

That interview took place twenty-five years after the film had been made. So I find it interesting to relate that this happens very often, to a

great many people. Since I myself have friends from elementary school, high school, and college, it took a while for me to get used to the fact that many of my industry's "close" relationships would not last. But now, with that in mind, I just try to enjoy and savor the fun times with a lot of people—and recognize that, like Chinese food, it can pass quickly.

name-dropping

In April of 1993, I was invited to a small birthday dinner party in New York City for Barbra Streisand at her home. I accepted, and a week before the party I was told that Liza Minnelli was now hosting the party at her home—and it was no longer small. In fact, it was now a buffet party, with about sixty or seventy people attending.

I politely declined. I've never been comfortable with strangers making small talk—and besides, I was single at this time and trying to recover from a messy divorce and a breakup with a much younger girlfriend. But then Barbra called. She said she had bumped into Jack Nicholson, and they found they shared the same birthday. (Month and date, not year.) He had asked whether they might merge the two parties. She said she wanted me to come—a personal call—so I agreed.

Liza had a large, beautiful apartment on the East Side of New York City. When I walked in, it was already crowded and noisy. I recognized no one, except some celebrities I didn't know. I was standing at the entrance to one of the main rooms when I heard my name called out, and I saw Barbra and Liza making a beeline to me. The entire party

stopped talking, looked, and seemed to wonder who the hell was this guy that they were both rushing to.

I didn't know Liza, but I heard Barbra say to her, "He's the guy I told you about." Then each took one of my hands and led me to a deserted room. I had no idea what was happening or where we were going, but I felt great—almost giddy. Then I saw it.

On the wall of this room, beautifully preserved, were the original designs of the Radio City Music Hall. It turned out that Liza's father, the director Vincent Minnelli, had drawn them. Sensing my sincere interest, Barbra and Liza left me alone, and I spent a good deal of quality time studying those unbelievably intricate designs.

After a while, I began to get hungry—really hungry. I had to find my way back to where the eats were. And what a spread! Fantastic food—as good as the captain's table on a cruise. I piled on my food and looked for a quiet spot to eat.

I found a room, empty except for a bartender, and sat down on a bench window. Halfway through my feast, someone said, "Excuse me," and walked past me to the other end of the bench. It was a woman's voice, and I didn't look up—I just made room so she could get by, and kept eating. My solitude had been intruded upon.

"Are you a friend of Jack's?" I heard from across the bench.

"No, Barbra's," I said, and finally looked up.

It was Michelle Pfeiffer. She was beautiful, with very little makeup on. She told me that she and Jack were then shooting the film *Wolf*. We talked for quite a while. No one, not even the silent bartender, interrupted. There was no artifice; there was no trace of the Hollywood movie star. Just an intelligent woman and a quietly excited guy talking. The most animated she became—and I found it quite touching—was about a new baby in her home. She was a proud and happy single mother and felt no qualms about sharing her joy, even with a stranger.

Eventually, she left the room to return to the party, and I sat alone for a while, daydreaming away. Then I went into a large room where party talk was going on, and I saw Mike Nichols beckon to me. I was

thrilled to see a familiar face. We chatted a bit, then were joined by Jack Nicholson. All three of us had a fine time talking. Out of the corner of my eye, I saw Michelle leaving the party, and I realized it was probably also time for me to say goodbye to Barbra and Liza and thank them.

All of a sudden, someone tapped me on the shoulder. I turned around and was surprised to see Michelle with her coat on. She said, "I was at the elevator and realized I hadn't said goodbye." She stuck out her hand.

I shook it and she left. I found Barbra and Liza, said my thanks and goodbyes, and went home. I had had a great time. I should add that there was never a moment with Michelle that she'd had the slightest interest in me as anything but a fellow human being.

I wish I could have said the same.

"vita & virginia"

I was dating a girl who lived in London. My mother found that hilariously funny. "When you were younger, you wouldn't date a girl who lived in Brooklyn," she said. "Now you're flying to England."

But Merryn, who would become my wife, was worth it. Then, now, always.

It was in London that I had lunch with an old friend, Simon Relph, a film producer. I asked him about a play in the West End called *Vita & Virginia*, about the relationship of Virginia Woolf and Vita Sackville-West. He had seen it, recommended it, and said it was closing in two days. Merryn and I attended its last performance, which starred Eileen Atkins and Penelope Wilton. It was truly an incredible afternoon. I hadn't heard the English language spoken so beautifully in years; I had forgotten just how lyrical and intelligent it can be.

Simon had given me the name of the producer, Robert Fox, whom I visited the following day. I told him, "I'm interested in bringing *Vita & Virginia* to New York."

"You know, I've just lost 190,000 pounds on it," he said.

"Well, I think it's a special piece, but I have some changes I'd like to make."

"And they are?"

"A new director for New York City. Eileen Atkins, of course, but I have an idea for the perfect Vita Sackville-West: Diana Rigg."

"Oh, she'd be good—but how do you feel about Vanessa Redgrave?"

"Sure, absolutely. Get Vanessa Redgrave."

Now, I have to set the scene properly. At this time, I knew next to zero about the theater. I had only co-produced one show—twelve years previously. Robert's office was very modest. Vanessa was a movie star; I thought he had little or no chance of getting her.

But he promised to call, and three weeks later he said, "Julian, Vanessa has agreed to do it."

I damn near fainted, but as if I had expected the news, just said, "Great." (I found out later that Ms. Redgrave had been Robert's mother-in-law when he was married to Natasha Richardson.)

The play was a literate but limited two-character piece, based on the letters of Virginia Woolf and Vita Sackville-West. It was adapted by Eileen Atkins, who had co-written *Upstairs, Downstairs*. So producing it on Broadway in the mid-1990s made no sense to me. In Robert's office I had told him the play should be presented in a large off-Broadway theater, and he agreed. There were only two off-Broadway theaters with 499 seats—the Variety Arts and the Union Square Theatre—so we would try to get one of them.

We also needed a director. Zoe Caldwell was suggested. I had not seen any of her work as a director, but I respected her work as an actress and was confident she'd be effective with the two leads. She happily agreed, and we now had all of the major elements we needed to start the producing process.

I left the theater in London very excited. I had ideas, thoughts, and plans—but I also had notes. I told Robert that, and he said, "Why not tell Eileen?"

He gave me her hotel number in Washington, DC, where she was

performing, and I called with some trepidation. I had never met Eileen. She had written a very successful series; I had only produced one play. Who the hell was I to give her notes?

But she was gracious. She agreed to some of them and disagreed with others, and I hung up pleased with our conversation. (And, I should add, on the ones she agreed with, she made the changes—and later agreed with one she hadn't agreed on at first.) I loved working with her right from the beginning.

Zoe, Eileen and Fox's partner Lewis Allen (who had co-produced the play in London), Zoe's husband—the legendary Broadway producer Robert Whitehead—and I visited the two theaters, The Variety Arts and Union Square. Everyone agreed, for this play, that the Union Square was best. In its configuration it resembled a London theater, with a wide orchestra and a small mezzanine. That was good for the intimacy we needed for a two-hander.

Vanessa was somewhat dismayed. She'd thought she was going to Broadway, and was surprised to hear of the new theater economics. (Also, her sister Lynn was going to do her one-woman show on Broadway.) All in all, it was not an easy beginning. But she finally accepted it, and loved the theater once she saw it.

I was sure that raising money to finance the play would be easy. The theater was under new management. This would be their first show, and to have Vanessa and Eileen would establish the theater quickly. They agreed, and invested about twenty to twenty-five percent of the budget. Robert, Lewis Allen, and I were responsible for one-third each of the remaining money. I had never raised any money for a theater production, and I decided I would put in some of my own money.

Now, this is not what a producer should do. He needs to get OPM—Other People's Money. But at that time, I didn't know how to ask anyone without saying I was investing myself. It was a nightmare. Most of my wealthy friends turned me down. They were still angry with Vanessa for her support of the Palestine Liberation Organization and her anti-Zionist speech at the Academy Awards.

I argued that that was fifteen years ago. "There has to be a statute of limitations," I said. "This is art, not politics." My words fell on deaf ears. I was in trouble.

I felt the play was a risk. I knew it appealed to a limited audience. But I had given my word. And I wanted to produce in theater. So with a heavy heart, I became one of the largest investors in the play.

I believed then (as I do now) that it was a good idea to take a show out-of-town first. I am often challenged about that, either by fellow producers or by the director or stars. The producers usually object for financial reasons; the others object for personal reasons, not wanting to leave home or family and friends. But I don't remember anyone resisting on this show.

We opened in Connecticut. The audiences disliked it a lot. Many walked out. It was too sophisticated for them—too many words. They hadn't been told anything about it. I was a basket case. Robert stayed in London. He had many other shows to worry about. I only had this one, and worry I did.

At the end of one evening in Connecticut, halfway through the run, I was slumped over a seat in front of me. One of my producing partners, there with me, was Meyer Ackerman. We had met many years previously, and he and I had partnered in two film theaters in Bennington, Vermont, as well as on *Widows' Peak*. He said, "I don't care what happens. I am proud to be presenting this play with you. It's a great evening in the theater."

It was like spinach to Popeye. And it proved, just like the play, the power of words.

On to New York City. Merryn and I attended the early previews. On the third or fourth one, we arrived just about curtain time. As we ran in to the theater, she whispered to me, "Why are these people standing around? Why haven't they taken their seats?"

Then we found out. We now had standing room only. We were on our way.

We had sold out the previews. In fact, our very first group took the

entire theater as soon as our first ad appeared. (The group was called Dykes on Bikes.)

But now we had to face the reviews.

The first line of *The New York Times* review was "Vita & Virginia Is Not a Play." I read that line three times. Not a play? *Not a play?* But *The Times* loved Vanessa and Eileen. And almost every other critic loved the show. (Incidentally, all the other critics thought it *was* a play.)

One of the strongest memories I have is of going to the show with Zoe Caldwell. Since the show was sold out, we would often lie on the floor in the back of the theater, listening. The standing room was only in the mezzanine; the orchestra had just enough room for us to lie on the floor. We would take turns peeking at the stage. It was quite an adventure.

Vita & Virginia broke all the box-office records for an off-Broadway show. Our top price was $45, and we were selling out every performance. We had a very profitable show. It was one of the most exciting experiences I ever had in show business.

"death defying acts"

Elaine May had written a one-act play entitled *Hotline* that I saw in Chicago. I thought that if I could get two more one-acts from New York City writers, I could have a great evening of comedy. I wanted all the plays to have an edge, be about neurotic, urban people, and, of course, be funny. I had read Woody Allen's short story *Death Knocks* in the *New Yorker* and wanted that to be a companion piece to *Hotline*. I also wanted a one-act by Herb Gardner, *I'm With Ya, Duke,* to round out the evening.

But you don't always get what you want.

Jean Doumanian was an old friend and a fellow producer, so I gave her copies of Elaine's and Herb's plays and asked if she and Woody (who was her friend) would join us. Very quickly she gave me the good and bad news. She and Woody would join us—if Woody could write a new play. I loved *Death Knocks*, but Woody didn't want to adapt it to theater.

Elaine and I talked it over and agreed. But Herb Gardner, who had said okay initially, now said no. He wanted to present an evening of his one-acts, and he wanted to put *I'm With Ya, Duke* in that evening.

216

I tried to convince him he could still do this evening another time, but he remained adamant, and I started looking for another writer.

Then one morning, I read a long interview with David Mamet in the newspaper. We had known each other when he lived in Vermont, and I had stayed with him and had taught his acting class.

So I picked up the phone and called.

"Hi, David, It's Julian Schlossberg."

"Hi, Julian—what's up?"

"I have Woody and Elaine—"

"I'm in."

"You don't even know what it is!"

"I don't care," he said. "If you have Woody and Elaine, I'm in."

And that's how David Mamet came on board.

Now we needed a director—and a special one, since all three of our writers also directed, and none of them wanted to direct either their play, another play, or all three plays. (In the theater, the writer has approval of the director.) No matter whom we suggested, one or two of them turned them down.

I was in London when my friend Michael Palin asked me if I had seen *City of Angels* in New York City. I somehow had missed it, and so I went with him and our wives to see it. We all loved it, and I thought the direction was fantastic. So I called all the writers and suggested the director, Michael Blakemore. It took a while, but they all approved him.

(Before rehearsals began, Michael did an interesting thing. He sat down with each writer and had them read their plays to him aloud. He told me he learned a lot from these readings. The pace, the intonations and the emphasis became more apparent when you heard them in the writer's voice.)

We still had no title for the evening. The writers agreed: "Let's just call it *Three by* each playwright." I told them I didn't like that idea; they (rightly) told me to come up with something better.

I agonized for days. Then, early one morning, I woke Merryn and announced, "I think I got it: *Death Defying Acts.*" All three plays, one

way or another, had death as a theme. My wife liked it—and suggested we go back to sleep, which we did.

The next day, I called all three with the new title. David said yes immediately. Elaine said, "Call me back in two hours"—and then agreed. Woody said, "Let me sleep on it for twenty-four hours"—and then concurred. We now had our director and our title.

Almost everything I had heard and read about working with Woody Allen turned out not to be true. I'd heard he was isolated and distant, but he gave actors notes, he collaborated with the director, and I was always able to talk to him. Our auditions were held in his office—actually his screening room. We saw many, many actors there. One whom he turned down was someone I had seen perform and felt was perfect for the role. I went to Woody and asked if he would consider seeing her again. He looked up at me and said, very firmly, "I will see anyone you feel strongly about, as many times as you want." She returned, auditioned again, and was hired.

I insisted that we do the plays out-of-town first. The writers were fine with it, but Michael was reluctant. He felt that with five full weeks of rehearsal, we'd be fine. But I was concerned. These were first-class writers with new plays. Not only did the plays have to work individually, but the evening had to coalesce. I certainly didn't want to be previewing in New York City with these powerhouse names and not be ready. So I reached a compromise with Michael. We would do it in Stamford, Connecticut, where we had previewed *Vita & Virginia*. It was one hour from New York City.

Mamet's play was the opener. It ran about twenty minutes. Elaine's was second, and ran about forty minutes. We then had an intermission. Last was Woody's play, which ran over an hour. It ended with the cheating husband being shot and killed. It was hilarious until the killing. The audience was stunned. They walked out, dazed. They had been having a great time with Woody's play, and then—*bam.*

For two straight nights, I stood in the back of the theater with Woody. Each night he felt the air go out of the audience. He felt the

giant letdown. After all, he had been a stand-up comedian. He, more than most, could feel an audience. I said nothing, but just looked at him. And he said nothing in return. But on the third night, when I looked over at him, he said, "All right, all right, I'll change it." And the next day, he did. The husband still got shot, but in the backside—and the audience went home happy.

We were ready to play New York City. When we did, we became a huge hit. I now had the two biggest hits in the history of off-Broadway—playing simultaneously.

"moscow stations"

With these two massive successes, I was hot. Like the last time with the Ziegfeld Theatre, it wouldn't last long. But for now, the grosses were flying in on both plays, in the two largest theaters off-Broadway.

Neil Simon was trying to find a home off-Broadway for his new production of four one-acts, *London Suite*. When he was told that I had both theaters, he asked a mutual friend, "What the hell is Julian Schlossberg doing in theater?"

What I was doing was having a wonderful time. I went again to London and saw one of the greatest dramatic performances onstage that I have ever seen. (And I had seen Paul Muni in *Inherit the Wind* and Paul Scofield in *A Man for All Seasons*—that kind of great acting is rare, and years and years later, it is still burned into my consciousness.) The production was called *Moscow Stations*. Unlike the plays I've just mentioned, it was not an important play. But its star, Tom Courtney, was incredibly compelling, the only actor onstage. And Tom offstage was a gentle, kind, and loving man.

I came back to the U.S. and called my investors. "We have done

very well on our first two shows together," I told them. "Let's do one for art—for theater. Let's give back a little."

Some agreed. Others said, "What are you, nuts? You want me to invest in a show for art—to give back a little? You're crazy, no way." So a group of us pooled some money together and, joined by the English producer Brian Brolly—who had presented the show in London—we opened in New York City. (I should also add that the same theater operators who had co-financed *Vita & Virginia* chipped in, albeit reluctantly. They were the hardest to get to agree.)

In all fairness to everyone involved, and to even those who declined, the play had three big strikes against it. It was about a [1] Russian [2] drunk [3] intellectual. Not one of those three categories seemed to inspire long lines at the box office.

It was my third show in the 1990s, and I was about to learn an important lesson. In theater then, and even now, a drama needs the blessing of *The New York Times* critic. Musicals, the most commercial, are the least vulnerable in this respect; comedies next; and drama last—and, unfortunately, least. There are many examples of musicals overcoming bad reviews—some comedies have—but no drama (unless it stars a giant name) can overcome a bad *New York Times* review.

So when I opened the *Times* on Monday morning to find a terrific review, I was euphoric. We had another hit!

Not so fast. As it turns out, some plays, even with an excellent *New York Times* review, do not succeed. I was dumbfounded; I couldn't believe it. But I'd learned a valuable lesson: you cannot be sure when dealing with the public.

We played for four months. Tom Courtenay was a dream to work with. He returned to London afterward, and a few years later he was knighted.

(When I called to say, "Sir Thomas," he said, "C'mon Julian, it's just Tom. You know me."

"Of course I do," I said. "How's the wife?"

He paused, then replied, "You mean Lady Isabel.")

In my office, I have some of the window cards of the plays I've produced. It's not just the successful ones. Many producers have told me that some of their favorite ones are the ones that didn't make money. In my office, *Moscow Stations* is right there in a prominent position. If you look close, it says, "To Julian, this pen is giving me trouble. You gave me joy. Love, Tom."

I feel the same way.

after "moscow stations"

After I produced *Moscow Stations* and worked with Tom Courtenay, he and I had become good friends. We saw each other in New York City and London often with our wives.

Once, the two of us went together to a famous Chinese restaurant in London, where we shared the same dishes. I came down with food poisoning. After not hearing from Tom for a couple of uncomfortable days, I recovered enough to call him, and asked whether he had gotten ill. He told me he had not, then went into a lengthy explanation about bacteria and parasites in the U.S. versus England. I hung up, surprised and relieved that my friend hadn't expired.

One day Tom called to tell me he was doing a comedy in London with his dear friend, Albert Finney. The producers hadn't raised all the money, and he wondered if I would be interested. I said that I would want to be involved in anything he and Albert would be in. He sent me the play and I called him and said, "I'm in."

Tom was delighted, and gave me the producer's number. I called his office and he got on the phone immediately. I repeated what I had

told Tom, and he said in a clipped British accent, "Well, let me get back to you in a day or two."

I was taken aback by that response, but had dealt enough with the English to realize they could be laid back and unenthusiastic. And he certainly was both.

When I relayed the conversation to Tom, he was shocked. He couldn't understand it. I said, "Let's wait a day or two and see what happens."

To this day, I have not heard back. After a few days, Tom said he and Albert were willing to quit the show unless I co-produced. I felt that made no sense for either of them, and thanked them both profusely for the offer. I assumed, correctly, that the producer had found the money somewhere else. (Incidentally, the show was called *Art,* and it was a huge success in both London and New York.)

Somehow, not getting that show didn't bother me. I think it was running the Walter Reade theaters that helped—I knew there would be other opportunities next week, or next month, or next year. I knew that if Tom and Albert had prevailed, there would be nothing but bad blood and resentment for my presence. And finally, as things worked out, I did produce the next show by the same author, and with the same director, as *Art.* And it was also a hit. But that's another story.

Ironically enough, I went with Merryn to the last London performance with Tom and Albert starring. We were invited to the cast party, and I saw Albert Finney in ecstasy. I asked Tom if this was Albert's general demeanor.

"No," he said, "he was just so happy to have completed the run."

I believe he never did do theater again.

I was a little uncomfortable about meeting the producer who hadn't called back. It turned out, as I was told, he hadn't been invited. It seems that without my presence, there was plenty of resentment from the stars. But the party was memorable. There was no one present there who could have been described as laid back that evening.

"cakewalk": anything but

Peter Feibleman, a fine novelist and playwright, invited me to see a play he had written about Lillian Hellman. He had introduced me to Hellman years earlier, and I remembered how much fun she was to socialize with.

I was somewhat curious to see his play. So Merryn and I flew to Boston to see Elaine Stritch starring in the production. We were not disappointed. Stritch was a compelling Hellman, gripping in every way.

I met with Peter afterward and talked about directors. I met with Stritch and showed her off-Broadway theaters. Stritch had suggestions about rewrites; Peter had different ideas. Peter and Stritch had known each other for years, and agreed to disagree. So I had a play I believed in, and now needed to find both a star and a director.

I came up with a list of actresses. Number one on my list was Helen Mirren. She wasn't the Helen Mirren of *The Queen* yet, but she was well known enough—and she was a terrific actress. She was charming and gracious on the phone, and she said she would read the script, which I sent immediately.

A word about sending out a script. You hope and maybe even pray for a yes. But here's a truth I learned the hard way: don't ever believe that no news is good news. No news is, well, no news. Except time is ticking away. Sometimes an entire film production or a multimillion-dollar Broadway show is riding on a script being read by a star or an agent. (Or a manager. Or a lawyer. Or a wife.) So believe it or not, a quick "no" is in many ways very good. It's the second-best answer. You don't lose much time, and you can go on to the next star. Knowing this, I always give deadlines for an answer. It's not because I'm tough; it's because the train is moving, and we can't be stalled for too long. It's also better for my emotional well-being. I feel a little less helpless that way.

Helen politely declined. We were back to square one. Peter reported that Marshall Mason, the Tony Award–winning director, was coming to New York City, and he asked me how I felt about Marshall directing the show. I didn't know Marshall personally, but he had directed a lot of plays and had a good reputation. It sounded like a good idea to me.

We dined at Peter's home, just the three of us. Marshall liked the play. We all showed interest. We talked schedule. But no one fully committed. If that sounds to you like a group of dogs sniffing each other, you'd be correct.

I called the actress Debbie Monk, who had worked with me on *Death Defying Acts,* and asked her about Marshall. "I won the Tony for *Redwood Curtain* because of him," she said. I asked Mike Nichols too, who advised, "Grab him." That was more than enough due diligence for me. I called Marshall, and he agreed to direct.

I had thoroughly enjoyed working with Linda Lavin when we did *Death Defying Acts.* She is truly a great stage actress—both a superb comedienne and a fine dramatic actress. She has power, real power, onstage. And the role we wanted to fill required both dramatic and comic chops. Marshall and Peter concurred, so I called Linda. She read the script mercifully quickly and said she'd do it.

Now we needed a young, handsome leading man in his thirties who could act. That's not easy to get in the theater—an actor with assets like

that is catnip to movie and television executives, who are ready with far greater money than the stage can provide. Nevertheless, we auditioned and we auditioned and we auditioned. Finally, we were able to get Harry Hamlin to fly in. He nailed the role: he was funny, sexy, and believable. We had our leads.

As I said, I try to open all the plays I produce out-of-town first. I was tipped off about a beautiful theater in Winston-Salem, North Carolina, spoke to the artistic director, and sent him the script—and in no time flat he agreed to present the show.

Now we needed a theater in New York City. My first call was to Ben Sprecher, who ran the Variety Arts Theater. We had worked well together for the entire one-year run of *Death Defying Acts*. Sure enough, he liked the play too. We scheduled dates so that we could open in New York after the Winston-Salem production. We were off and running.

Well, maybe not.

The actors had agreed to a six-month run, plus two weeks performing in North Carolina, plus four weeks rehearsal. That was seven and a half months altogether. Harry Hamlin called to say he had received an offer to do a Tennessee Williams revival of *Night of the Iguana*. It was a four-month commitment, plus four weeks' rehearsal—two and a half months shorter—and offered him more money. He wanted out with no hard feelings.

I had no contract, so he had no legal obligation. We had already sent out press releases, informed both theaters' management of his participation, and told his co-star. Nevertheless, Hamlin walked. At least he had called personally. But it wasn't right, and I let him know I did have hard feelings about it.

Back to the drawing board. Michael Knight, a star of the long-running daytime serial *All My Children,* came in to read, and it was clear he fit the role beautifully. Charming and handsome, he immediately worked well with Linda.

Rehearsals went fine. Marshall and the actors got along well. Peter did some rewriting. We all knew there was work to be done, but that's why

we were going out-of-town first—to put the play up on its feet. It had changed a lot since Boston. I had left some space, a few weeks between North Carolina and New York City, to rewrite and rehearse if necessary.

Our first preview in North Carolina was one of the worst nights of my life in theater. Somehow, from New York City to North Carolina, many new turntable moves had been added. (This is when a part of the stage turns around with a new set for a new scene.) We had as many turntable moves as most musicals. But the turntables froze. They just didn't move. We had to stop the play twice. I slunk so deep into my seat that I couldn't even see the stage. One of those times, in an airport scene, the traveling bags didn't come down the carousel. Our two game actors moved effortlessly to the next scene in a Beverly Hills home. In the middle of that scene, the two traveling bags came flying out of the wings and into the Beverly Hills set. The audience laughed and laughed. I cried and cried. Peter Feibleman, our writer, left the theater when he saw the luggage go airborne.

Sometime later in the show, Merryn nudged me. "What's that?" she asked. A man dressed all in black was crawling slowly on his hands and knees from stage left. Maybe because he was all in black, he thought he couldn't be seen. First we heard a titter, then a pocket of laughter, then pointing and full-throated, hearty laughing as the North Carolinians witnessed our black lizard, wrench in hand, trying to fix one of our faulty turntables.

After the curtain came down, I said to Marshall, "We have to cut all the turntable moves by tomorrow night."

"Impossible," he said.

"I'll stay up with you all night," I promised, "but this can't go on again this way."

Marshall was able to cut all but four turntable moves without me. Our two-hour show ran over three hours on the first preview.

Many other things went wrong with the show, too: blocking, lighting, acting. Linda was justifiably upset. I assured her, as best I could, that help was on the way.

Peter was semi-destroyed; after a few previews, he was totally destroyed. He wouldn't talk to Marshall. He wouldn't talk to Linda. He wouldn't talk to anybody but me. When he finally let me into his locked hotel room, I found him unshaven, hungover, and in a state of desperation.

"Peter, if we could have any director in the world, who would you choose?"

"Mike Nichols."

"Okay, I'm calling Mike. If he says he's making Act II the first act and Act I the second act, you must say 'Great!' If he says he wants to cut a half-hour of the play, you'll say, 'Good idea.' He's our only chance."

Unbeknownst to Peter, I had called Mike earlier, told him of our huge problems, and asked if he could help. He'd said, "Peter will never let me do what I want. I've advised him in the past of cuts, and he's always resisted."

So with that in mind, I called Mike. "Mike, I'm here with Peter and he wants to talk to you."

Peter took the phone. "Mike, we need you," he said. "The play is in trouble. If you can come in to help, I'll do whatever you say. Whatever you want, I'll do. Yes, Julian's here—I'll put him on."

"Hi, Mike."

"You son of a bitch," Mike said. "I can't believe you got him to say that."

At this point, Marshall and I were barely speaking. He believed the play was so much better than Peter or I thought it was. To top everything else, my shoulder had frozen after the second preview. I'd had a confrontation with Marshall, and I'd wanted to hit him. But I couldn't do it. It wasn't my style. Now I couldn't lift my arm, or move it. I couldn't even apply deodorant. Merryn, each morning, had to apply it for me.

I asked Marshall to meet me in the lobby at eleven a.m. We went to the hotel bar, where he ordered a drink and I ordered a tomato juice. I told him I was bringing the show to New York City without him. I expected him to try to dissuade me or fight with me. Instead, he showed

no emotion—just pretended he didn't care, or truly didn't. And then he said, "Fine. I've done all I can with *your* show."

I thought of The Rolling Stones' *I Can't Get No Satisfaction.*

Still, there was an unexpected positive result to our confrontation. When I returned to my room, I was able to tell my wife, "Look, honey, I can move my arm a bit." It was starting to defrost.

Mike did revamp the play. He had the set rebuilt. There were no turntables. We hired a new set designer. Mike worked and rehearsed every day. He took no money. He said, "If it's successful, I'll leave it up to you to take care of me." I will never forget his incredible generosity and loving support to Peter and me, and to Lillian's memory.

All the king's horses and all the king's men couldn't put *Cakewalk* together again. We got mixed reviews. And *The New York Times* didn't like it. (I was told the paper didn't like Lillian Hellman personally.) But everyone loved Linda. Mike had said when he joined that he would not put his name on it; Marshall agreed to keep his name on it.

After the play opened, I went to physical therapy to get my arm to work. I also needed mental therapy. It had been a horrendous three months. It was, and remains to this day, the hardest play I ever produced.

closing night

During the early years of our marriage, Merryn and I visited London frequently. She had left her mother and all of her friends to move to New York City, where she knew almost no one. We felt we should visit London so she wouldn't get homesick. Fortunately, I was often able to do business in England, as there were many distributors selling films for the United States market. Over the years I bought dozens of movies for theatrical, video, and television release. Great Britain became a large supplier of both new and older films.

On one trip, I contacted Eileen Atkins, who had co-starred in *Vita & Virginia* in New York a few years earlier. We had stayed in touch, and she invited us to the last performance of a play she was in at The National Theater, an Ibsen play called *John Gabriel Borkman*. I was not familiar with the play. But I was excited about the cast, which included Paul Scofield and Vanessa Redgrave as well as Eileen. It doesn't get better than that.

Here's the funny thing. None of my friends in London had seen it. Many said they found Ibsen too heavy-going. Others had no desire

to go. As with enjoying the Cannes Film Festival, once again I found myself a minority of one. In fact, the only other person enthusiastic about seeing it was Merryn.

But what a play! What performances! What direction! (By Richard Eyre.) Some critics say it's minor Ibsen. Well, I beg to differ; I found that last performance and its extraordinary cast to be major Ibsen. Twenty-five years later, I can still remember scenes.

After the performance, we went to the stage door, where our names had been left. We were shown to Eileen's dressing room, where she and her husband Bill greeted us. Eileen took me to see Vanessa, as we had worked together on *Vita & Virginia*. We had not seen each other for years. It was a warm reconnection.

As we were leaving Vanessa's dressing room, I saw a man running up and down the corridor, yelling, "I'm free, I'm free!" It was one of my favorite actors of all time, John Gabriel Borkman himself—Paul Scofield. (If you have never seen him, rent or stream *A Man for All Seasons*, *The Train*, or *Quiz Show*. If you love Shakespeare, I suggest you see his magnificent *King Lear*.) I was thrilled to meet him, and a happier man at that moment in time would be impossible to find. He now was a free man.

Eileen, Bill, Merryn, and I then went off to dinner. We were on a high after the excitement of the play and the backstage visit. Somehow, we got on the subject of women's rights as we dined. Eileen said she had an incident she wanted to relate.

This is how I remember it. One late afternoon during the run, Eileen arrived early. The stage manager asked to speak to her. He explained that the snow machine had broken down, and there would be no snow for the evening performance.

Eileen became annoyed and said, "This is supposed to be the finest theater in all of Europe. We are all working for very little money, and the least we expect is that the production itself will be first-class."

The stage manager agreed and asked if she would perform. "Of course," she said angrily.

When Vanessa was informed, she suggested that the cast and crew cut up newspapers into small pieces and have them substitute for the missing flakes. She agreed to perform, but the newspapers backstage remained intact.

Meanwhile, Paul Scofield was seated in his dressing room. The stage manager knocked on his door to advise him about the faulty snow machine. Paul responded quietly, "No snow, no Paul."

As if by magic, the machine was in full operation when the show began.

Eileen's point was that the two lead actresses had agreed to go on. One had even suggested a solution. The male lead felt the entitlement to simply refuse to perform. Because of him, the problem was solved.

And that was Eileen's take on women's rights. She knew there was still a long way to go.

"power plays"

Alan Arkin sent me a one-act play that he had written. I liked it, but I had some notes. I'm sure it is the bane of most writers' existence to hear those dreaded words from an actor, director, or producer: "I have some notes." But Alan replied, "Let me and my son, Tony, who's an actor, read it to you."

"Okay," I said, "but let me get a small theater and an audience in to listen."

I called Elaine May. I knew she admired Alan. Even though they are always grouped as Second City alumni, they'd rarely worked together.

The little theater I found had stadium seating, and I invited about sixty people. Elaine ended up seated behind me, and throughout the reading she was banging on my shoulders and laughing.

On the way home she asked, "What are you going to do with the one-act?"

"I'm going to get you to write one too," I said. "And it can star you and Jeannie." Elaine's daughter Jeannie had been nominated for the Academy Award, and had won the New York Film Critics Award for

Best Supporting Actress for *The Heartbreak Kid*.

At that time, Elaine and I lived in the same building. Alan and Tony's reading had been held on a Friday afternoon; on Monday morning, around eight a.m., I passed my front door and saw that an envelope had been pushed under it. It was a new one-act by Elaine—and a good one, at that.

I was so excited. I would be producing and presenting two comedy legends, along with their offspring. I sent the two one-acts to my friend Ben Sprecher, who ran the Promenade Theatre on the Upper West Side. It was the best and highest-grossing off-Broadway theater uptown, even though it only had 399 seats. It was perfect for the two one-acts. Ben liked both plays so much, he asked if he could co-produce them with me. I, in turn, loved the idea of the theater's management having an additional reason to root for the play's success. As a former theater operator, I knew part of the booking process was, "What's next?"—not so much the attitude when the theater is a co-producer.

Alan Arkin had done a lot of stage directing. I asked him if he would direct the plays. He naturally had some trepidation, since he was also acting in one and he would be directing his son in that very play. But he agreed. We had our director.

Well, not so fast.

I woke up one day with a start. I called Alan and Elaine and set up an emergency meeting over lunch at a Japanese restaurant. I got right to the point.

"We have a great built-in audience ready to see you guys live onstage, in person, in New York, for the first time in thirty years," I said.

They both just stared at me.

"So here's the ad: Alan Arkin and Elaine May starring in blah, blah, blah." (We had no title at this point.)

More blank stares.

"Well, I'm a customer, I pay my money, but I never get to see you both together. All the ads say Alan Arkin and Elaine May, and yet you're never together."

Alan immediately said, "I'm not writing another play."

"Well, I guess that leaves me," said Elaine.

Here's the irony. Elaine wrote her first play over a weekend. The second play took her months and months. Elaine had decided, unilaterally, that she had three difficult tasks. One, all four of the actors had to be in this play. Two, all four had to have equal-size roles. And three, their roles in this play had to be completely different from their roles in the other plays.

I was going crazy waiting. I've worked professionally with Elaine more than anyone else. It is a joy. It is a challenge. It is the most stimulating, the most exciting experience you can have. And yet:

Julian Schlossberg to Elaine May: "When can I read the play?"

Elaine: "Very soon."

Julian: "That's what you said last week."

Elaine: "Yes, I did."

Julian: "Elaine, I need this play. What can I do to move this along?"

Elaine: "There's nothing. It's very hard. I've told you what I'm trying to do."

Julian (losing it): "Forget these self-imposed rules. Where is it written that they have to be different characters and the same length? It's killing us."

And in a strange way, that was true. Both of us felt we were being killed for different reasons.

But Elaine finally finished the play, and it was really funny. The first fifteen minutes were just Alan as a dentist and Elaine as his new floozy and dense nurse. It was hysterical, and played even funnier onstage,

since Elaine wore a tight nurse's uniform with obvious breast and rear-end enhancers. I lived near the theater, and a few times every week I would attend the performances. Sometimes I'd watch the whole show, and other times just stay to see the first fifteen minutes with those two. They never did the play the same in those fifteen minutes. They did the rest of the evening pretty much the same. But those few minutes alone, they were like two great musicians doing riffs, or like Astaire and Rogers dancing—two consummate pros playing comedy tennis and just acting away.

So we finally had all three one-acts. I was at a party in New York when I bumped into Lynne Meadow, who was the artistic director of the Manhattan Theatre Club. When she asked me the famous question, "What are you working on?" I told her about Alan and Elaine and the one-acts. She asked to read them. I asked why, and she said, "Maybe we can do them together."

"What good would that do me?" I asked.

"Well, we'd play it for my subscribers, and then you'd take over for the public. We'd also finance the production and we'd be partners."

I loved the idea of the Manhattan Theatre Club financing, but I was concerned about having a new partner and what that might mean. In show business, and perhaps in all business, there is a golden rule: "The gold rules." I didn't want a ruler, even for the money. *But one must be practical when one produces,* I told myself. *Let her read the plays. If she doesn't respond, it's all over. Let's think about it only if she likes them.*

About the same time, a director let me know he was moving to Seattle to take over as Artistic Director of ACT. He wanted to kick off their new theater with something special. I sent him the plays, and we had our out-of-town tryout. We had our dates in New York at the Promenade theater too, all of which had been cleared with the actors. We were ready to start rehearsals.

But it wouldn't be so easy.

First, Lynne called and wanted to make a deal. I had mixed feelings. This was my baby from the get-go. I had brought Alan and Elaine together,

persuaded Alan to direct, obtained the Promenade as a venue. But I liked Lynne. I liked a lot of Manhattan Theatre Club's plays. I liked very much not having to raise the money. Alan and Elaine said it was up to me; so, after arduous negotiations, we reached an understanding.

We rehearsed in New York City and played four weeks in Seattle. It was tough—toughest on Alan, who was directing all three plays and starring in two of them. For the blocking of the actors, Alan had a stand-in for his roles. He didn't have enough time to learn his lines or his blocking. At one point, during the time we teched (cueing the lights and sound), he said to me, "You're now directing, because I still don't know my lines."

I gave notes every night after each preview. I worked a lot with the set designer and even more with the props. The props, which are enormously important to most actors, are often not sufficient out-of-town, due to budget constraints on the out-of-town theater. We realized, after the first two previews, that we needed more props—and on top of that, the stage was rather bare.

Marlo Thomas, a dear friend of Elaine, Jeannie, and me, had flown up to see the second preview. She is a dynamo of energy, and together we went shopping all over Seattle. We arranged for carpets, furniture, vases, dishes, you name it. We got some for promising a credit in the program, others we obtained on loan with a note that I was responsible for damages, and for the rest, well, we paid for what we needed.

The actors were thrilled, the set designer and stage manager were not so thrilled, and the theater personnel were totally confused when we brought in all the new materials. It was wild and wacky, but proved successful. I confess, however, we left some noses out of joint.

Elaine and Alan rewrote late into the night, rehearsed during the day, then performed in the evening. It was a grueling schedule, but by the end of the run, we had our evening pretty well locked.

On to New York City, where the early previews were a bit rocky. We thought we knew where the laughs were by now, but Seattle is not New York. Some of the easy laughs were no longer easy. Some of the

more sophisticated humor was now being realized.

By the fourth preview, we were in the groove. By the time we opened, we had a word-of-mouth hit. The great reviews made it a hard ticket to get. After six months, Alan and Elaine's contracts were up. We felt we needed to replace them and keep the show running.

I talked to an enormous number of actors in the New York area. Many were interested at first. But as soon as they realized they were replacing Alan Arkin and/or Elaine May, they felt it was a no-win opportunity for them. They couldn't originate either role, and they would invariably be compared to Alan or Elaine. Other actors came to the theater, and once they did, they passed. It was that daunting to see Alan Arkin and Elaine May onstage.

We had to expand our horizons and our budget, or close the show. So we started looking in Los Angeles to bring in two names. Well, the costs were just staggering. Plane fares, limos, hotels—or an apartment. Just the hotel or apartment costs alone could wipe us out. So the idea was to try and find actors who had a New York City apartment—and, if you were being greedy, were also married. I was able to get half the prize. Richard Benjamin and Paula Prentiss were married, and two very gifted comic actors.

Alan could finally just direct, but Jeannie and Tony faced a strange hurdle. They rehearsed each day with Dick and Paula, and performed each night with Alan and Elaine. Talk about leading a double life!

So half a new cast came in. The show continued to run, and I had happily produced another commercial evening of one-act plays.

As this story suggests, there are many reasons why one-acts rarely get produced commercially. One is that they require more work on everybody's part.

Why?

You often need three different sets. You also need more time to rehearse. In a regular play, the actor, in whatever scene he or she is rehearsing, is learning about his or her character. They may learn something in a later scene that they can use in an earlier scene. With three

one-acts the actor has three different characters. When he's rehearsing play number one, whatever he's learning is only good for play number one. Nothing is applicable for plays number two or three. And you can only rehearse one at a time. So the rehearsal schedule is complicated. I always give five full weeks to rehearse.

On top of that, the director has to try and find some consistency for the entire evening. That's often quite a feat. But the biggest challenge is the audience:

"I liked play number two the best."

"I only like one and three."

"Number three was the worst."

You're just asking for trouble presenting three one-acts.

The fact that I have done it four times may tell you something about this writer.

dinner parties

Every night in New York City, there are hundreds of dinner parties. When we lived there, Merryn and I avoided them whenever we could. We preferred the company of friends, and we loved entertaining in our home.

That said, however, when we were invited to Al and Louise Hirschfeld's dinners, we tried to go. Theirs was an authentic salon where interesting people from the arts and politics mingled.

Their brownstone was on East 95th Street. Al worked on the top floor under a skylight, drawing while seated in a barber's chair.

The first time we came into the home, I saw Hirschfeld's drawings on the wall. I don't mean hanging in frames—the entire wall was filled with some of his great work. Think Picasso's *Guernica* in size and shape.

The dinner parties there always started one flight up, in a small, cozy den where drinks were served. It was there that we found who was going to join us that evening. We never asked ahead of time; like kids, we always wanted to be surprised. (I can't remember all the guests over the years, but Woody Allen, Mike Nichols, Elia Kazan, Arthur Schlesinger, Eli Wallach, Anne Jackson, and Betty Comden are a sample.)

After drinks, we descended two floors to a dining room with a large rectangular table. Al had installed a motorized chair on the side of a banister, which he rode the two floors. He always sat at the head of the table. At the other end was Louise, his gracious wife. Merryn and I were actually invited to Louise and Al's wedding. It was a festive affair. At the time Al was ninety-three, working every day, and by all accounts enjoying his life to the fullest.

I remember sitting to his left one night at the dinner table. He was talking to us about a visit to Tahiti he'd made in 1929. The subject changed, but I couldn't stop thinking, *Here I am, sitting beside a man who more than seventy years ago was painting on the island of Tahiti.*

During a rare lull in the conversation, I leaned over to Al, who was hard of hearing, and asked "What was the exotic island of Tahiti like, Al, in 1929?"

Grinning, he said, "It was smelly. It was full of garbage and flies, and I couldn't wait to get the hell off it."

* * *

Actress Lee Grant is married to the producer Joe Feury, and they always have great dinner parties. They have a double living room, and on one particular occasion, I found myself in a room alone with the writer Jimmy Breslin. We were on opposite sides of the room, and since we were strangers, we merely nodded hello and waited for more people to join us.

First in was Shirley MacLaine, who greeted me warmly with a hug and a kiss. Next was Elaine May, who did the same thing. Now Jimmy, reporter that he is, was interested. When both of the ladies had gone, he came over to me and said, "Hi, my name's Jimmy Breslin."

I answered, "Hi, my name's Julian Schlossberg."

He just stared at me. I watched as he computed the name and came up blank. He had never heard of me. I was, however, a big Breslin fan—I'd read his columns for years and had always wanted to meet him. He told me he had just returned from Columbine, and described the school and the parking lot where the infamous shootings had occurred.

I told him about my work on Orson Welles' *Othello,* and then a strange thing happened.

Two men, raised in New York City, who could certainly talk, suddenly went quiet. For some reason, we had nothing to say to each other. Even now, as I write this vignette, it makes no sense to me. As we both sat silently, staring at our respective walls, a man came over and asked, "Can I join you?"

Breslin immediately replied, "You might as well, we're dying here."

* * *

Merryn and I often entertain at our home. When we lived in Manhattan, it was like a salon where people of all ages and professions came together. The only permanent guest who could always be relied on to help and to lead conversation was Elaine May. While there was plenty of lively talk during dinner, wonderful and surprising happenings often took place after the meal.

One night, the writer Edna O'Brien suddenly stood up and decided to recite poetry. I had produced one of her plays, and this was not her first visit to our home. As soon as she finished, New Age doctor Andrew Weill, a first-time visitor, started to sing "Danny Boy." I stopped him and said, "Wait a minute—you're a first-timer here. 'Danny Boy' will have to wait." He laughed heartily, and after the next person finished talking, the good doctor sang a lovely version of the Irish standard.

Another evening, Carol Burnett led all of us in the living room in a dance number, choreographed on the spot by Stanley Donen. There was always stimulating conversation and an enormous amount of laughter. I remember sitting at the head of the table and thinking, *How happy I am, surrounded by exciting and entertaining people.*

After all, Merryn and I only invited those we truly wanted to spend an evening with. No unwanted relatives. No mates that no one liked. Every person was someone we either knew or knew of. I don't remember ever not having a great time. I know the guests did also, because more than once, Merryn and I would say goodnight and leave them still

talking in our living room. One of those occasions it had gotten to be one or two in the morning, and I needed my eight hours to run my company efficiently—so we would just tell our guests to let themselves out whenever they were ready to leave.

When we moved to the country, which was an hour north of New York City by car, the parties lessened. One reason was that we were, thankfully, living a quieter life. That was the main reason we had sold our apartment in the first place. Also, it wasn't easy asking or encouraging people to drive up for dinner. Two hours' commute was a deal-breaker. But luckily, we made new friends—and some of the old group still occasionally show up.

At one particular brunch, a high-powered couple got into a minor spat about control. They both admitted they had to be the captain of the ship, and went on to confess candidly that this was the major trouble with their relationship. For a moment, there was dead silence—and then I piped up.

"In our home, there is only one captain, and it's me," I said with great gusto and strength; then I added, meekly, "but Merryn owns the ship." The tension was broken—and equally important, I had scored a big laugh.

Merryn was once told by a friend in California that we hung around with intellectuals. We both had a laugh about that comment. We didn't believe it to be true at all—but we do appreciate that we have a lot of fascinating friends.

"the beauty queen of leenane"

Michael Palin once again wanted us to see a play. He chose *The Beauty Queen of Leenane* at the Duke of York Theatre in London. I had never heard of it.

Well, it just so happened I loved the play. I was mesmerized. I wanted to bring it to the United States. I immediately contacted the Royal Court, which was presenting it. I had meeting after meeting, but nothing was accomplished. Unlike Robert Fox, who responded quickly with *Vita & Virginia*, I just got a lot of lip service. Never once was the Druid Theatre in Ireland mentioned; never once did they tell me they alone didn't have the U.S. rights.

To this day, I have no idea why I was treated, in my opinion, so shabbily—but I was. I left London dejected about my inability to even get a no, or anything more than a lot of talk.

At that time, I was producing several plays, and was in Seattle with Alan Arkin and Elaine May trying out *Power Plays*. My general managers, Leonard Soloway and Stephen Levy, were producers in their own right. We had worked together on a number of plays, but we had never

co-produced. They called me in Seattle to ask whether I had heard of a play called *The Beauty Queen of Leenane*. I launched into a tirade about the Royal Court, and they listened politely to the raving madman, then told me they were co-producing it and wanted me to join them.

Of course, I did. We opened at the Atlantic Theatre, off-Broadway, to rave reviews.

I wanted to keep it off-Broadway, where I'd had a lot of success. They wanted to move the show to Broadway. I argued it was an Irish play with no stars and a story in which the daughter kills her mother at the end. (And it's not even euthanasia.) I was voted down. No one agreed with me.

So off we went to Broadway. And it was a hit. We won Tony Awards for Best Actress, Best Supporting Actress, Best Supporting Actor, and Best Director—a historic first for a female director.

Now at the Tonys, it was time for the Best Play award. Having just won four out of five major awards, I was feeling confident. I was there in my tuxedo, straightening my bowtie and getting ready to go up along with my fellow producers to accept the coveted prize, when Alec Baldwin came out. He opened the envelope, and I thought I heard him burp. But no, he hadn't. He had said one word, which, if you say it fast like he did, sounds like a burp: *Art.*

So we hadn't gotten all five major awards. But the four we did get were a stunning achievement nonetheless.

I had absolutely nothing to do with *Beauty Queen's* success. It was the same play I had seen in London. It was like buying a stock that triples: you make money, but you've had zero to do with any part of the triumph. That's not producing for me—but I'm still happy and proud to have *The Beauty Queen of Leenane* on my list of credits.

one tough negotiation

Tony Walton, one of the finest set designers for film and theater, invited me to go see a two-character musical called *Noel and Gertie*. It was the story of the friendship of Noel Coward and Gertrude Lawrence, and was playing at the Bay Street Theatre in Sag Harbor, Long Island, in New York. It was written by Sheridan Morley, a well-known English theater critic. Tony had designed a small but ingenious set for the show.

I didn't like the title, but I did like the star, Twiggy. I didn't know her personally but I had seen her in *My One And Only* on Broadway and *The Boy Friend* on film. She had been terrific in both musicals. I watched the show with my wife, and afterwards we met backstage with Twiggy and the director, Leigh Lawson, who were happily married.

Leigh and Twiggy wanted to move the show to New York City, and already had a producer with whom they suggested I be a partner. I didn't know the man—plus, I always made it a point to be the lead producer. But I was so taken with Twiggy and Leigh that I volunteered to be the unofficial "godfather" to the show, although I still had some reservations about the show and its title.

Well, as the months went on and we talked and met for dinners, I just fell in love with both of them. Even from London, we would talk once or twice a week—as their show began to unravel. Dates were changed. Budgets were altered. Theaters were lost. Money evaporated.

Finally, Leigh asked, "Why don't you just produce it? We'll get rid of the other guy, and you'll be the lead producer."

Whoa! That was not what I'd had in mind. But as in the last scene in *Some Like It Hot*, nothing I said would stop Leigh.

Julian: "I don't like the title."

Leigh: "So we'll change it."

Julian: "There are some scenes that don't work for me."

Leigh: "So we'll get them rewritten."

Julian: "What if I want them out?"

Leigh: "I'm sure we can work together on it."

Julian: "I'm not sure I can raise all the money."

Leigh: "I'll help you raise some."

Checkmate. And on top of all the accommodations they were willing to make, I loved Tony's set. So that's how it happened. We were lucky enough to get Harry Groener, who had starred on Broadway in *Crazy For You*, to co-star with Twiggy. And we changed the title from *Noel and Gertie* to *If Love Were All*. We knew it wasn't the greatest title. An "if," "and," or "but" to begin a title is not terrific. (It's better than a "no," however. Negative is hard to sell.) But it was an improvement. *If Love Were All* was a song in the show, and we felt that as a title, it

captured what the play was about.

Leigh and I went to work on the script. Twiggy and Harry were great to work with. A two-hander requires both actors to be terrific, or the show has no chance—and they were great throughout all the performances.

Leigh raised some money, as promised. I did as well, but I was still short as we started to rehearse. Out of nowhere I received a call from Mark Golub, whom I had known when I was on WMCA radio. He asked if he could see me, and we set a date. When he arrived, he said he was now a rabbi, had followed my theater career, and wondered if he could invest in a show and learn something about the business.

He was so pleasant, and clearly sincere, that I told him I needed some money for *If Love Were All*. If he would invest, I would welcome him at meetings and he could learn a lot about producing. He readily agreed. I called Leigh and Twiggy and told them we now had all the financing in place.

Well…not so fast. As can happen, near the end of rehearsals, one of our four investors had a reversal of fortune and fell out. I was now shy ten percent of the budget. But then something unheard-of happened.

The day I received that bad news, I was having lunch with Bill Haber, an old friend. Bill had been one of the founding partners of CAA and a prolific producer. When I got to the restaurant, and because I didn't have much of a poker face, Bill asked, "What's wrong?"

I told him the news. "How much do you need?" he asked. As soon as I told him, he volunteered, "I'll put it in."

I was stunned. I hadn't considered Bill as an investor, because he produced big Broadway shows. I thanked him profusely and told him I would forward him the necessary papers. When I got back to my office, a much happier man, I was in for my third shock of the day: Bill had sent the check by messenger before I could even send over the papers. I will forever be grateful to Bill for his friendship and largesse.

If Love Were All turned out to be a fine show, was received well, and enjoyed a decent run. I was grateful to Twiggy, Harry, Leigh, Tony, Sheridan, Mark, and Bill for helping to make it happen.

the arclight theatre

I was now producing plays on- and off-Broadway. I had a lot of investors, and yet I was frustrated. I was constantly trying to think of ways to make putting on a play less risky. There's a famous saying about producing in theater: "You can't make a living, but you can make a killing." It's true. It's like wildcatting for oil: when you hit one, it's a gusher. But you don't hit often.

As mentioned, I did have one rule about my work in theater: I took all my plays out-of-town first. You would think that the writers and directors would be thrilled with such an opportunity. Often, though, they aren't. They don't want to leave home, and they'd rather not preview and perform twice. The actors, on the other hand, are usually thrilled. Many lead a gypsy life anyhow, and it gives them an opportunity to work on their roles and to try things out.

To paraphrase Alan Jay Lerner from *My Fair Lady*, "I'm an easy-going man." But this was one area where I never wavered. Every play I produced commercially played out-of-town before coming to New York. I felt that especially with new plays, they needed to be fine-tuned

away from the neon glare of Broadway. It always proved helpful. We cut, rewrote, trimmed, tested lines anew. As you have read on *Death Defying Acts*, we once even changed an ending.

I've produced out-of-town productions in Seattle, Winston-Salem, Buffalo, Boston, and many times at The Rich Forum in Stamford, Connecticut, and the idea that all audiences are alike was never my experience. Out-of-town, the people are much more open and accepting than New York audiences. Often in New York, the critics have influenced the audience reaction. The preview audiences in New York, however, arrive without preconceived notions and often respond warmly. Any actor, writer, director, or producer will tell you that they've done a show where in previews they received bravos and standing ovations, then, after some mixed reviews—worse than no bravos or standing ovations—they were instead seeing walk-outs. That can occur the very next night, after three weeks of cheers and hurrahs.

Because I produced a fair share of comedies, I knew that some of the laughs would always be lost out-of-town—especially if they were written by sophisticated authors like Woody Allen, Elaine May, or Larry Gelbart. Some of a show's biggest laughs would be received out-of-town politely, with titters; major laughs sometimes occurred when no one involved with the show expected anything more than polite laughter. And in New York, of course, the opposite seemed to occur. Where we'd gotten titters, we got guffaws; where we'd gotten belly laughs, we got titters. Needless to say, there were areas where the laughs were similar. But not as much as you might think.

Out-of-town performing was always the best shot I could give investors at "making a killing." Then one day, I had a different idea: take new plays and try them off-off Broadway. I was confident I could persuade some well-known actors and directors to work with me; thus, for relatively little money, my investors and I could try out a play. The cost would be a fraction of that of a Broadway or off-Broadway play. I needed only one play to be a hit to cover the cost of all the plays, plus a handsome profit. On top of that, it would be my own theater. And

I could do plays that interested me. Unlike with film, with theater I knew—having been raised in New York—that there were enough people there with my taste, and one successful play could be moved to a Broadway or off-Broadway theater.

So Meyer Ackerman and I raised the money. And it was reasonably easy. One share was $12,500, and we raised $400,000. The most I let anyone in for was four shares. I wanted it to be a lot of small investors for what I hoped would be a yearly stipend.

Having the funds, I looked for a theater. I wanted a lease for one year with an option to renew. I had no idea if I would like doing this, after all; it looked great on paper, but I wanted to hedge my bets.

One night I was walking home with my wife from a restaurant near our home. We passed a large open gate with a sandwich board near it advertising a show. We walked down a flight of stairs, but the entrance door was locked. The next day I returned, and this time it was open.

I had found a lovely 99-seat theater with a huge stage. It was in the basement of a church. Very quickly, the owners and I made a deal. It was called the Arclight Theatre, and I ended up producing five plays there in a year. We showcased stars like Eli Wallach, Anne Jackson, Gene Saks, F. Murray Abraham, Joyce Van Patten, and Jeannie Berlin. I learned quickly, though, that I had to keep the theater booked as much as possible—otherwise, I was paying rent and salaries, and no income was coming in. And I hadn't lined up enough plays in advance, so I was spending an enormous amount of time reading plays under pressure.

Ultimately, keeping the theater dark was costing a lot of money every week, so I compromised in my choice of plays at times. And even so, the venture didn't ultimately prove financially feasible.

But it was a fun year—and I did enjoy, for that short time, trying to figure out a new way to make a living in the theater.

expecting the unexpected

After producing *Vita & Virginia*, I stayed in touch with Eileen Atkins. Years went by, and then we met one day in New York City. She had recently appeared in London in a play called *The Unexpected Man*, with Michael Gambon. She wanted to come to New York with it, but Gambon didn't want to do it again and they were having trouble finding a lead actor.

We went over a potential list of names, but for various reasons either the actor, Eileen, or the producers had passed. I asked her, "Who would be your first choice after Michael?"

"Alan Bates," she said immediately. I loved the idea of Alan. He was a name and hadn't been in New York City for years. He was also a fine actor. And the combination of Eileen and Alan would mean a great night at the theater. But he had turned it down.

Eileen and I said our goodbyes, but I remained intrigued. After I read the play, I was even more convinced that Eileen and Alan would be ideal for it. Time went by—months, in fact—and I kept asking Eileen what was happening. She always said, "Unfortunately, nothing."

"I know Alan has said no," I said. "If he's ever coming to New York City, let me know. I'd love to meet him and hopefully work with him one day."

Eileen said okay, and months later called to say that Alan was indeed coming to New York City. She had told him about my wanting to meet, and he'd agreed. He would be staying at the Wyndham Hotel, right next to my office. I thought that was a great sign. So I called the hotel, spoke to Alan, and made a date for lunch at the Palm Court at the Plaza Hotel. After all, I was known as a producer—no sandwich shop for Alan.

My partner, Ben Sprecher, and I picked up Alan at his hotel and crossed the street to the Plaza. We had a delightful lunch, and talked about everything under the sun except theater. I've always found it funny, the ritual of waiting until the end of a meal to discuss why you're there. If I know the person I'm meeting, I often say, "Let's get the business over first. Then we can have a good time." Almost everyone responds to that, since otherwise we're just vamping until we get to the real reason we're there.

But Alan was a stranger, and so the dance went on for almost an hour. Finally, theater was brought up. We asked him if he would ever do a play in New York City. Yes, he said, but it would have to be something special. So why had he turned down *The Unexpected Man*? His answer surprised us: at the time it was offered to him, his mother had been ill, and he had been taking care of her. Sadly, she had since passed away.

Ben and I were now in a very peculiar position. We weren't the producers of the show. We had nothing to do with the London production. But we wanted to produce the show in New York City, we wanted Alan for it—and we knew Eileen did too.

"Why not come to New York City and do *The Unexpected Man*?" we asked.

"Oh, I don't know. My work is in London."

"To the theatergoing public—who, as you know, are older—you're a star," I argued. "The younger generation doesn't know you. Most of

the guys running the film studios don't know you. Come to New York and be rediscovered."

"You think those guys will come to the theater?" Alan asked.

"No, but they'll send their representative. Producers and directors will come. It'll be a hot ticket. We'll do it off-Broadway at the Promenade Theatre—Ben's theater—399 seats. They'll be standing on their heads to get in."

"I don't know. I'll have to think about it."

"Of course. But I can guarantee you that something will come of it for you."

I know that last sentence sounds just like something a producer would say. How could I, or anyone, guarantee that? But I felt it in my bones—my whole being. And at the times when I felt that, I became even more motivated.

Eventually, Alan did indeed say yes. We got the rights. And the play was a big success—because of Eileen and Alan.

Incidentally, during the early previews of the play, the director Robert Altman came to see it. He went backstage after the performance, and on the spot offered both Eileen and Alan parts in his new movie, *Gosford Park*. By the time the six-month run was over, Alan and Eileen had received several offers for various other projects. The exposure, plus their enormous talent, had come through.

"fortune's fool"

For two years in junior high school, I had a terrific teacher named Seymone Pansick. He introduced all his students to various parts of the humanities. He was able to make learning fun. Greek and Roman mythology, Shakespeare, poetry, history—all were brought to light in a creative and stimulating way. He read and acted out parts, brought in experts to teach our class, and even took us on field trips. Of all my teachers in school, he was the biggest influence on me.

Forty-seven years later, the actress Rita Gam brought me an obscure play by the Russian writer Ivan Turgenev. I found it exciting. It reminded me of the plays of my youth that I had seen on Broadway. She said Alan Bates wanted to star in it—but Alan was currently in *The Unexpected Man,* and had never mentioned it to me. I called him, and he confirmed he wanted to do the Turgenev on Broadway.

Rita suggested several directors, including Arthur Penn. Right then and there, I picked up the phone and called him. We had tried for years to find a play or film to do together. Despite many attempts, we hadn't been able to interest each other in a project. This time he said send the

play—and the next day, he called. I was astounded on two counts: first, it had been less than twenty-four hours, and second, he said yes.

And that's how *Fortune's Fool* began.

Having Alan and Arthur committed was a great beginning. There was a fine co-starring role, and we all wanted a top actor to bring it to life. Alan thought of Derek Jacobi, and we heartily agreed. I contacted Derek who, fortunately, told me he would be coming to New York City very soon.

I have always tried to talk to the talent directly. Agents and managers are rarely on your side when it comes to theater; they're losing their client for many months, for small dollars compared to film and TV possibilities. So Derek and I enjoyed a lunch together, and he told me he loved the play and had in fact performed it in England. The only wrinkle was, he wanted to play Alan's role—not the co-starring role. So after a pleasant meal, we parted and I found myself back to square one.

Next, Arthur called and said, "What about Frank Langella?" I loved the idea, but said that Frank had a mixed reputation. Arthur said he'd known him for years and could handle him. Alan wasn't sure, but when I told him that he and Frank would be great for the box office on Broadway and the production would have two fine actors—and added that Arthur wanted him—Alan demurred, and I set about tracking down Frank Langella.

It took a while, but I found him in London starring in *Moon Over Buffalo* with Joan Collins. We spoke at his hotel, and he asked to read the play. After only a few days, he called to say, "I want to meet the man who would put a Turgenev play on Broadway in 2002."

I called Alan and told him the good news: we had his co-star. Alan, with his British reserve, seemed less than excited to me. However, he decided to go to the New Vic Theater to see Frank perform, then he visited him backstage and came away enthused.

When Frank returned to New York City, we set up a meeting at his apartment. He is a sensational host. As we settled comfortably in his living room, he was leaning forward when I asked him, "What do you

expect from a producer?"

He sat back in his chair and just stared at me. Finally, he said, "I've never been asked that question, but I know what I want: don't lie to me, just tell me the truth."

I promised him that I would, and then I told him what I expected from an actor: "Know your lines and come to me with any problem, so I can try to help. As long as it's for the good of the play, I will do my best to make it happen." We shook hands on our verbal deal.

We were on our way.

* * *

At age seventy-nine, Arthur Penn was a dynamo. He collaborated on the script with the adapter, Mike Poulton, and directed a fantastic rehearsal process. The script was then put aside for a while, and the lines were forgotten. Penn's process involved actors finding their character through improvisation—but it wasn't what that word might imply. The rehearsal allowed the actors to delve into themselves and try all kinds of experiments in a safe environment to see what worked. It was quite exciting to observe.

Only once, in all the many months we worked together, was there a problem. Frank had picked from various swatches a particular outfit he would wear in the show. In Stamford, where we were previewing before Broadway, I had invited my friends Elaine May and the director Stanley Donen to see a preview. Stanley felt Frank's outfit was wrong, and told him so.

I found all this out later when the costume designer and my co-producer called to say that Frank wanted a new outfit and they had refused. They wanted me to talk to him. But he called me first and asked to see me. In person, he told me he had said nothing about his misgivings until Stanley confirmed his feelings. It was somewhat costly, but I agreed to do it with one proviso: either the new outfit or the old one would be worn. No third try. For me, as I explained to my unhappy co-producer and costume designer, it was for the good of the play. To

have an actor performing unhappily and uncomfortably eight times a week made no sense. We wanted him to do publicity and be part of a happy company.

Then, in our Stamford tryout, I found the set too glamorous. It was supposed to be a manor that had gone downhill due to neglect—but the set actually sparkled. I spoke about it with Arthur, and he agreed to take a second look now that he was satisfied with the acting and the pacing of the play. A few days later he called me in New York City and said, "Come up this weekend. You'll be quite happy with the set."

I arrived, was taken backstage, and walked with Arthur all around the set.

"Well, what do you think?" he asked me.

"Arthur, we've gone from brand new to new."

For the only time in our long history, Arthur walked away from me in a huff. But subsequently in New York City, he did have the set distressed, and it finally reflected a home gone to seed.

Alan Bates ended up winning the Tony Award for Best Actor, and Frank Langella won Best Supporting Actor. The play itself was nominated for a Tony for Best New Play. *Best New Play?* Yes—strange as it seems, it had never played on Broadway, so it qualified at the time as a new play. And incidentally, during the entire run of the show, not one of the thirteen actors ever missed a performance—an unheard-of thing on Broadway in 2002. It remains one of the plays I'm proudest to have produced.

* * *

So now that I was producing *Fortune's Fool*, a literate Russian play, I wanted to try and locate my junior high-school teacher, Mr. Pansick, to come to the show as my guest. I'd never forgotten him, and I felt the show was something he'd appreciate. It took a while, confronting the bureaucracy of the New York City Board of Education—but finally he called, and we set a date to have dinner with our wives and then see the play.

Everyone loved it. After it was over, I wanted my old teacher and his wife to meet the two stars. We all went backstage and gathered in Alan's dressing room, where I said to Frank and Alan, "I want you to meet the man responsible for all of us being on Broadway."

I watched Mr. Pansick tear up as he shook their hands. It was truly an unforgettable night.

a wedding at marlo and phil's

One of the first guests on my radio show was the actress Marlo Thomas. At the time, she was starring on Broadway in a comedy written by Herb Gardner called *Thieves*. We hit it off immediately and went out for dinner after the show. And that began a forty-eight-year friendship that continues to this day. (Growing up an only child, it was ironic that as an adult I gained two sisters: Marlo and Elaine May.)

Marlo is the hostess of many wonderful dinner parties. After she and Phil Donahue married, the two of them hosted fabulous yearly Thanksgiving, Christmas, and New Year's celebrations. Sometimes they added Labor Day, July 4th, and Academy Award dinners to the get-togethers.

My favorite, however, were the sleepovers they held in their beautiful home in Westport, Connecticut. There would be six couples there, sharing a sumptuous dinner, arguing politics, and then playing charades. The next morning, outside each couple's bedroom door on a tray were large orange juices, fresh coffee, and all three New York City newspapers. I was generally up first and would quietly descend the

staircase into the living room. Often, Phil was there, and we ended up competing doing the *New York Times* crossword puzzles. (He almost always did better than I.)

On one particular New Year's Day, a very prominent and wealthy New Yorker was downstairs alone and seemed anxious to talk. He kept saying over and over, "I can't believe it. I opened my door and there were all three New York newspapers, fresh orange juice, and coffee. It's unbelievable."

What I found interesting was that this man could have done what amazed him so, every day of the year, for dozens of guests. It was then that I realized that all of his money didn't equal knowing what to do with it: how to be a sensational host—how to enjoy your life.

Marlo and Phil's annual Christmas party, held in New York City, was a true gala event. Phil brought in many of the biggest names in politics and broadcasting. Marlo invited show-business luminaries. I often called my mom the next day and said that Merryn and I were the only people there we'd never heard of.

Most of the other parties were much smaller. Often, the same group were invited and I recognized that we had all become family. In fact, in Merryn and my case, with the exception of our mothers, these were our only family. And we had chosen them and they us—family not by blood, but by friendship.

Marlo told me one day, "If you ever get married again, we're throwing the wedding party." Laughing, I replied, "Well, that won't happen!" I had been married twice, and had also had long-term live-in girlfriends. I had mapped out my future; it was obvious I wasn't easy to live with. I foresaw having a series of girlfriends, and then in old age asking the last one to stay with me to the end. "I have some money in my pension," I imagined saying, "so stick with me and I'll leave it to you."

However, when I met Merryn, I shocked my mother, my friends, and myself when I realized I wanted to marry her. Marlo, true to her word, threw the wedding party: eighty people in a big white tent, entertained by the Peter Duchin Orchestra. When we arrived at "our"

favorite home in Westport, we were surprised to find two flags flying on a flagpole: the Union Jack and the Stars and Stripes. That was Phil's touch, and it made us feel so glad to be in our friends' loving arms.

Many toasts were given by our friends. The actor Charles Grodin said, "Let me get this straight. They've been to Venice on their honeymoon. This is their wedding party. And they're getting married next month?" (It was true: the other two times I'd been married, I'd done everything in the right order, and we saw how that turned out! This time, I figured I'd better do it all in reverse.)

A judge married us in our living room. When I was asked, "Do you take this woman to be..." I said yes, and Marlo yelled, "That's the best thing you've ever done!"

I can happily write that on our marriage license, our two witnesses were my sisters: Elaine and Marlo.

"sly fox": the casting of a broadway play

On the next Broadway play I produced, I decided to keep copious notes on how it all unfolded. I'm glad that I did, so I can illustrate here what it takes to cast a Broadway show. This wasn't a musical, which is usually harder—but it turned out to be a wild roller-coaster ride nonetheless.

Every time I finish producing a play, I wonder why I do it. What is the siren that lures me to try another play? I've produced TV and video specials too. They're much easier, and I generally make considerably more money with them. On top of that, they have a long life and can play all over the world. They can be sold and resold, and eventually be part of my estate.

Feature films are the same as the above—and they can grow into a worldwide phenomenon.

Straight plays in theater generally close in New York City, and that's it. Oh, occasionally you can get a national tour—though it's rare. And you can sell the stock and amateur rights for a fair advance. And every

264

once in a while, HBO will do a *Dinner with Friends* and Showtime will do *Our Town* with Paul Newman. But ninety percent of the time, you play one theater on Broadway or off-Broadway, and that's it.

So why do it?

I'm reminded of the film *Patton,* with George C. Scott. After one particular battle, he walks among the carnage, turns to an aide, and says, "God help me, I love this!"

I guess that says it all.

<p style="text-align:center">* * *</p>

Wanting to work with Arthur Penn again, I sent him a new play. He passed. Then he sent me a new play. I passed. Then I sent him a film script. He passed.

Finally, one day Arthur said, "What about reviving *Sly Fox?*"

Now, *Sly Fox* was one of the funniest plays I had ever seen. Larry Gelbart adapted it from the classic Ben Jonson play *Volpone,* and it had starred George C. Scott and an all-star supporting cast. It was a big hit in 1976.

The only problem for me was that it would be a revival. I had produced more than thirty plays, and not one of them had been a revival. I wanted to present new plays in America. But on the other hand, this would give me the chance to work with Arthur again, and with Larry Gelbart for the first time. Plus, I thought a play about greed was more meaningful today than ever before. So I suggested it to my partners, Roy Furman and Ben Sprecher (who had also co-produced *Fortune's Fool*). Both readily agreed.

All great comedy writers have a distinct rhythm. Having worked with Woody Allen and Elaine May, I had learned that some actors can pick up that rhythm, and some cannot. It doesn't necessarily mean an actor isn't good—he or she may be great, but still be unable to capture the meters. It isn't natural to them. This is one reason producing a comedy is a dangerous prospect; show-business history is full of comedies being miscast.

So who would play the lead in *Sly Fox* in 2004? My co-producers, Arthur, and our casting directors, Stuart Howard and Amy Schecter, met to come up with our list for the lead.

Then we ran the names by the writer, Larry Gelbart, in Los Angeles for approval. In the theater, the writer is especially important. Unlike in the film business, you can't change a word of the script without his or her okay. Writers also can veto an actor, a director, or a designer. It's probably the major reason writers continue to work in the theater. They have an enormous say in the production, and with any luck their work will be well realized.

These casting sessions are fun, but exhausting. Names are thrown out and rejected for all kinds of reasons. One big reason often volunteered is that So-and-So is a pain in the ass. Now as glib as that appears to be, it makes a huge difference. Theater is a hard enough process on its own: there, anything can go wrong. If the word is out that an actor is difficult too, why hire him or her?

Here's why. Number one, a great actor will help inspire a great play. That's pretty hard to resist.

Number two is, they'll be great in the part. Think of all the actors you've seen where the part and the star came together; then check your Academy Award winners, and see how many repeated that one great part. You'll be amazed at how many didn't.

Number three, that pain in the ass gets you the money. Non-musical plays on Broadway don't have a great track record of making money, so raising the dollars with them is difficult. That said, that "pain" of a star stands to make your life as a producer much easier.

Number four, your writer or your director—and sometimes both— might love the guy or gal. Why? Because he or she is a pussycat with them. The star knows that he needs the writer to create another role, and may trust the director to work with them again. But the rest of us are fungible, easily replaced—or so they think.

And so, with these facts present but unspoken, the casting meeting begins.

"How about Gene Hackman?"

"He lives in Taos and is painting."

"He's in his seventies. He's not moving to New York for six months."

(The part required close to an eight-month commitment, counting five weeks' rehearsal and two weeks out-of-town.)

"He worked with Arthur in *Bonnie and Clyde*."

"I also did *Night Moves* with him," agreed Arthur. "But he's not going to do it."

That ended Gene Hackman—or, more accurately, Gene Hackman ended that.

"I've got an idea: Gene Wilder. And he lives in Connecticut."

Now here's another important point. A star who lives in the New York-New Jersey-Connecticut area is expensive enough, but if he lives out-of-town, you have to add a first-class round-trip ticket, a luxurious apartment in Manhattan, per diems—you get the point. The budget goes bananas. So living in Connecticut is a big selling point to most producers.

"Gene hasn't done theater."

"He was great onstage in *Laughter on the 23rd Floor*. I saw it in London."

"Arthur, you gave him his first film role, also in *Bonnie & Clyde*."

"Forget it. I offered him this role in the past."

"How about Paul Newman?"

"Yeah, he likes comedy—and he's not offered that many."

"And it's Larry Gelbart."

"Also, he has an apartment in New York City."

"Arthur, you directed his first film too, *The Left Handed Gun*."

"No, that was *my* first film. But Paul has just finished doing *Our Town*. I don't think he's going to do another show so soon. Also, that was a limited run, and we need at least six months."

And so it went.

We needed a star. It was a starring role. George C. Scott had performed the original, but this was twenty-eight years later. There were

more opportunities for stars by then, and not just in movies. There was HBO. Many foreign companies were producing Hollywood films—all paying much better money and giving the star an easier life than eight shows a week, every week, for more than six months. Also, stars did network TV shows for millions. Plus, they got residuals for years to come if those productions became a hit: a good legacy for their families. The competition was daunting.

"Wait a second. How about Burt Reynolds?"

"Has he done theater?"

"Are you kidding? He had his own theater in Florida."

"Really! Has he ever been on Broadway?"

"No—never. And that really is much more pressure than a theater in Florida."

"I think we'd get a lot of publicity with Burt coming to Broadway."

"And to the theatergoing public, he's still a major star."

"And the tourists will really want to see him."

"Arthur, are you okay with him?"

"Yes—go get him."

And so, from our point of view—pending Larry's okay—we had our lead.

Of course, we needed Burt's okay, too. And as it turned out, Burt was available. He loved Larry Gelbart, and he respected Arthur Penn and said he had always hoped he could work with him. And Larry was happy with Burt, too.

So I called Burt to talk about the play. He wasn't in, so I called a second number and left my usual message:

"I'm a New York producer. Try not to hold that against me. I have a script by—etc."

Now I had to hope he'd call back.

Often, a manager or agent will tell you the star is interested. But that could mean many things.

Interested in starring—but also directing.

Interested in starring—but only with his girlfriend.

Interested in starring—in the movie (but not your play).

So "interested" can't be taken to the bank. But if I only could get a phone call back, I could try to judge how interested was *interested*.

Well, the call came back quickly. And there was Burt: serious, charming, and inquisitive. We talked about the dates, the schedule, going out-of-town first, five weeks (not the usual four) for rehearsals, and supporting him with an all-star cast. In my mind, he was interested; in fact, he remembered the play. His buddy Jackie Gleason (they had done *Smokey and the Bandit* together) had starred in the short-lived road company production. (Short-lived because Gleason had suffered a heart attack and had to cancel.) Burt asked if I'd send the script, and I sent it overnight and I told him I would call back in a week.

A week later, I called. No answer. I left messages.

At this time, Roy, Ben, and I were producing Elaine May's *Adult Entertainment*. We were in rehearsal at the Variety Arts Theatre when I was told that a Mr. Reynolds was calling. He had read the script and had loved it. "I understand Larry's rhythm," he said. "I can do this."

I hung up the phone and called Ben, Roy, Arthur, and Larry. I was very excited. Burt would be great for the show, and the show would be great for Burt. It was the best kind of chemistry. A win-win for all.

Ben and I had several meetings with Gerald Schoenfeld, Chairman of the Board of the Shubert Organization. Finally, he agreed we would have the Royale Theatre (now the Jacobs Theatre). It was all happening just as we had hoped. At the same time, we were talking to many different actors for supporting roles. We hired a set designer and a costume and lighting designer. We were on our way. Nothing could stop us.

A contract in show business is a funny item. Many are never signed. I once did a show with Judd Hirsch, and to this day his contract has never been signed. Someone once said, "In our business, a contract is the *beginning* of negotiations." We've all read stories about stars signing contracts for a certain period of time, for a certain amount of money, and then demanding more money and less time when the show turns out to be a hit—not to mention producers who have said to actors, writers, or

directors at various times, "Screw the contract!" (Then, of course, there's the favorite line of those who think they have the power, "Sue me.")

So since we didn't know Burt, and lots of money was being expended in good faith, we put together a contract. Ben and I negotiated with Burt's manager and even provided him with a list of all the major stars' salaries on Broadway. We were right on target with all his peers.

Finally, after weeks of negotiations, we hammered out a deal. It was time to take the next step: securing the out-of-town theater.

For many years we had taken our major shows to the Rich Forum in Stamford, Connecticut. This venue was run by George Moredock, an intelligent and caring promoter. He was also excited by Burt Reynolds, knew the play, and was eager to present the pre-Broadway production.

Now, almost all Broadway shows have two acts with an intermission. So we'll now have an interlude. But don't miss the second act—because a funny thing happened on the way to the Rich Forum.

floria lasky

Floria Lasky was a force of nature. She was my friend, my mentor, my trusted advisor, and my attorney for close to forty-two years. She was intelligent and powerful, opinionated and domineering, kind and supportive—and I loved her.

I didn't always love her. For the first five years I was intimidated by her. She scared me. She was tough. How tough? I once saw her make an agent cry. An *agent*.

Here's how it happened. I had optioned a book to be made into a movie. When the contract came, lo and behold, it did not reflect the terms we had agreed to. I called Floria.

"Have him come to my office, and you come ten minutes earlier," she instructed. When I arrived, she said, "You say nothing at this meeting. I'll do the talking. Sit at the head of the table, and I'll be to your right."

Then in came the agent. He's swaggering, cocky; Floria is kind, professional, quiet, reserved. The agent starts babbling away. All of a sudden, a ringed finger comes forward, pointing at him, and I hear her growl, "Now, *you* listen to *me*."

The agent braced.

I braced.

The office braced.

Most of Fifth Avenue in the 40s braced.

Floria then proceeded to annihilate, exterminate, eviscerate, and finally decapitate this man. He melted like the Wicked Witch of the West in *The Wizard of Oz*—except, in his case, he melted in his own tears. Needless to say, we got everything we wanted.

Having Floria as your representative was like being a cub to a mama lion. Over the years, there were lots of cubs. But there was only one lioness.

"sly fox," part 2

I couldn't believe what I was hearing.

"Burt changed his mind."

"What do you mean he changed his mind?"

"I mean he's decided not to do *Sly Fox*."

"Does he have any idea how many lives he's affecting with this cavalier attitude? People have turned down other jobs, money has been expended, and not one, but *two* theaters have been booked. This is outrageous."

But there it was. We had thought Burt needed us as much as, if not more than, we needed him. It was a perfect role for him. He was excited. We were excited.

And now, *ta-ta*.

I received a call from Burt's attorney. Burt, he said, had not known about some of the terms of the contract. He, the attorney, had never seen any of the correspondence. Burt didn't know about blah, blah, blah.

I cut him off. I myself had talked to Burt about a lot of the blah, blah, blah. We had even talked about other casting. I had introduced

him to my New York physical therapist on the phone so he could watch over him when he was on Broadway.

His attorney was attempting to be soothing. I'm generally a sucker for the soft-spoken word, so I listened. He would talk to Burt. Maybe there was something we could do. Perhaps he could turn it all around.

"Forget it," I then heard myself say. "It's only three months before rehearsals, and I won't enjoy a restful night if he says yes. If he can say no now, why not two months later? No thank you, Mr. Attorney. This ship has sailed."

As I hung up, I realized the ship was also sinking.

I had so many calls to make, I didn't know where to begin. Arthur and Larry, Ben and Roy, Jerry Schoenfeld and George Moredock, the designers—the mind boggled.

We've all heard the expression, "timing is everything." When we called Jerry Schoenfeld at the Shubert Organization, he said he would give us *three weeks* to find a star. Considering how late it was in the year, and the fact that the Royale was a prime theater, it was a generous offer. So it was back to the drawing board—or in this case, to another casting meeting.

"Dustin Hoffman hasn't done theater in a while."

"He was great in *Tootsie*."

"Larry was one of the writers."

"He loves comedy."

"He did *Death of a Salesman* and the *Merchant of Venice* on Broadway."

"This would be great for him."

"He has apartment in New York."

"It's up for sale."

"Arthur did *Little Big Man* with him."

"Fellas, stop—I'm afraid he's got a movie this fall."

"Are you sure?"

"Yes."

"There has to be someone we're forgetting."

"How about Al Pacino?"

"Is he that good in comedy?"

"He's a great actor, he can do it."

"Wait a second. He's doing *Salome*."

"No, he's *talking* about doing it. He hasn't committed."

"Yes, he has. I talked to Marisa Tomei and they picked the months already. It's right in the middle of our schedule."

"C'mon, guys, we've got to come up with someone."

"What about Nathan Lane?"

"He has a new TV show."

"I'm told it's not going forward."

"It hasn't even premiered yet."

"Nevertheless."

"Well, I know he knows the show. George C. Scott gave him his big break in *Present Laughter*."

"Arthur, would you call him?"

Arthur did. And Nathan did know the show—he had seen it three times and loved it. Now he would read it from the standpoint of playing the George C. Scott role. He read it fast. And he loved it. But he thought Max Bialystock (*The Producers*) was too similar to Foxwell J. Sly, and he passed.

"Let's think of an Englishman."

We were in another casting meeting.

"How about Albert Finney?"

"No, he wouldn't come to New York with *Art*."

"But that was years ago."

"Yeah. He's told friends, no long runs in America."

"Funny that six months is now considered a long run."

"Well, the Roundabout and Manhattan Theatre Club lets them do three or four months only."

"Yeah, but they're non-profits."

"So are we."

"But not on purpose."

"Hey, you know who did *Prisoner of Second Avenue* recently in the West End?"

"No!"

"Richard Dreyfuss."

"Right! He'd be great."

"He would, and he lives in New York City."

"And he's been looking for a play."

"Arthur, would you—"

"Yes, yes. I'll call."

Richard Dreyfuss is a world-class actor. He won the Academy Award for Best Actor in *The Goodbye Girl*. He has appeared in some of the most successful films of all times, including *American Graffiti, Close Encounters of the Third Kind, Jaws,* and *Down and Out in Beverly Hills*.

So Arthur called him. And Richard said yes. We worked out the dates and set rehearsals to begin January 5, 2004.

Our bipolar existence continued as we entered a new phase of *Sly Fox*. It was looking good once again.

Anyone who produces a Broadway play will tell you that you have to do many things simultaneously. All this time, we were trying to put together our supporting cast.

Hector Elizondo had originated the role of Simon Able. It called for a younger man than Sly. Perhaps a son, or at least a kid-brother figure. Sly was the teacher, Able the student.

Our first choice was John Leguizamo. He had the energy the role demanded, and he was funny. But he read it and passed. (We weren't surprised; he played one-nighters all over the U.S.A. and could make more in one night than in four weeks on Broadway.) Next was Robert Sean Leonard, whom I had worked with on *Below the Belt*. Bobby is a wonderful comic actor, as well as an excellent serious actor—but he warned me in advance that with our dates, he would be doing four plays in a row without a break. He needed time off and he needed some money. He read it quickly and said no. Third was Denis O'Hare. Denis and I had known each other for a while, and had even talked about doing a play together. But he, too, read the play quickly and said the part didn't speak to him.

As I've said, a quick no is the second-best answer you can get. Because I never offer the same role to two actors at the same time, I need an answer so I can stop looking or move on. So I was grateful to John, Bobby, and Denis for their quick replies.

Stuart Howard had put Jason Biggs into the Broadway hit *The Graduate,* in Dustin Hoffman's role. Jason had first appeared in *Conversations With My Father* on Broadway when he was twelve years old. Now, at age twenty-five, he was starring in his third *American Pie* film and had the lead in a new Woody Allen movie. Both films were coming out within a two-to-three-month period. He was, in the parlance of the day, HOT. So we arranged a one p.m. appointment at Arthur's home.

The meeting with Arthur began. We were impressed with Jason's seriousness and articulateness. He easily guided us through his personal and professional life, and by the end of the meeting we wanted him.

His manager and agent reported that he wanted to do it. We gave a tight deadline to confirm, and sent a deal memo. We were told Jason was now in Australia and flying to England. Couldn't we wait until Monday? "Of course," we said. On Monday, we were told that *American Wedding* (*American Pie 3*) had gone through the roof at the box office—and Jason's manager had received more than a dozen offers for film. The theater—and specifically *Sly Fox*—would have to wait.

Sometimes things happen out of left field. David Schwimmer, of *Friends* fame, was another close call whose quickly changing schedule put the kibosh on things. He was finishing the series and had, with seven other friends, started The Looking Glass Theatre in Chicago. He loved theater and was also directing in film and TV. The idea of working with Arthur Penn was exciting to him. So we sent him the script. He read it, liked it, and arranged to meet Arthur and me for an early lunch. We were both impressed with his intelligence and commitment to theater, and I thought we had a great chance of getting him.

So what went wrong? Our dates. He needed to start four or five weeks later than our schedule permitted. We tried to move things

around, but with his schedule and ours we just couldn't make it work. Close—but no cigar.

So we still had no Able.

The old man, Crouch, had originally been played brilliantly by Jack Gilford. We decided that Joel Grey would be ideal to play him. Both Arthur and I spoke to him separately, and he said he was interested. (Oh! That word again. My feeling is that Forest Lawn Cemetery is filled with producers and directors who were told that an actor was interested.)

So we sent Joel the script and called his agent. Joel had just shot a pilot, and we were in first place if the pilot wasn't picked up. Since TV wasn't generally interested in actors over thirty (except in smaller supporting roles), we thought we had a good chance and agreed to wait a few weeks.

The pilot wasn't picked up. I felt confident we were in. I called Joel, and he told me excitedly about his photography show and invited me to see it during the two more weeks it would be up. I said great—I would go see it at the end of the second week, and perhaps we could go out and celebrate *Sly Fox* also. There was dead silence on the phone, then finally he said, "Do you think we can negotiate in two weeks?"

I was speechless. Unlike movies or TV series, Broadway presents a tiny dance floor for negotiating. There's the salary, the billing, an out (if any) for a film or pilot—and that's most of it. The number of weeks and the actual dates are all disclosed upfront, before you even send the script. So I told Joel I'd thought we could do it in the next two weeks. Joel told me he needed more time—like a few months—to decide.

We agreed to move on.

There's another terrific role in the play: the lawyer, Craven. We all thought Ron Leibman would be great in it. Ron is a fine stage actor and had won a Tony for playing Roy Cohn, another attorney, in *Angels in America*. I sent him the play and he responded quickly, but said he would like to play the old man Crouch, not the lawyer. I told his manager he might be too young. Ron, through his manager, said he would take off his toupee, and told us to imagine his face in makeup. He said he had

an "old man's face," and promised he would be great. Larry, Arthur, and my co-producers agreed, and a meeting with Arthur was arranged. They all knew each other, and their meeting went well.

After a week of talks—where we foolishly thought we were almost done—Ron changed his mind. Six months as a supporting player was too long, he decided. Of course, from the get-go it had always been six months—and Crouch was his idea, not ours. But he met with Arthur and then…bye-bye. (Stuart Howard, our casting director, once said, "You know how to make an actor unhappy? Give him a job.")

It was a difficult call to make, but after months of trying to get a top theater and finally succeeding, we were now giving it up. Jerry Schoenfeld at the Shubert Organization had heard it all in his time. He was gracious as always, and sent us on our way with no hard feelings.

But we were determined to find our cast to act with Richard Dreyfuss.

<p style="text-align:center">* * *</p>

One weekend, Arthur Penn and I were still batting around names when he thought of Jack Klugman for Crouch. Ben Sprecher knew him, and found out he'd be in town the next day. Ben delivered the script to his hotel, and I called him.

"It's a very funny script," Jack said.

"You'll be great in it," I said.

"I've been doing *On Golden Pond* for ten weeks on the road."

"That must be grueling."

"No. I love it. Before this, I did *Death of a Salesman*. I love the theater."

"Jack, come back to Broadway. Work with Larry and Arthur. It doesn't get better than that."

"Kid, I'm eighty-one years old. I love New York City, but January and February—I hate those winters."

"I'll get you a car, a driver. We'll try to get you a special schedule for you to rehearse."

"You hear my voice?" Jack had lost a vocal cord, and had a very raspy voice. "The doctors have worked miracles. It takes an audience a little time, then they get used to it."

"Jack, for the first time your voice and your role truly go together. Give it some thought. We all want you."

We knew it was a long shot. After you've had the lead in *Death of a Salesmen* and *On Golden Pond*, it's hard to go back to supporting roles. But as promised, he called. He wished us well.

Bob Dishy had originated the role of the jealous husband, Truckle. Dishy is an incredibly inventive actor who brought down the house whenever I saw the play. I wanted Bob to return in our production.

"Julian, why should I do this again?" he asked.

"Because it will be new to you."

"Why? Has Larry rewritten it?"

"No, but it's now twenty-eight years later. You're older, and you'll bring many different shadings to an older jealous husband. And it will feel new to you."

"Uh-huh. Well, give me a week to think it over."

A week later, I called.

"Julian, what's the hurry?"

"Well, Bob, I'd like to line up the cast as fast as I can. I'd like to know who's playing Mr. Truckle before I hire Mrs. Truckle. Because you know the play, and because you scored so well in it, I came to you first. It also helps us in deciding who will be Crouch and Craven."

"Okay, I'm really interested—just give me another week."

"Fine, Bob, but then I must move on."

I really wanted Bob Dishy. It's one thing to believe someone is made to play a role. But to have already seen what he'd brought to the stage—well, as they say, seeing is believing.

When I spoke to him again, Bob agreed to do it. Ben proposed what we thought was a fair deal to Bob's agent. We were told he needed more money and that he wanted much better billing.

Interestingly enough, what was cited was his last deal on Broadway.

The film and TV business often use "the last deal" as a guideline. Everyone knows this doesn't apply to working on PBS, or Woody Allen films, or low-budget films. But one major studio, or one network, will call another to find out what the actor was paid the last time. But once again, theater is different: musicals pay more money, small casts can afford to pay more, and so on. Still, for the stage, the money is small compared to film and TV, which means there's little room to maneuver.

Bob's last play on Broadway was a four-character play. He'd had excellent billing, a good salary, and even a percentage of weekly profits. This was what he felt he should have in *Sly Fox*. But there's a big difference between having only four actors in a play and having—as we did—seventeen. On top of that, Bob's last play had no major stars. We were going to have two, and one had already committed. This was like comparing apples to skyscrapers—forget oranges.

Bob didn't see it that way. So we met at my office. We laughed and reminisced for two hours. At the end of the meeting, we drove uptown and I dropped him off. Both parties, I felt, were happy.

The next day, we received a long list of demands from Bob's agent. It was as if the meeting had never taken place. Ben felt we were better off before I had the meeting. He was probably right.

So I called Bob's two representatives. I told them we had no choice, and that if we didn't have a yes from Bob in two days, we were moving on. The next day, I hoped Bob's people would convince him. Sometimes if you feel you have an actor's representative on your side, you can prevail. Ordinarily, however, managers and agents aren't thrilled with theater, as I've mentioned: the percentage of their client's income that they're receiving is very small compared to what many of their people can make in other mediums.

But Bob's reps knew he would be great in the role. Also, if there were lots of heat on the show, many studio heads and producers should see it. And if they did, they might want Bob for television and film.

So we only had two days to wait for Bob's answer.

I had spoken to his agents on a Wednesday. On Thursday at 4:20

p.m., the lights in New York City went out. As the evening progressed, much of the Northeast was blacked out as well. That made the Friday deadline at five-thirty p.m. a moot point, so we would have to wait until Monday. The blackout received top billing.

The minor points were negotiated. Bob gave in a little. We gave in a little. And finally—right at our last deadline—we concluded our deal. I called Bob and told him I was glad it was done, that he would be great, and that I was looking forward to working with him.

The role of Mrs. Truckle had originally been played by Trish Van Devere (a.k.a. Mrs. George C. Scott). Mrs. Truckle is a pious young woman who is wanted by all the eligible and not-so-eligible men in San Francisco. Her husband, Mr. Truckle, is an insanely jealous husband—and with good reason. So we needed a beautiful actress who could do comedy.

When we were casting *Adult Entertainment,* Elizabeth Berkley came in to read. She had received fame in the TV series *Saved by the Bell,* and also starred in the movie *Showgirls.* The irony was, when she met Elaine May and Stanley Donen on *Adult Entertainment,* they felt she didn't look or sound like a porn star. She had a true innocence and a purity that came through. After she left the audition, I ran after her. I told her in the lobby of the theater where she'd auditioned that she had done very well—and that, despite her role in *Showgirls,* she didn't strike any of us as a porn actress.

So when we were looking for Mrs. Truckle, we thought of Elizabeth. She flew in from L.A., auditioned for us, and nailed the role. Arthur and Larry said yes, so I called her an hour later and told her she had the part.

Elizabeth truly couldn't believe it. She kept saying, "Are you serious? Is this for real?" When I told her she really had the part, she said she was crying tears of joy.

So far, a lot of this writing has been about what actors put producers through. The opposite takes place too, and is, at times, worse. Actors are promised jobs and never called again. Actors are called back two,

three, and four times—and then turned down. Actors are sometimes fired and first hear about it when they read it in *Variety*. I remember Robin Williams telling me how he'd found out that *Mork & Mindy*, a huge television hit for years, was cancelled by reading it in *Variety*. Unfortunately, it works both ways. And when you finally get a job in theater, after a month of rehearsal, you can close in a day. On television, your series can be cancelled after two shows. In the film business, your film can disappear over a weekend after you've shot for four or five months. If you're going to produce, you have to have the hide of a rhino—*and* there is so much rejection in the acting field.

So with Elizabeth, it felt good to make someone so happy. However, her agent had problems with the contract. I was in shock once again. It certainly should seem by this time that no rational person would be in shock. But there I was, agape.

Here's the problem: there used to be only agents. As a producer you tried to figure out, *Is this demand from the actor or the agent?* Sometimes, it was both. But that was it—two people. Now there are managers and lawyers in the mix too. It makes it difficult, sometimes impossible, to determine who's asking for blah, blah, and blah.

Elizabeth, or her agent, or her manager, wanted her name on the Broadway marquee. She had been in the West End in London in *Lenny,* a play about Lenny Bruce, and had been on the marquee there. She had been in fifteen films and had always been in the paid advertisements. Why couldn't and shouldn't she be on the marquee and in the ads now?

Our reply: we had seven actors out of seventeen who *should* be on the marquee. We had a writer and director who *had* to be on the marquee. We had a title, *Sly Fox*, which *had* to be on the marquee. That was already ten names. It would be one of the most crowded marquees in Broadway history.

Anyhow, we solved that problem—and some others. And we waited. The agent said he was satisfied. And then, once again, we heard nothing. We decided to give it a Friday deadline, and we waited. On Monday, the

agent said that Elizabeth would end up being out-of-pocket financially with our offer, and told us what would make the difference.

"If we say yes to this amount, is it a deal?" I asked.

When he said yes, I said on the phone, with the agent listening, "Ben, let's do it."

"Let me check," Ben said—and then he yelled, "Ben, should we do this?"—which made me laugh—and replied to himself, "Yes."

We put the new offer in writing, everyone signed it—and we had another role cast.

<p style="text-align:center">* * *</p>

Eli Wallach, an old friend, told me at a party that he would like to play the role of the old man Crouch. I told Eli that he was being considered, but that I was only one of three votes—and I would get back to him with an answer within a few weeks.

The following week, Eli called and asked again about *Sly Fox*. I told him the truth, that we were looking to cast the two leads first and then we would turn our attention to the co-stars. What I didn't say was that we were concerned about his age. No one questioned his acting ability. But he would be over eighty-eight years old—doing eight shows a week for over six months.

Finally, after lots of soul-searching, Larry and Arthur agreed to go for it. I called Eli on the weekend with great excitement to tell him the role was his. Unbelievably, he hesitated—then asked if he could get out of the show early. They had been trying to raise the money to make the film adaptation of *Visiting Mr. Green*, a two-character play that Eli had triumphed in, and he felt sure they would do it.

By now you know I'd been shocked before, but this turn of events took me by surprise. *He* had called *me* for this role! But I spoke quietly and deliberately, from the heart.

"Eli," I said, "the one thing I know after forty years in show business is that a bird in the hand is worth two hundred in the bush. Don't give up this role!"

"Okay," he said. "Let me read it, please."

"Okay, but I need an answer soon."

"I know. I'll call you in a few days."

As I hung up, I realized once again that I should take absolutely nothing for granted when producing.

A little over a week later, Eli and I spoke.

"Julian, I have an idea," he said. "Don't say no until you've heard it all, okay?"

"Sure."

"I'll work January, February, March, April, and even all of May. That's five months. I'll take four weeks off, and you tack it on the backend. So I'll give you the time you need, except for that four-week out."

"Eli—I don't know. If it weren't you, I'd say no immediately. I have favored nations clauses with at least four and maybe six other actors." *Favored nations* meant no actor could have more than a two-week out, unless everyone else did too. "Also, there's Larry, Arthur, and my co-producers to consult with. I'll give it a try, but I'm not optimistic."

All of my partners voted no. It wasn't against Eli; we all wanted him. We just couldn't give a four-week out. So I had to give Eli the bad news. I called his agent and asked him to talk Eli into the play. He said he'd try, but then called back to report that he'd talked to him and Eli was going for the film.

The film never did happen.

* * *

I was a fan of Kevin Nealon from *Saturday Night Live*. I thought he did a fine job doing the Weekend Update; he was an excellent sketch comedian. I worried a bit about how he'd play a lawyer in a straight play on Broadway. Many sketch comedians—even excellent ones—are weak actors. However, Arthur and Larry thought the role of Craven—a farcical role that didn't change much during the show—could be done well by Kevin, so we went after him.

The good news was, he was interested. The bad news was, he had

just sold his New York City apartment. But we sent the script anyway.

Very soon after reading it, Kevin confirmed his interest. I thought it might be a good idea if he and Arthur spoke on the phone, so Arthur agreed to set up a call. Then we were told, to our chagrin, that Kevin was out of the country for two weeks. We had other actors on our list, but we decided to wait.

I received a call right before Labor Day weekend from Kevin's agent: Kevin wanted to have Arthur's phone number so he could call him. Arthur agreed, and I gave the agent his number, asking Arthur to call after he spoke to Kevin.

After Saturday and Sunday came and went, I called Arthur.

"Haven't heard a thing, kid," he said.

(One of the many reasons I loved working with Arthur was that he still called me *kid*.)

"That's strange," I said, "but I'm sure he'll call soon. After all, today is the holiday."

On Tuesday, when Arthur had still heard nothing, I called Stuart, our casting agent.

"Well, here's another weird one," I said. "Arthur never heard from Kevin."

"*What?* He called and wanted his number—he asked if he could call. What the hell is the matter?"

"It's okay, Stuart. Let's just move on."

"Okay," Stuart agreed glumly.

Somehow, I wasn't glum. Maybe I was adjusting once again to the strangeness of the business. As I was musing, my assistant Ruth said Stuart was back on the phone.

"Listen to this," he said. "Is it possible for Kevin to call today?"

"Arthur's in New York City now. Hold on. I'll check with him."

Arthur laughed, but said okay. The next day I called Arthur back and asked if he had heard from Kevin. He said no.

Now I was angry.

"Stuart, end this with Nealon. I don't care how he treats me, but

Arthur Penn deserves much more respect. We'll somehow do the play without him."

Later, Stuart called again. "Kevin's rep said he wants to call Arthur. I told them it was over, but they're going to call anyhow."

"Fine—just call Arthur and alert him. Who knows? Maybe he *will* call."

He did call. They did talk. Then Arthur called me—and we agreed. We both said no.

<p style="text-align:center">* * *</p>

On top of everything, we still needed an Able.

The funny thing about casting is that sometimes you forget somebody. That's why it's important not to take any order as first, second, or third choice: someone may become available out of the blue. Reasons vary. Their series is dropped. Their marriage is over. Their film is cancelled. Their girlfriend or boyfriend lives in New York City. You get the idea. An actor may suddenly emerge who would have been your first choice if you had only thought of him or her, or known they were available.

This was the case with Steve Buscemi. Steve was a big favorite of all of us. He has an offbeat manner and a quirky style that is genuinely appealing. His career began in New York City theater, and he had a minor role in a film I produced, *In the Spirit.*

The good news was, Steve was in New York shooting *The Sopranos,* and would read our script over the weekend. We were told he was diligent about reading and answering quickly. I wonder why it didn't surprise me that we heard nothing the first week…but in typical producer fashion, we said another ten days, and we'll move on.

We gave his agent the deadline and waited. Stuart called Steve's agent at twelve-thirty p.m. the day the answer was due. The agent yelled, "We have until five-thirty, what's the hurry?"

We waited five more hours—and then were turned down.

I felt we had an incredible pedigree—for some actors a

once-in-a-lifetime offer. Larry Gelbart, the writer; Arthur Penn, the director; Richard Dreyfuss, the star—and a play that had been a hit comedy. For Broadway in 2004, this was as good as it gets. All of these incredible pluses. And yet, as you have just read with these *Sly Fox* chapters, plenty of frustration and aggravation too.

Well, in the end, we did bring together a great cast and a terrific show, which garnered solid reviews. But we went through hell to get it—and we still lost money to boot!

b.f.f.

How many people have you met who are totally unique? One hundred percent original? Reminding you of no one else you have ever encountered?

Add to that a word that's bantered around a lot—*genius*—and you have Elaine May.

It's not possible for me to describe the love and admiration I have for this extraordinary woman. She has helped me in so many ways and in so many instances; we complement one another in a unique way. (She has said, "Everyone in the business thinks I'm crazy, but I'm a closet sane person. Everyone thinks you're sane, but you're a closet crazy.") She is a very private person, and has spent a lifetime turning down scores of print interviews, TV and radio appearances, and almost all public events. However, she did march with Dr. King in Selma. She has performed for presidents. She did perform in the very first AIDS benefit on Broadway. In 2019, she won the Tony for Best Actress for *The Waverly Gallery* on Broadway. And in 2022, she won the Academy Award for Lifetime Achievement.

She received the National Medal of Arts from President Obama. As he was putting the medal on her, she said softly to him, "You don't even know who I am." The president laughed and kept repeating, "I do, I do."

Elaine is fearless. She has fought with major studios. She has gone to court with studios as well. She has refused millions of dollars over the years from projects she didn't like—and still became the highest-paid script doctor in Hollywood. She has two rules she insists on if she accepts a rewriting assignment: first, she will take no credit on the screen or off, and second, the writer has to call her personally and say it's okay.

Those rules came about after she rewrote the smash hit *Tootsie*. I asked her why she wouldn't take a writing credit. She said she'd been told that the last writer, Larry Gelbart, had quit, but then discovered that he hadn't in fact walked away—and learned he was upset that she had rewritten some of the script. From then on, she insisted that any writer involved in a project had to call her and okay it. Both Dustin Hoffman, the star, and Sydney Pollack, the director, publicly thanked Elaine and said that without her contribution, there would be no *Tootsie*.

Her first film as a director was *A New Leaf*. She also wrote the screenplay, and on top of that was the female lead. Please consider what I just described. Your first film as a director, and you write and star in it? It doesn't happen often. And the film was a success—so much so that it holds a one hundred percent critics' rating on Rotten Tomatoes. How often does *that* happen?

Initially, although the studio (Paramount) loved the script, they refused to give her approval of the director or the actors. That wasn't unusual for a first-time writer, or even a seasoned one. But the studio would approve her if she wanted to direct. Now *that* was unusual. She agreed only because they wouldn't give her any approvals as the writer.

One day, as she was casting, she received a call from Cary Grant. He had read the script and wanted to play the lead. His only concern was the end of the film, where he had to be in the water—specifically the rapids. I asked Elaine, "Why did you turn him down? He'd have been perfect." Elaine smiled and told me, "I knew nothing then. I didn't even

know about doubles or stand-ins. When Walter Matthau"—who played the role—"didn't want to go into the rapids, I told him I'd turned down Cary Grant because he wouldn't go in the water. Walter went in."

Her second film as a director was *The Heartbreak Kid,* written by Neil Simon. It was given rave reviews and won many awards. What was universally hailed was the acting, and both Jeannie Berlin and Eddie Albert won the New York Film Critics Award in the Best Supporting Acting categories. They were also nominated in that category for the Academy Award.

I've written previously about *Mikey and Nicky.* I'm proud to have been the worldwide distributor of that film for over forty years. When I left Paramount, I was able, with Peter Falk and Elaine's help, to negotiate ownership.

And finally, *Ishtar*, the last movie Elaine directed. Upon its release, and even before, its budget was savaged, and the film itself received mixed-to-bad reviews. But in time, a strange thing happened: *Ishtar* was recognized as prescient in its depiction of the Middle East situation. *The New Yorker*'s Richard Brody called it "a wrongly maligned masterpiece." Charles Bramesco wrote in *The Guardian,* "Its failure has been outed as undeserved." Quentin Tarantino and Martin Scorsese have heralded it, with Scorsese calling it one of his favorite movies of all time. It has become a cult sensation. And Elaine's comment is my favorite of all: "If all the people who hate *Ishtar* had seen it, I would be a rich woman today."

As a writer, Elaine has been nominated twice for the Academy Award: once for *Heaven Can Wait* and again for *Primary Colors.* She earned the Writers Guild Award for Best Screenplay for *The Birdcage,* and she won the British Academy Award for *Primary Colors.*

I have produced all of Elaine's plays for thirty years. She also directed (and I produced) the Emmy-nominated documentary on Mike Nichols for American Masters.

Even now I can hear Elaine saying, "Stop, don't write all this." Okay, my dear friend, I will listen and stop—except to say that you are the best.

movie tales

One day I received a call from a film producer, Martin Poll. He had produced, among his many movies, *The Lion in Winter* and *The Sailor Who Fell from Grace with the Sea*.

He wanted to know two things: one, whether I had feature films available for Nigeria, and two, whether I could buy films for Nigeria from other distributors.

I told him yes to both questions, but asked to meet. I had my own questions to ask.

At the meeting, I was able to get all my answers. At that time, in the 1980s, Nigeria was controlled by tribal chieftains. They did not want to pay the high prices the major studios were charging. They would pay only $150 per hour for film. It worked out to approximately $300 per movie—a pittance, even by the standards of the day.

I would always meet resistance initially with other independent distributors. I reminded them that they had probably never sold Nigeria—and, equally important, I would license all their films. These two points almost always worked.

Then I got another surprise. The chieftains wanted no black-and-white films. This made no sense to me. There were some very good films that had been shot that way, and I had already licensed many of them for Nigeria.

As it turned out, the people of Nigeria—the largest English-speaking country in Africa—only had black-and-white television sets. Ah! But all the *chieftains* had color sets. Obviously, in this case, they prevailed.

So I had to go back to the distributors and explain that it was to be color films only. A lot of moaning and complaining ensued, but no one withdrew their films.

I ended up buying hundreds of films for Nigeria. I never heard a word after the films were shipped—I received a fair percentage of the total cost, plus the license fee, of course, on the seventy Castle Hill films that were sold.

* * *

My father was in and out of Mt. Sinai hospital in New York City a lot. He had emphysema, which proved to be a difficult way to go. He had smoked three packs of cigarettes a day for more than fifty years, and the doctors all thought it was a miracle that he'd lived as long as he did. He died at seventy-one, having been repeatedly told from the time he was sixty-five that this was the end.

Dore Schary, who had been an Academy Award–winning screenwriter and then the head of RKO and MGM studios, was also a patient at Mt. Sinai. Since he was on the board of the Walter Reade Organization, I knew him rather well. He was touched and pleased that I visited him as much as I did. I never told him Dad was also there. (Oh! All the lies of omission in one's lifetime.)

Dore would regale me with stories of the studio system. When he ran RKO, Robert Mitchum was under contract. Dore said Mitchum was a rebel and regularly got into trouble. The studio spent a lot of time trying to keep Mitchum's escapades out of the papers. At one costume party, he'd shown up nude with ketchup on his head, saying he'd come as a hamburger.

Dore also had a lot of trouble with Louis B. Mayer, who resented Dore's presence at MGM. Mayer had founded MGM and run it in its heyday, and now this new medium, television, was offering stiff competition. Attendance was down. Grosses were down. All the studios were panicking. And so the New York brass at MGM brought Dore in to help run the studio. It was also to push Mayer out—which is what eventually happened.

Dore told me he was told to try to meet all the stars personally, one by one. He said the meeting he remembered best was with Lionel Barrymore. Dore was outside a sound stage when Barrymore, in a wheelchair, was introduced to him. Barrymore said, "How old are you, young man?"

"I'm thirty-five years old, Mr. Barrymore," Dore said.

"Well," Barrymore replied, "You must be some prick to be running a studio at thirty-five years old."

The last time I visited, Dore asked me what I thought of Clint Eastwood as a director. I said I'd liked *Play Misty for Me,* but didn't see Eastwood as anything special.

"Screen *The Outlaw Josey Wales,*" Dore said. "This man is really talented. I believe he'll be a wonderful director one day. If I was running a studio, I'd sign him up."

He certainly proved to be right.

* * *

Titles are important for movies, TV, and Broadway. How important, no one knows—but they do help attract an audience. Sometimes they're easily forgotten, and someone may just say, "You have to see Hugh Jackman's new movie." (When you have a big star in a show or movie, that really helps you get the financing, the distributor, and an audience at the beginning of your run.) Titles cannot be copyrighted, but you also can't call your film or show *Gone with the Wind,* or *Star Wars,* or any big title from the past.

Years ago, I was teaching a class at UCLA and explaining the

importance of a good title. A student called out sarcastically, "Is *The Damned* a good title?" *The Damned* was a brilliant but violent Visconti film, depicting a family going through the Hitler years.

I immediately shot back, "What would you prefer, *The Boys in the Bund?*"—referencing a well-known film at that time called *The Boys in the Band*. I brought down the house with that answer—but I have no idea where it came from.

* * *

So with the so-called knowledge of titles, I screened a film called *Simple Blessings* for possible distribution. The film starred Julie Hagerty. I told the filmmaker, Amos Kollek, that it was a good film with a bad title: it was weak and conveyed little. He asked if I could come up with a better title, and I said I would if we made a deal. And we did.

In the film, Julie finds her new husband in bed with a girl in their apartment in New York City, runs out, takes a plane to Paris, then falls asleep. When she wakes up, she's in Israel. (Paris was the first stop. Yes, it's a comedy, and yes, it's a good film!) At that time, New York City was not enjoying a good reputation throughout the country. So I called the film *Goodbye New York*. We broke the opening-week record at the Embassy 72nd Street Theater. It was, of course, the film that did it—but the title didn't hurt.

* * *

There was a time when I was friendly with the fine German actor, Maximilian Schell. He had won the Academy Award for Best Actor for *Judgment at Nuremburg,* but he had wanted to direct films. And direct he did—but his films weren't commercially successful in America. They also had titles that weren't exciting: *The Pedestrian* and *The End of the Game* are two good examples. But he called me one day, all enthused.

"I've listened to you, and I have a great commercial title for my next film," he said.

"Great, Max, what is it?"

"*Tales from the Vienna Woods!*" he told me joyfully.

I tried to explain that this title wasn't it. Based on my influence and friendship, he made the film called—you guessed it—*Tales from the Vienna Woods.*

* * *

Amos Kollek returned years later with a new film. It was called *Three Weeks in Jerusalem.* To me that sounded like a travelogue. We argued back and forth, and finally I said, "Amos, that is the worst title I ever heard."

"That's what you said last time," he said.

"Yes," I said. "Up until then that *was* the worst title. But this beats it."

We finally settled on *Double Edge*, an okay title. But we also did have Academy Award winner Faye Dunaway—and that helped us a lot commercially.

* * *

Running Castle Hill Productions for nearly thirty years produced its share of stories. I remember one writer–director who had made a film with no movie stars. He had a former television star, who had never been in a successful film, in the lead. There were virtually no women in the cast, and the other male actors were from the New York stage and not well known.

Home videos were hot then—cassettes, but no DVDs. I sold the film to a company called Lorimar for $500,000, which was an enormous amount of money at the time for video rights, and I couldn't wait to tell my writer-director of my triumph. I knew he would be praising me and my distribution skills all over town. I doubt the film had cost more than $700,000 to make.

Into my office he came. I said, "Wait until you hear the news I have for you. I sold the home video, in the U.S. and Canada only, for half a million dollars."

There was dead silence, and then he said, "I have to tell you, I resent

the fact that you made $100,000 on one phone call." (I had a distribution fee of twenty percent.)

Literally banging my chest with every word, I slowly said, with real fury, "It took me over twenty years to be able to make that one phone call."

It was obvious that my praises weren't going to be spread over New York City.

* * *

Another writer-director had made a truly terrific film. Its only problem was that it was a documentary, and in the mid-1980s, documentaries rarely grossed much. But our whole company realized it was a prestige film to be representing.

At the same time, we were handling the sequel to a big, independent horror hit called *The Hills Have Eyes*. Naturally, it was entitled *The Hills Have Eyes 2*. I had the ad for it up on an easel. We had just had an advertising meeting and picked, out of many different campaigns, the one being displayed. The writer-director of the prestigious film came in right after the advertising meeting. He walked over to the *Hills* campaign and said with disdain, "You distribute this kind of film?" Quietly, I informed him that without that kind of film, I couldn't afford to distribute *his* kind of film.

He clearly got the picture—no pun intended.

* * *

I once had a producer come to me with a film with two movie stars. I screened it and found it playable, but no great shakes. At our meeting after I had screened it, he said, "I hate your business. I don't like the people in it. I don't like anything about it. I've made a fortune in real estate. This film has taken two years of my life, and I want out. I want you to buy me out."

"I don't have that kind of money," I said.

"What do you have?"

"I wouldn't want to insult you."

"These last two years I've been insulted plenty," he said. "I like you and the way you've treated me. You return my phone calls, you screened the film quickly, and you kept the meeting without rescheduling. You didn't keep me waiting in the reception area for an hour. Name your price."

I sheepishly told him $10,000.

He stared at me and didn't reply. A full minute passed, and he continued to stare. And then, quickly, he put out his hand and said, "Shake—we have a deal."

I did shake, but I wasn't feeling good about it at all. I said, "At least take a ten percent profit position."

"No," he replied.

"Then just sell me U.S. and Canadian rights, and keep the rest of the world," I said.

"Listen," he said, "I want out. I want nothing to do with your business. Nothing, do you hear me?" He was practically yelling.

So his lawyer sent the contract, I signed and sent the money, and that was the end of that.

It didn't happen very often!

broadway 2009

Being a Tony voter, like most things, has its pluses and minuses.

The pluses are the ability to see the biggest hit shows in the best seats when you want to go. The minuses are having to sit through shows you never would go to see, have no desire to see, and in fact would pay decent money not to see. So the honor comes with a curse. You must see every show. (As a producer, you sure wouldn't want voters not to see *your* show.) So every month on a weekend, Merryn and I would see four shows, counting matinees.

On one of our marathon weekends in New York, I said to Merryn, "Let's give ourselves time to walk to the theater." It was a Saturday night, so I knew it would be hard to get a cab, and it was a balmy evening.

New Yorkers have many things in common. One is that we are always mapping out plans in Manhattan: what restaurant, what garage, what street, what theater. It's a constant battle to find the best strategy to navigate the tricky waters that are midtown New York.

Saturday night often looks like New Year's Eve in Times Square. Theatergoers, restaurant patrons, and tourists from all over the world

converge in a few-block area. It's a mob scene. The Belasco Theatre is on 44th Street between Broadway and Sixth Avenue; the majority of theaters are between Broadway and Eighth Avenues. With that in mind, I said, "Let's not walk down Broadway or Seventh Avenue—let's walk down Sixth."

So down Sixth Avenue we walked. Times Square had recently been converted into a walking and sitting mall. No cars were allowed to go past 47th Street and Broadway. The area was filled, literally, with people sitting on beach chairs, watching or just resting.

Around 55th Street, we started to see lots of policemen directing traffic. That was strange, I thought. As we got to the Radio City Music Hall, many more police could be seen. Well, it was the second Saturday night when Broadway was shut down to cars. Maybe last Saturday had been a disaster and the police had been ordered to keep traffic flowing. Around 48th Street, we noticed no cars on Sixth Avenue at all. By 46th Street, we spotted helicopters flying above. By 45th Street, we saw police barricades and masses of people all on all four corners of 44th Street. Perhaps it was another big movie being shot in New York, we thought, with giant Hollywood stars.

We couldn't get to our theater. Every avenue was blocked with crowds and police. I spied, a bit up from the crowd, a young cop guarding a barricade, and told him we had tickets for a show down the street at the Belasco.

"May I see your tickets, sir?" he said politely. He studied the tickets and let us walk through the barricade, but then said, "Wait a minute," and volunteered to escort us to the theater.

Merryn thought that was such a nice thing to do. I said they may be called New York's Finest, but it's not for their escorting abilities. But true to his word, he returned. "What's going on?" I asked. "Are they shooting a movie?"

"No," he said, "the president and First Lady are coming to Broadway."

"Where are they going?"

"To the theater you're going to."

As we were being escorted to the theater, out of nowhere down

44th Street came five black limousines. The street had been blocked, so it was surprising to suddenly see this entourage. Men jumped out of the limos in front of the theater and proceeded to circle the area. And then we saw two gigantic machines converge on 44th Street and Sixth Avenue, blocking the street. They looked as if two giant tanks had mated with two enormous garbage trucks, and produced these two gigantic monsters. Both had what looked like huge thin lances protruding from their fronts, and they moved these monsters together until their lances touched. Nothing now could break through 44th street—no armored trucks, no terrorists in cars. For a while, 44th Street was sealed off.

The Belasco Theater has a very small lobby. There was the usual push to get in—except this night had a lot of extras. Secret service agents seemed to be everywhere. There was a metal detector, just like the ones at the airport. A large table had been set up next to the metal detector where the Secret Service checked packages and ladies' handbags. We could keep our shoes on, but we had to put our cell phones, keys, and coins in baskets. After going through the detector, everyone was patted down, either by a male or female agent, who had us spread our arms out and then turn around. (We did not have to do the Hokey Pokey.)

The show was the Lincoln Center production of August Wilson's *Joe Turner's Come and Gone*. It was an eight o'clock curtain, and I knew there was no chance of it starting on time. When we got in, three-quarters of the orchestra was empty. We were led to our seats in Row C, two seats off the aisle. The feeling inside the theater was electric. And the more people went through "customs," the more the electricity grew. Blythe Danner arrived. Meryl Streep was already seated. I saw Bernard Gersten, the co-head of Lincoln Center. Everyone was talking and laughing and waiting in anticipation for the first couple's entrance.

I looked up at both the mezzanine and the balcony. People had gathered on the far sides in droves to be able to see their entrance. It looked like rush hour on the subway. We were afraid there were too many people standing on one small area; fortunately, our fears proved to be unfounded.

It was now 8:45 p.m. No one was in the two seats in Row C on the aisle next to us. I said to Merryn, "Those are probably the emergency seats producers often keep for VIPs. We may be seated next to the Obamas." Merryn didn't think so.

I decided to go see Bernie Gersten, who was standing in the back of the theater. I walked up and, smiling broadly, asked, "Can't you get your shows to go up on time?" He laughed, and I then said quietly, "Where's the first couple going to be seated?" The theater looked filled to me, except for our two empty seats.

"Next to me and my wife in Row J," he said.

I looked. "Bernie, there are people seated there," I said.

"Just temporarily."

When I returned to Row C, the two seats on the aisle were taken.

Suddenly, a voice rang out: "Ladies and gentlemen, for security reasons, please take your seats."

We all complied and sat facing the closed curtain. It was now 8:50 p.m.

All of a sudden, we heard a roar from the back of the theater. We jumped to our feet and saw President Obama and the First Lady enter. A thousand so-called sophisticated people were on their feet hooting, hollering, cheering, and screaming. It was bedlam. Pictures were being taken. Flashbulbs were going off. Cell-phone cameras were being held high, flashing brightly. The First Couple smiled and waved. The president wore a white knit shirt, no tie, and a dark jacket; Michelle Obama had on a black cocktail dress. She was glamorous and radiated warmth. The president's skin was not the tan color one sees on television; it had a golden hue. He actually shone.

After they took their seats, the president's smile left—no waving at all. He just stared straight ahead at the closed curtain. It was almost as if he was in a trance. It worked, as I'm sure it has many times, and the crowd returned to their seats and sat down, and the curtain rose at nine p.m.

It was truly an unforgettable evening.

"relatively speaking"

Elaine May had written two one-act comedies, and we needed a third for another evening of theater. Having produced both *Death Defying Acts* and *Power Plays*, I was becoming somewhat knowledgeable about the three-one-acts format. Clearly I needed another one-act, but one that complimented Elaine's two. I read many, but kept coming up dry.

One day Elaine called to say she may have found one, adding, *See what you think*. Elaine is an avid reader. Her first movie, *A New Leaf,* was based on a short story, "Tender Heart," she found in an Ellery Queen anthology. So when she told me this play was written by Jan Mirochek, the name meant nothing to me. I was hoping for Woody Allen or David Mamet. But I dutifully read *Trotsky Is Dead* and liked it. It was a clever comedy that had never been produced in the U.S.A. We got the rights and again adhered to my policy of trying it first out-of-town.

A year before, I had taken a new play by the actor Charles Grodin, *The Co-Op Chronicles,* to the Magic Theater in San Francisco. We had a successful run and enjoyed working with the artistic director, Christopher Smith, who also directed the play.

So I called Chris and told him of the three one-acts, mentioning that Elaine was going to be the director. He read the plays and happily agreed to present them.

Having worked with Marlo Thomas, we both agreed she would be perfect for the lead in the longest of the three one-acts, *George Is Dead*. She read it and agreed to do the play.

So in the fall of 2006, we took off to open in San Francisco. Before rehearsals began, Elaine realized she didn't have enough time to direct all three plays. I suggested we ask Jeannie Berlin. She had directed *It's My Party* when I ran the Arclight Theater. It starred F. Murray Abraham and Joyce Van Patten, and had been directed well. As I mentioned earlier, Jeannie is Elaine's daughter, so we were keeping it all in the family. Fortunately, she was available and agreed to direct Elaine's other one-act, *On the Way*.

We needed a male lead for *Trotsky Is Dead* and for *On the Way*. We wanted one actor to play both roles. Mark Rydell, the film director of *On Golden Pond* and *Cinderella Liberty*, had spent many years as an actor. We sent him the plays and he agreed to come to San Francisco.

We had six or seven roles to cast, for which we auditioned many fine local actors. For the chauffeur in *On the Way*, we cast a young unknown named Daveed Diggs. He co-starred years later in *Hamilton* in New York City and won the Tony. He is no longer unknown.

The plays did well. *George Is Dead* specifically was hailed by all. So what next? I was convinced I needed a major writer's name along with Elaine's. As good as Jan's play was, his name was unknown. I didn't relish searching for a new one-act. I suggested to Elaine to try and combine her two one-acts and expand *George Is Dead* to a full-length play. Elaine agreed, and I waited for her to work her magic.

It took her a while, but she did it. We now had our full-length play, and we sent it to David Saint. David is a fine director who is also the artistic director of the George Street Playhouse in Rutherford, New Jersey. He read the new play and said he wanted to present it. "Oh!" he added, "but there's one big problem to be solved. You have to change the title."

"Why?" I asked.

"Two reasons," he explained. "One is that I don't want my subscribers to think it's about the death of George W. Bush"—who was then president—"and two, I don't want them to think it's the closing of my theater"—which was named George Street.

We opened with the new title *Roger Is Dead*. Marlo agreed to star once again. The reviews were good, the audiences loved it, but Elaine still didn't feel right about it. She said, "Let me make some changes—I have some rewrites I want to do."

Once again, time went by, and then Elaine delivered another version with her original title, *George Is Dead*. (It was starting to appear as if George had nine lives.) And this version was new and improved. I needed to find another out-of-town theater. And I wanted another star to play Marlo's character's husband, who, in this incarnation, had new scenes with her.

Years before, on my radio show, I had met and become fast friends with the actor Don Murray. Don had been the male lead with Marilyn Monroe in *Bus Stop*, had co-starred in *Advise & Consent*, *Bachelor Party*, and *The Hoodlum Priest*, and was Kathleen Turner's dad in *Peggy Sue Got Married*. I had seen him on Broadway with his ex-wife Hope Lange in the hit *Same Time Next Year* and knew he liked theater. So I called him and sent him the play, and he agreed to do it.

Now to find another regional theater, with the hope of finally coming to New York. David Ira Goldstein was the artistic director of the Arizona Theater Company, and on a hunch, I picked up the phone and dialed his number. I didn't know him. But I liked a man with three names.

My hunch was right. He responded to the pedigree of Elaine, Marlo, and Don. He only had one concern. *Oh no!* I thought. *Not the title.* But no: he said, "I want to play in two cities: Phoenix and Tucson." I was able to get everyone to agree, and we played successfully in both cities.

But I still wasn't ready to open the play in New York City. It's worth noting here that in almost all cities, except New York, there are

just a handful of theaters at most. In New York, there are more than fifty—and most of them are on or near Broadway. The competition is fierce, the reviewers unrelenting. We were always a success out-of-town, but playing New York can be, well, different.

Don Murray returned to Santa Barbara and Marlo, Elaine, and I returned to New York. And it appeared that despite our successful runs all over the country, we weren't going to play in New York.

One day, Marlo, Elaine, and I met at Elaine's home, and Marlo asked me, "What can we do about our play?"

"I'm sorry, Marlo," I said. "I don't want to produce it."

"Neither do I," said Elaine. "I tried twice to make it into a full-length play. It's really a one-act."

Marlo then said, "So *you* don't want to produce it, and *you* only want it as a one-act. So why are we here?"

"You remember how hard it was to find an additional one-act, let alone two one-acts?" I said.

"So how did you do *Death Defying Acts* and *Power Plays?*" Marlo asked. When I told her what I've previously written here, she asked, "Would you call Woody Allen? You know him. See if he has a one-act."

So I did, and Woody said he had one—but it had a big cast. I told him I didn't care, I read it, and it was funny. So adding in Woody's sister Letty Aronson, who had been producing Woody's movies, I now had a co-producer and two one-acts.

The search began for a third play. I called Neil Simon, Larry Gelbart, and David Mamet, all of whom were engaged and didn't have time to write a new one-act. No plays in the famous writer's trunk either.

One day I was seeing a play at the Atlantic Theater and arrived early. I started looking at the window cards hanging on the walls, depicting past productions. I was surprised to see that Ethan Coen (of the Coen Brothers) had written two or three plays that the Atlantic had produced. Maybe he could be our third playwright. Elaine, Letty, and Woody agreed, so I contacted him.

Ethan agreed to write a new one-act. And with everyone's okay, I

decided to go straight to Broadway, not off-Broadway. However, I was unable to get Woody to go out-of-town—so though it was going to be my third time in New York City with three one-acts, this time would be quite different: first, we'd be opening on Broadway, and second, there'd be no out-of-town tryout.

Once again, we tried to come up with a title that represented all three plays. Since each concerned relatives, I had an idea. Excited, I met with the three writers and Letty to propose the title *It's All Relative*. Dead silence filled the room. Then Ethan said, "How about *Relatively Speaking?*"

"I like *It's All Relative* better," I said.

But Woody and Elaine sided with Ethan, and that ended that.

It had been another long and arduous road to get to Broadway with three one-acts, and I resolved never to do it again.

And yet…

"bullets over broadway"

After *Relatively Speaking*, I was contacted by Letty Aronson. She wanted to know if I would be interested in co-producing a Broadway musical based on the film *Bullets Over Broadway*. I loved the movie and thought it would make a great musical. I also loved the title. Letty said she had convinced Woody, who wrote and directed the movie, by saying we would use some of the popular songs of the period—mostly the 1920s. I asked whether Woody would direct and she said no, he wanted a top Broadway director.

Even though this was a dream come true, I had never produced a big Broadway musical. I had produced three small musicals: *Tommy Tune: White Tie and Tails*, James Naughton's *Street of Dreams*, and the aforementioned *If Love Were All*, starring Twiggy and Harry Groener. But this would be as big as it gets. Lots of actors, dancers, musicians—and millions of dollars needed for expensive scenery, elaborate costumes, orchestrations, arrangements, and so much more.

The first step was to find a director. Woody, Letty, and I had enjoyed the Broadway hit *The Producers*. Its director, Susan Stroman,

won Tonys for Directing and Choreography, and had worked closely with Mel Brooks (who, like Woody, had written and directed the film the show was based on). Known professionally as "Stro," she was an unknown personality to all of us. So Woody, Letty, and I met with her. It's hard to remember meeting anyone so warm and charming and knowledgeable. She knew the film and was eager to work with Woody to help adapt it to the stage.

We decided we'd do a workshop once the play was ready. A workshop of a musical is staged in a modest way, without a full orchestra, set, costumes, or lighting. Many musicals start this way. Stro and Woody would pick the songs that would accompany the action. Then we would need a place to do the workshop and cast it. We also needed the money to finance both the workshop and the show.

I had never been so excited. This was my best chance at that elusive brass ring. *Bullets* had it all: a terrific film, a sensational director, and some of the top songs from the American Songbook. I knew we would get a great cast; we already had Santo Loquasto for the set and William Ivey Long for costumes.

Budgets were drawn, and Letty and I set out to announce the project and raise the money. Once we announced, we were contacted by several producers. At one of the first of many meetings, a well-known producer offered $500,000 to invest. I was thrilled until I heard Letty say, "We're looking for a minimum of one million dollars."

Now, we had discussed what Letty was saying. But I couldn't see turning half a million down. So I piped up: "Let us get back to you on that offer."

When we left his office, I said, "Letty, theater is some of the hardest money to raise."

"I realize that," she said, "but let's try for the one-million minimum. I think we can do it."

The next day, I called the half-million-dollar producer back and said we were going for the one-million minimum. And we stuck to that. While some folks balked at the minimum, many did not. It was,

on paper, the hottest show of the coming season. We raised it all, and never had to drop the minimum.

We cast for the workshop, and hired many well-known Broadway actors and some TV stars. This somewhat replaced my desire to go out-of-town (which I already knew Woody wouldn't do, since he'd refused to go on *Relatively Speaking*). By the time the workshop ended, we had learned a lot. Songs were replaced. Some actors were as well. Our dates going forward for rehearsals conflicted with some of the remaining actors' schedules. And so we found ourselves casting again for acting roles, as well as for some of our dancers.

While all this was going on, we needed to find a theater that was available for our dates. My first choice was the Winter Garden, a large and beautiful theater that had a history of long runs—*Cats* and *Mamma Mia* to name two. Also, as I mentioned, I saw my first play there, the musical *Peter Pan*. I'm not superstitious, but I admit I liked the symmetry; perhaps it would be from my beginning to my end. I was in my seventies then, and if *Bullets Over Broadway* was the hit I expected it to be, it would require lots of time and oversight because we shared in all rights worldwide. (Yes, visions of sugarplums danced in my head.)

Our dates didn't work for the Winter Garden. We then found that the Broadway theaters that could accommodate musicals were booked with long runs, so Stro, Letty, and I made a list of possible venues that we might play, depending on their availability. One day, as casting was going on, I received a call from Jordan Roth, who runs Jujamcyn Theaters. He wanted *Bullets* at the St. James Theater, where *The Producers* had played. I liked that symmetry even more than the Winter Garden—and Woody, Stro, and Letty agreed.

We had our theater.

* * *

Zach Braff had starred on the TV series *Scrubs* for many years. He wanted the leading male role, and we wanted him. We had another actor we liked a lot as well, but Zach was chosen.

Not so fast.

Zach's rep said he needed more money and less time. We explained this was what we had to have time-wise, and the salary had already been raised for him from our budget.

We were at a stalemate when Zach called and asked if we could have dinner. I agreed, and since we had gotten to know each other during the workshop, he asked directly, "Do you have someone else for the role?" I said we did, and that we wanted him, but this was our final offer—and it was no bluff.

The next day, we closed his deal.

The female lead, Helen Sinclair, proved to be the hardest to cast. Every female Broadway star wanted the role, and they all agreed to audition. After all, it was a chance to be seen by Woody Allen and Susan Stroman in what looked like a new season's blockbuster. (Dianne Wiest had also won the Academy Award playing the part in the film.) Some came back for a second audition; finally, Marin Mazzie won the coveted role.

The gangster Cheech was played in the workshop by Bobby Cannavale. He was great in the role, sang well, and was a joy to be around. We wanted him and he loved the part, but film and TV opportunities had come rolling in. So we were back to auditions. Once again, a lot of well-known actors auditioned, yet we were having a hard time finding the right guy.

Then one afternoon, in came a Canadian actor I didn't know. In fact, none of us knew him. He was tall, well-built, and sang well. His name was Nick Cordero. When he came back a second time, he nailed it. We had our Cheech.

At rehearsals, Stro and our assistant choreographer, James Gray, taught Nick how to dance, and he learned quickly. He did so well that when watching him lead the gangsters in *Tain't Nobody's Bisiness If I Do*, one would think he was a trained dancer. (Well, he was—as he had attended the Stro and Gray Dance Studio.)

In rehearsal and in previews, I was constantly reminding Nick that

he was playing a killer. He needed to be meaner and tougher. I said I was going to get him a little cute dog to kick before he first went on. We would laugh. The last time I said, "Meaner, please," he replied, "Julian, I'm a Canadian." But he did get tough, and was nominated for a Tony.

During rehearsals, we developed a friendship. Even after *Bullets* closed, we saw each other at times, and once shared a great lunch. At the restaurant, I introduced Nick to Alan Alda, and then to Danny Aiello. He was genuinely thrilled to meet them—and I, in turn was excited by his reaction. He was such a kind and outgoing man. Everyone adored him. When he died from COVID-19 at forty-one, the theater world and the public were stunned. It was a true loss.

<p align="center">* * *</p>

During previews, Stro, Woody, Letty, and I would meet at intermission to discuss the first act in the theater manager's office. On one matinee, my mother attended. I went to see her briefly at intermission and then ran to our usual meeting. Stro asked me quickly, "How does your mom like it?"

"She's loving it!" I said.

"Well," said Woody, "at least we got the ninety-year-olds."

I was so sure that *Bullets* was going to be a hit that I would have been willing to violate the major rule of the Lead Producer's Handbook: if needed, I would have put up my own money. That's what you call confident.

But it didn't go that way.

I had no idea why we weren't successful. Everyone in the business thought we were going to be the breakout show, the show of the year. Nancy Coyne, the premiere advertising maven, said, "It's the *Guys and Dolls* for 2014." But we didn't have a long run.

Here are some of the reasons I've heard as to why *Bullets* didn't score big.

One, the very day the box office opened, Woody was accused again of being a child molester by Mia Farrow and his daughter, Dylan Farrow.

Two, Ben Brantley of *The New York Times* didn't give us a good review. Yet some of the biggest Broadway hits of all time—*The Phantom of the Opera, Cats, Les Misérables, Mamma Mia,* and others—had been given far worse reviews, and still played for many years, so a harsh *Times* review doesn't necessarily stop many musicals.

Three, many writers and some critics said they were disappointed that the show didn't have an original Broadway score. All of a sudden, we were branded a "jukebox musical." Yet if you check, there were major critics who wrote rave to positive reviews.

Fortunately, we had a very successful tour throughout the United States. We continue to play around the world, and we even returned some money to our investors.

I believe that was my one big chance for a long and successful run. I believe Stro, Woody, and the actors, dancers, and designers—in fact, all involved—delivered the show that I wanted to see on a Broadway stage. But professionally, I have never fully gotten over its premature closing.

my impossible dream

My favorite subject, when I was a kid, was history. It was also my major in college. As an adult, I entertained friends and acquaintances with the names of presidents and events in historical order. But my life was in show business—producing, casting, reading new plays and film scripts.

And then I saw Ken Burns' television series on the Civil War.

I was overwhelmed. This was history told through the letters of those who had lived it. It was not written by those who were told what happened—it was written by those who *made* it happen, those long-dead soldiers who had reported in the present what would be studied as the past.

I thought, *Who would write these letters now in my century—the 20ᵗʰ century? Who writes letters today anyhow?* There are countless emails, newspaper stories, and movies. Professional voices on TV describe what happened to real people, as written by historians or spoken by pundits. But who would speak about the first cars, the first planes, the first World War? What was it like to hear radio in your home, to live through the Roaring '20s, to make do during a worldwide depression,

and to experience a second World War? Who could discuss the beginning of television, landing on the moon, the invention of the personal computer, the advent of the Internet and atomic energy? These were major events—and they seemed endless.

I marveled at having lived in the 20th century. It was the only century where the U.S. had dominated the world. Centuries past were mostly controlled by European nations: Great Britain, France, Spain. But in economic and military power, industry, scientific discoveries, and much more, the U.S. came into its own by the end of 1999.

With this as a background, I made a decision. I would try to research the men and women who had made history happen in the 20th century. To interview them. To see and hear their voices. To examine the major events that had occurred during their lifetime, and hear how those incidents had affected their lives—and how, conversely, they had caused or participated in those very same events.

I wanted the participants' ages to span most of the century. I knew this would be a race against time, and I had no idea how I was going to get the luminaries to sit down and talk to me. But I made up a wish list that included bold face names, and I showed it to Merryn. She loved the idea, but she also wondered how I could possibly get to these people—let alone persuade them to be interviewed. I'm not famous. I had no network backing me. I couldn't even guarantee that their interview would ever be broadcast.

So how to start? I began by calling ten people I knew, many of whom were friends, and asking if they would participate. They all agreed. I then found a studio in New York to lease for two consecutive days. I hired a camera crew and scheduled five guests for each day. Well-known actors, a major theater leader, a former film studio president—all famous and respected leaders in show business.

I knew this would not be an easy task. Ten prominent people in two days to talk about the 20th century! What interested me most was learning about their background, their early years, their family members, their major influences and setbacks—the formative years that had

shaped their entire lives. Almost all were well over seventy-five years old. I felt they could provide a unique point of view that I hoped would be interesting. Most of them had been interviewed many times. But it was almost always about a film, play, or book that they had been involved with. And it was often little more than a short soundbite. I scheduled over an hour for each of them.

I decided to conduct all of the interviews without any notes. I studied whatever research I was provided with, and I complemented that with my own. My idea was to have conversations, not interviews—to listen to what the person had to say, and follow up if something was said that needed clarification, elaboration, or perhaps a new subject. In addition, I would use mnemonics to make sure I had salient events or questions in mind. As a kid, I had been taught that the way to remember the Great Lakes was a word—HOMES: H-Huron, O-Ontario, and so on. Similarly, while I made sure I knew a lot about my interviewees, I always had my mnemonics in mind during our sessions.

One of the requisites of doing each interview was sitting close to my guest. We faced each other, but I knew many of them might have trouble hearing. And equally importantly, I knew I *definitely* did. Later on, I remember Walter Cronkite saying, "I'm a little hard of hearing." He then paused, smiled, and added, "Hell, I'm deaf as a post."

It was a busy time. I was running a company, producing a play, looking for films, and doing interviews. Edna O'Brien, a fine writer, had written a play I was producing called *Triptych*. We were in rehearsals when she told me she had to leave early, as she was having dinner with the Schlesingers. I asked if that was Arthur, the prominent historian and John F. Kennedy's presidential advisor, and she said yes. Up until then, I had been interviewing those in the arts: actors, writers, and directors—including Edna. I asked, tentatively, "You think you could ask Schlesinger if he would consider doing the series?"

She replied, "I am sure he'll do an interview with you."

He did, and his interview changed the trajectory of the series. After him, I was able to get Ted Sorensen, Robert McNamara, and John

Kenneth Galbraith, all from the Kennedy presidency.

Once I had those four important names, most of my new wish list fell into play. And often through friends, I was able to recruit many more witnesses. For example, Chuck Grodin got me Mario Cuomo; Richard Schickel, Clint Eastwood; Elaine May, Ben Bradlee; Marlo Thomas, Ralph Nader. As the list grew, and with a little help from my friends, it became rare for me to be turned down.

One of the amazing things was how forthcoming these witnesses all were. They recognized my sincere interest in their life story. I wasn't a journalist looking for a "gotcha" moment. I truly believe they welcomed the opportunity to look back on their lives with the perspective only time can give. For many, it was the last interview they would ever sit through.

I traveled to Boston, Washington, Houston, Los Angeles, and San Francisco. I studied each day before an interview as if I were taking a college final. I was always prepared. Many guests made comments like, "I never told this story before," and, "Where did you learn that?" I remember Neil Simon laughingly declaring, "You know more about my life than I do." Sometimes, however, I also heard, "I never said that," or, "That never happened"—which was always after I said something I'd read on the Internet. I learned to ask about anything that was questionable (meaning from the Internet) before I began an interview.

When I screened the raw footage of the interviews for my friends Elaine May and Stanley Donen, they encouraged me to keep going. I realized no one had ever done a series like this—in fact, more than twenty years into the 21st century, that is still the case. There have been overviews of some highlights of the last century; there have also been occasional decade-by-decade studies. But none have our depth, nor the extraordinary number of major players I interviewed to comprise our fourteen hours of viewing.

*** * ***

When Elaine once asked me, "How are you going to put this together?" I answered, "Hello, how." And we both laughed.

But it was a good question.

Once again Meyer Ackerman joined with me and our other partner, James Fantaci, to help make the show a reality. It was to be a fourteen-hour series. We planned to use film clips, newsreel footage, archival material, and the music of the period to craft a decade-by-decade chronology of the 20th century, illuminated by first-person accounts of eyewitnesses.

Elaine, to my eternal gratitude, agreed to write the commentary and direct each episode. We worked with various editors. I would lay out a show and the topics, pick the music, and gather the various sound bites to accompany the footage. I would write some narration, purely as a guide for Elaine. Once it was ready for her to screen, I would watch as she took notes, made comments, and asked questions. Then she would go to work and provide us with her alchemy, changing straw into gold.

Besides her extraordinary talent, Elaine brought to the series another incredible asset: she knew absolutely nothing about history. She was the perfect audience, a true test case.

How could I believe that in the 21st century I would find and speak to a World War I veteran? Be surprised when Governor Mario Cuomo told me, "Nixon suggested that I run for president against Bush, and that's a story I never told?" Be astounded when David Rockefeller recalled, "Three generations back, my grandfather had an opportunity to—and voted for—Abraham Lincoln?" Hear former Secretary of State Madeleine Albright admit, "Anybody who says they're glad the big jobs are over is lying?" And hear Beverly Sills, after having been badly treated by the New York Metropolitan Opera, reflecting, "I proved that you can be an international star without the Met?" William F. Buckley told of working in the C.I.A. when his boss was E. Howard Hunt of Watergate fame. Gore Vidal shocked me when he stated, "Do you know that every single commander, from Eisenhower in Europe to Nimitz in the Pacific, advised against dropping the atomic bomb?" Despite my extensive research, almost every witness had something fresh to impart to the series.

I was able to attract 140 guests, many of whom are legends, to sit

down and share their stories: presidents, movie stars, senators, generals, authors, governors, newscasters, playwrights, revolutionaries, business leaders, the first female Supreme Court justice, the second man to walk on the moon. Some asked to limit their time to thirty minutes, then stayed for hours. Others came back for a second interview to discuss a new topic that they hadn't covered, or to elaborate on an issue. Almost every person was remarkably candid. All contributed insights into the events that shaped the world we live in today.

And then an amazing thing happened. Some witnesses volunteered to encourage other leaders to interview. It peaked with James Baker, Secretary of State, and Governor John Sununu, Chief of Staff to President George H. W. Bush, separately asking if I would like to interview the former president. And they delivered.

My mnemonic for the president was David B. D was for living through the Depression, A—Analysis of his presidency, V—Veteran of World War II, I—Iraq War and Iceland with Gorbachev, D—Dana Carvey's imitation, and B—the fall of the Berlin Wall.

*** * ***

When Gore Vidal told me, "The U.S.A. stands for 'The United States of Amnesia,'" I knew he was right. In answer to that, Elaine and I wanted to make history enjoyable and fun to study—not just memorizing dates and facts. And perhaps, our approach could help Americans not repeat the same mistakes over and over again.

In the early part of the 20th century, when people got together, they talked of the new books they had read. But once movies, then TV, and now streaming came to pass, it's always a film or taped program that folks talk about. So I hope that through this series we can both entertain and educate.

And I want to leave something behind to show that I was here. Having no children, these 140 interviews are my legacy—along with, I hope, fourteen meaningful hours entitled *Witnesses to the 20th Century*.

Here is the list of all of our witnesses:

try not to hold it against me

F. MURRAY ABRAHAM

SEC. MADELEINE
ALBRIGHT

BUZZ ALDRIN

ROBERT ALTMAN

SEC. GEN. KOFI ANNAN

DAME EILEEN ATKINS

LAUREN BACALL

HERMAN BADILLO

JOAN BAEZ

F. LEE BAILEY

SEC. JAMES A. BAKER

ERIC BENTLEY

SID BERNSTEIN

FATHER DANIEL
BERRIGAN

BEN BRADLEE

TOM BROKAW

HELEN GURLEY BROWN

DAVID BROWN

PAT BUCHANAN

ART BUCHWALD

WILLIAM F. BUCKLEY

PRES. GEORGE BUSH, SR.

OLEG CASSINI

MARGE CHAMPION

NOAM CHOMSKY

SCHUYLER CHAPIN

DEEPAK CHOPRA

PROF. IRWIN COREY

NORMAN CORWIN

JUDITH CRIST

WALTER CRONKITE

GOV. MARIO CUOMO

ANGELA DAVIS

OSSIE DAVIS

SEN. BOB DOLE

STANLEY DONEN

PHIL DONAHUE

CLINT EASTWOOD

DANIEL ELLSBERG

GEORGE ELSEY

SIR HAROLD EVANS

WILLIAM B. EWALD, JR.

JULES FEIFFER

REP. GERALDINE FERRARO

HORTON FOOTE

SONNY FOX

BETTY FRIEDAN

JOHN KENNETH
GALBRAITH

LEONARD GARMENT

FRANK GEHRY

LARRY GELBART

WILLIAM GOLDMAN

LEE GRANT

HANNAH GREEN

ALAN "ACE" GREENBERG

VARTAN GREGORIAN

STANISLAV GROF

RUTH GRUBER

GEN. ALEXANDER HAIG

PETE HAMILL

KITTY CARLISLE HART

PAULINE HELPERN

DON HEWITT

GEOFFREY HOLDER

DOLORES HUERTA

REV. JESSE JACKSON

try not to hold it against me

QUINCY JONES

BEL KAUFMAN

GEOFFREY KEAN

SEN. BOB KERREY

AMB. JEANE KIRKPATRICK

SEC. HENRY KISSINGER

JOE KLEIN

MAYOR ED KOCH

LARRY KRAMER

MATHILDE KRIM

GEORGE LANG

ANGELA LANSBURY

ROBERT LANTZ

FLORIA LASKY

ARTHUR LAURENTS

ART LINKLETTER

NORMAN LEAR

WILLIE MAYS

SEC. ROBERT MCNAMARA

ARTHUR MILLER

GRACE MIRABELLA

WALTER MONDALE

RALPH NADER

MIKE NICHOLS

EDNA O'BRIEN

SANDRA DAY O'CONNOR

GORDON PARKS

ARTHUR PENN

PETE PETERSON

DAVID PICKER

ANTHONY PIERRO

GEN. COLIN POWELL

VLADIMIR POZNER

HAL PRINCE

TONY RANDALL

DAN RATHER

OSCAR DE LA RENTA

GOV. ANN RICHARDS

DAVID ROCKEFELLER

DOLORES ROLAND

DR. ISADORE ROSENFELD

SEC. ROBERT RUBIN

SHOJI SADAO

RICHARD SCHICKEL

ARTHUR SCHLESINGER, JR.

CHARLOTTE
SCHLOSSBERG

GERALD SCHOENFELD

GEN. BRENT SCOWCROFT

SEC. GEORGE SHULTZ

BEVERLY SILLS

NEIL SIMON

LIZ SMITH

RICHARD SONNENFELDT

TED SORENSEN

GLORIA STEINEM

LEONA STILLMAN

DR. LOUIS SULLIVAN

GOV. JOHN SUNUNU

DR. WILLIAM TILLER

HELEN THOMAS

MARGARET TRUMAN

ARCHBISHOP TUTU

TWIGGY

LIV ULLMANN

JACK VALENTI

GORE VIDAL

ELI WALLACH

DR. JAMES WATSON MILTON WOLFF

JACK WELCH AMB. ANDREW YOUNG

DR. MILTON WEXLER EVA ZEISEL

ELIE WIESEL HOWARD ZINN

To this day, I have no idea how I was able to get these luminaries and leaders to agree to be interviewed. I look at this list, and I marvel that I actually met these extraordinary people and was able to hold my own interviewing them.

It was truly my impossible dream.

<p style="text-align:center">* * *</p>

When I started the *Witnesses* project, I had no idea if I could get some of my wish list to participate. I didn't know if I could raise the money needed. If I did attract the names and the financing, who would help me shape this gigantic undertaking? As you can see, I was able to get many of the most significant people of the 20th century. I raised the money and got a first-class writer-director to collaborate with. That's all the good news.

Elaine and I filmed six shows. We started at the beginning of the century, 1900, and went up to 1955. We needed more funds to finish, so we went to the marketplace. It was not an inexpensive budget. But it was totally in line with the average cost of one-hour programming. We hoped for a cable system, the PBS network, or a streaming service to come on board.

My two partners, while still supportive, had decided they had given enough at the office, and they were right. I raised some more money,

filmed seven more witnesses, and then went on to produce two Broadway shows, two off-Broadway shows, a national tour, and an American Masters Mike Nichols special with Elaine May writing and directing. And then the pandemic took hold and once again we were stalled.

I have spent most of my life buying and selling. I understood why this wouldn't be easy. But I knew many of the buyers, and I wasn't selling the sizzle—I had the steak. They could taste it. Plus, a top chef was involved. And that great list of names, with forty to fifty of their sound bites per show!

Ultimately, we will find a suitable partner to broadcast *Witnesses*. Meanwhile, I continue to remind myself of my reasons for doing it. I don't want younger voices, or pundits, or biographers, all of which have been suggested to me to sell the series. I want the real people who impacted the major events of our time—or those who lived through them. They are living history, and their stories matter.

Now knowing my American history, I remember a story. William H. Seward, Andrew Johnson's Secretary of State, purchased Alaska from the Russians for $7 million. In many circles, he was vilified for buying this vast wasteland, which became known as Seward's Folly. There is, however, a happy ending to the tale. Gold and oil were discovered there, and Alaska is recognized today as a brilliant acquisition. I am hoping that what some would probably call Schlossberg's Folly will experience a similar success someday. Just a small percentage of Alaska's would suit me fine.

I had so many wonderful experiences while making this series. Working with Elaine May day and night. Learning and researching constantly. Forming new friendships—the most enjoyable being one with Ted Sorensen, President Kennedy's speechwriter and advisor. It turned out we lived near each other in New York City, and also in Westchester County. Almost every week we drove to the country, either on Thursday or Friday, then returned to New York on Monday. We laughed, argued, told stories, socialized with our wives, and thoroughly enjoyed each other's company.

When Ted died in 2010, his wife Gillian asked me to help her select

some of their beautiful photographs, showing his exceptional life. I went over to her home and, upon seeing them, had an idea. I borrowed the photos and asked my film editor at the time, Maggie Noble, to work with me to create a moving tribute to Ted. We scored it with a haunting instrumental rendition of "I Remember You." I showed it to Gillian and got her approval.

On December 7th, 2010, a memorial for Ted was held at Alice Tully Hall in Lincoln Center. Many speakers lauded his exceptional character and career. Bob Kerrey, Bill Moyers, Caroline Kennedy, Robert Caro, and many others all spoke eloquently of his accomplishments. At the end, the film we had created was shown. I was glad I had a part in saying goodbye to Ted.

I am a man blessed with enthusiasm. It's probably in the genes: I go into all my endeavors seeing the famous glass at least half full. So whatever happens with *Witnesses*, I know I experienced it. I have recorded part of the 20th century, and I don't regret for one minute having done it.

memories

The word *memory* is interesting. In French, it's *souvenir*. And it really is just that. Some things you retain like souvenirs, often for a long time. Here are some of mine.

My first wife Susan once said, "Julian would never buy an elephant, but if there were two on sale…"

My friend Milton Wexler, who was an analyst, once told me I would be content in business if I kept a cash register on my desk. All I needed was a sale a day—the actual amount wouldn't matter. Just ringing up a minimum of one sale would suffice.

* * *

Milt Goldstein, when he was president of CBS Cinema Center Films, once said, "Julian is an independent distributor with a capitol I."

* * *

Peter Falk, Elaine May, and I were once involved in a deal together. One day, Peter said to me with some disdain, "If you had a little more larceny in you, we could all be millionaires."

* * *

Mike Nichols was a very funny, witty guy. Once at lunch, I asked him if he had seen a new film, *Joan of Arc*. He answered, "No, I haven't. But most people in this country think Joan was married to Noah."

One day I was speaking on the phone with him and I asked him whether he had seen the play *The Graduate*, which was on Broadway at the time. He had directed the film on which it was based; in the Broadway version, in one bedroom scene, Kathleen Turner famously bared it all.

When he said he hadn't seen it, I said, "Mike, it's the highest-grossing straight play in the history of Broadway." There was dead silence, and then Mike replied, "I don't understand it. We all have a naked fifty-year old at home."

* * *

Shirley MacLaine was doing her show at the Palace Theater on Broadway. We had a date to have dinner, and after her performance I went back-stage to pick her up.

As we came out of the stage door, there were many young fans waiting to get her autograph. She turned to me and said, "Julian, I have to sign all these kids' playbills and photos. I'm sorry."

I told her I would wait. As she signed away, a young girl asked who I was. When I said, "I'm nobody," she turned to the girl behind her and said, "He's nobody." Suddenly it was being passed down the long line and repeated out loud: "He's nobody, he's nobody." Soon they were pointing at me and repeating the phrase as it continued down the queue. I whispered to Shirley, "I'll meet you at the restaurant."

I could only take so much anonymity.

* * *

The movie *The Producers* was premiering at the Fine Arts Theater. Making my rounds to visit some of the Reade theaters, I was carrying a small overnight bag, since I was about to leave on a short trip.

When I got to the Fine Arts, I was surprised to see Mel Brooks, the writer-director, standing with a friend outside the theater. When he saw me, he yelled his usual greeting, "Schloss–Berg"—as if those were my first and last names. Upon seeing my traveling bag, he asked, "Where you going?"

"Chicago," I replied.

"Chicago is double Newark," he said.

* * *

I've been privileged to meet three presidents. The first was Bill Clinton, at a fundraiser that Barbra Streisand hosted. I was on my way to the bathroom when the Secret Service and the president arrived, passing me in a hallway. I was surprised at Clinton's height and his ruddy complexion. He said hello and shook my hand. I said, "We're all counting on you," to which he replied, "I'm trying, I'm trying"—and kept walking.

In my second meeting with a president, Merryn and I flew to Houston to interview former President George H. W. Bush for the *Witnesses* series. He was a gracious and delightful host in his elegant suite of offices, in which he had duplicated the Oval Office seemingly to a tee.

Bush was forthcoming and candid, even admitting that "trapped between the Reagan presidency and the Clinton presidency, I sometimes found it hard to believe I was president." At the end of the interview I asked, "Mr. President, would you consider imitating Dana Carvey imitating you?" (On *Saturday Night Live,* Carvey had done a spot-on imitation of the president.)

Without a moment's hesitation, he spoofed Dana doing him, including the hand gestures.

My third meeting with a president occurred when, along with Jeannie Berlin, I happily accompanied Elaine May to the White House when she received the National Medal of Arts from President Obama.

At the end of the ceremony—where along with Elaine, George Lucas, Herb Alpert, Renee Fleming, and others were given the award—the president and First Lady took pictures individually with all the honorees and their family and friends. Elaine, Jeannie, and I waited for a while, and were then ushered into a separate room, where the Obamas and the White House photographer were prepared to take our picture. The president—who by this time, I'm sure, wanted to get this over with—said, "C'mon, c'mon, we have to hurry."

I said, "Please, wait a minute, Mr. President."

"What is it?" he asked.

"I just wanted to let you know, this was one helluva bar mitzvah," I said.

He and Michelle laughed out loud. As we left, Elaine said to me, "These people must be desperate for laughs."

what's it all about?

As a young man, I couldn't wait to get older. Grown-ups seemed to know the score; so many of them appeared to my young eyes to have it together. However, they often confused me by saying, "This is the best time of your life, so enjoy it." I thought, *This can't be the best time of my life. I don't know who I am. I know I'm not a child, but I sure don't feel like an adult. My moods are up and down, and while I know I want to be in show business, I'm living on the wrong coast—and what can I do in show business?*

Now I know what they meant. No rent to pay, no kids to worry about, no car payments—in essence, no family or financial worries. But to any young person who has been told this, no: it is *not* the best time of your life.

In my opinion, there are only two major goals in life: to find a person you love and want to live with, and to discover how you will spend your days and/or evenings in your "career." Let your motto be, "It's only work if I don't want to do it."

I am a fortunate man. I found the love of my life—though it took a

while. With some luck, we will be together over half my adult life. We're almost there now. And I found a career in show business that gives me joy, great friends, an ability to be creative, and the opportunity to have lived where and how I pleased. I truly feel blessed.

For eight decades, I've resided on our planet. Here are some things I've learned.

Regarding show business. Almost everyone I ever met who wasn't in the entertainment business had two jobs: theirs, and show business. Everyone has opinions on movies, television, theater, actors, and singers. But if you want to really be part of it, I've discovered it's never too late. If you always felt you could write or act or sing, go for it.

But remember, you have to want it badly. How badly? Badly enough that it consumes you. That you are willing to pursue it day and night. That you are willing to let your personal life suffer. That rejection may become a daily or weekly experience.

A simple analogy: most people are barely holding on to the ledge. After some time, they let go. If you are willing to not let go, you have a chance to make it. Of course, you need talent. But without passion and true grit, your chances are almost nil. Talent on its own isn't enough.

Today, show business gives folks more of a chance than ever before. People with little talent but one good idea can become Internet stars. There are reality shows, streaming services, hundreds of channels—plus the ability to easily record performances for auditions or demos. Of course, this has led to even more competition than ever before. So do not let go of the ledge.

It's rarely black and white. I often hear people say, "We only have two choices." But is that true? I often try to find a third alternative—it's often the best choice. And because in most situations, the two choices we see are "Plan A or failure," I also always try to have a Plan B in mind when faced with a problem. One nearly always exists. Find it, and I promise it will ease the stress you may be feeling.

Decisions on the spur of the moment. Try not to make these. Sometimes there is no choice, and one must. But take an hour, or a day, and weigh the alternatives. Hear both sides of the story. So often, one person sincerely presents the facts to you, and there's no doubt this person is in the right. But don't ignore the other side, no matter what.

It's amazing how the same incidents—or facts—can be interpreted in two, three, or more ways. In the classic Japanese film *Rashomon,* four people describe varying accounts of a murder they all witnessed. That title is now a part of the English language. Before judging or joining sides, seek out the information from the opposing players.

Strike while it's hot. Opportunities are always available. Seeing them is the hard part. But equally difficult is knowing when and how to jump in.

Most people don't like change. We hold on to everything, even our old shoes and clothing. Try not to be paralyzed by the prospect of change. When faced with major decisions or problems, ask yourself, "What's the worst thing that can happen?" When you look at it this way, you can generally handle the situation. If you know the worst, you can face it.

A truly tough task. It has been written that an unexamined life is not worth living. I feel we should all examine our lives. I, for one, years ago, had a terrible temper. I had a lot of rage within me, and it often came to the surface. I could go from an easygoing guy to an angry man in a matter of seconds. I tried to control it, but until I found a wonderful wife and partner in Merryn, I wasn't too successful.

And she acted as if we were in the story of *Androcles and the Lion.* I had this thorn in my paw, she removed it, and it hasn't bothered me ever since. She helped me gain control of those negative impulses. Merryn was able to accomplish this with more love and kindness than I had ever known. I know my anger is not totally exorcised. But I would be wildly disappointed and ashamed of myself today if I let my temper erupt again.

Another of my flaws was being impatient, at times, with people

who were slower than I. Once again, my wife came to the rescue and showed me the error of my ways. She pointed out that everyone had some sort of intelligence. Someone slower in one aspect of life could be excellent in another. When I took the time to really think about that, I realized it was true.

She also talked about, as she put it, watering people. If someone was scowling and unfriendly, within seconds I watched her magically turn that person around, simply by saying good morning and asking sincerely, "How are you today?" I swear that simple watering can invariably do the trick.

We all have flaws. The challenge is to figure out how to correct them. Start by being truthful with yourself. Sometimes it can be fun to analyze the clues like a detective and solve the case. It's great to isolate the problem and its origins. But that's only the beginning. Equally hard is to change or overcome your behavior. Decide what flaw you wish to change—that's half the battle—and then spend the rest of your life trying to evolve into a better person. As the old philosopher once said, "It couldn't hurt."

Why we are here, or what's it all about. I do not have the answer. But I am positive of one thing: we should try to evolve.

Introspection or taking stock of oneself is important; we must each attempt to change some of our behavior or personality. It's easy to blame our father, our mother, our society, our neighborhood, our childhood. Clearly, they all have had an effect on us. But we must try at some point to take charge of our own lives. Sure, the past may have influenced us, even hurt us and scarred us—but there remains a present and a future. We can help mold that future. It is never too late. It's about willpower. It's about wanting to improve.

Shakespeare said it well: "The fault is not in our stars, but in ourselves."

*** * ***

I will never retire. I may not have a choice, but as long as I can stay healthy and think clearly, I will try to produce.

As I write this, the pandemic is in full bloom. Yet I have fourteen projects in different stages of development. That's more than I have ever had.

Why? you may ask. Well, as any producer will tell you, it's important to be developing several possibilities. The old concept of throwing a bunch against the wall and hoping some stick is often part of the producer's handbook. Also, working in motion pictures, theater, and TV gives me the chance to have three times the projects of a producer who specializes in only one area.

As you may have noticed while reading this book, the word *producer* can have many meanings in show business. It can mean solely providing money, financing, or helping to finance a project, in return for which the financier receives some ownership and a producer credit. These donors often make little or no contribution to the project, but are listed as a producer. Another example can be an attorney, a manager, or the agent of a major star who has helped put together the financing or casting, or who has it in his or her contract to be listed as a producer because they represent the star. Then there's the situation I wrote about in *Widows' Peak.* I was brought a writer's treatment, with two actresses attached; I developed it; and then others raised the funds. There are many other ways to be listed as a producer as well, which is why, in the credits, you will often see a lot of names.

But for those of us who find the projects, hire the writer, find the director, develop the property, get involved in the casting and the hiring of the crew, and find the financing, it can be a rewarding and exhausting process. And it's one of the main reasons I have fourteen projects today: I can do all of the above. After close to fifty years of producing, you meet a lot of talented people who you hope feel comfortable with you and will want to work with you again.

In 2020, I had three plays ready to go into rehearsal. Pre-pandemic, the directors, the stars, the theater, and the funding were all in place. Post-pandemic, who knows? I returned the money to the investors; I had no signed deals with anyone, because they were folks I had previously worked with. By now, they may have been offered other shows. I'm just biding my time.

Some projects I've tried for years to make happen. One is a movie I've developed with three separate major studios over fifteen years. Another is a revival of a fine American play. There's also a one-woman show with a well-known TV star. I know I want to finish the *Witnesses* series. I want to do a play by Elaine May. I'm working on a play with a famous actor about his life that he will perform, and a terrific musical about the life of Lerner and Loewe.

And that's just the first half of the fourteen.

On top of that, I want to get this book published so my friends can be relieved of my asking, "Do you want to hear another chapter?" And I want to share my last act with Merryn, who has brought me joy.

As I have written, I don't believe any of us are dealt a great hand throughout our *entire* life. Certainly, some get better hands than others. But having found a career that I love and a woman I adore, I know I have been very fortunate. Frank D. Gilroy, who won the Pulitzer for *The Subject Was Roses,* told me that my tombstone should read, 'Quality was his undoing.'" I would prefer to have the first words of *Scaramouche*, by Rafael Sabatini: "He was born with a gift of laughter and a sense that the world was mad."

My friend, the late actor Charles Grodin, often said at the end of a phone conversation, "Here's my closer." So here's mine:

To paraphrase Frank Capra's film title, it's been a wonderful life.

acknowledgements

walter anderson, who tirelessly helped and encouraged me for so many months.

ruth better, my loyal assistant for 30 years—with the greatest attitude.

james carpenter, my patient editor, who wrestled me to the ground and sometimes won.

mike claeys, who helped a great deal in many ways.

larry eckerle, a dear friend and fine writer, blessed with a great sense of humor.

roy furman, my "bro," advisor, and head cheerleader.

elissa grodin, who helped me with her calm demeanor and fine ideas.

steve karmen, whose notes were like the work of a top surgeon.

elaine may, who so many times has shown me the way.

try not to hold it against me

marly rusoff, who made the book happen.

catherine saraceno, who typed and retyped all the changes.

milly sherman, whose friendship and wise words are always appreciated.

marlo thomas, whose insights and charming demands just had to be adhered to.

Index

index

index

index